The Best of Times

Motifs from Postwar America

Reflections on Nostalgia

Wyn Wachhorst

authorHOUSE®

AuthorHouse™
1663 Liberty Drive
Bloomington, IN 47403
www.authorhouse.com
Phone: 1 (800) 839-8640

© 2016 Wyn Wachhorst. All rights reserved.

No part of this book may be reproduced, stored in a retrieval system, or transmitted by any means without the written permission of the author.

Published by AuthorHouse 01/25/2016

ISBN: 978-1-5049-6314-5 (sc)
ISBN: 978-1-5049-6312-1 (hc)
ISBN: 978-1-5049-6313-8 (e)

Library of Congress Control Number: 2015919111

Print information available on the last page.

Any people depicted in stock imagery provided by Thinkstock are models, and such images are being used for illustrative purposes only.
Certain stock imagery © Thinkstock.

This book is printed on acid-free paper.

Because of the dynamic nature of the Internet, any web addresses or links contained in this book may have changed since publication and may no longer be valid. The views expressed in this work are solely those of the author and do not necessarily reflect the views of the publisher, and the publisher hereby disclaims any responsibility for them.

For Kailey, Riley, Will, Maddie, and Molly

**The final meaning of the past
forever lies with the future.**

Ten of the essays and memoirs were published previously in slightly to moderately different form: "The Nature of Nostalgia" in *Narrative Magazine*, "Crossing the Wide Missouri" in *The Yale Review*, "The Romance of Spaceflight" in *The Massachusetts Review*, "The Inner Reaches of Outer Space" in *The Virginia Quarterly Review* and *The Dream of Spaceflight*, "Come Back, Shane!" (McGinnis-Ritchie Prize for best essay of the year) and "The Last Locomotive" in the *Southwest Review*, "The Greatest Generation" and "Pieces of the Past" in *Gentry* magazine, "Fragments of Eden" in the *Trumpeter*, and "The Romance of Extinction" in an anthology, *Phoenix from the Ashes*.

"It is a rare piece of writing that combines engaging ideas with compelling images and lyrical style. I have long admired Wyn Wachhorst's ability to do just that, and this collection—award-winning, some noted in *Best American Essays*—is surely his finest work yet."

—Donald Kennedy, president emeritus of Stanford University and past editor in chief of *Science*

"Interweaving autobiographical pieces with a wide range of sources and imagery, Wachhorst's powerful prose evidences a deep understanding of nostalgia—both as an abstract concept and as an intensely personal experience."

—Janelle Wilson, author of *Nostalgia: Sanctuary of Meaning*

"Nostalgia is typically an old person's pleasure and crutch, but Wyn Wachhorst makes backward looking a cause of contemplation, reflection, and analysis. "Nostalgia," he rightly says, "is far more than a wallowing in fruitless regret." As he looks back at his life and the America in which he grew up, he takes the measure of postwar American culture and shows us what it was like to come of age during the formerly derided decade of the 1950s. This book is not merely one man's memoir. Interweaving memories of his life with discussions of larger subjects, he shows us, soberly, rather than sentimentally, what our country was once like."

—Willard Spiegelman, editor in chief, *Southwest Review*

"Among the losses Wyn Wachhorst so movingly chronicles in these essays, the retreat from manned space exploration was perhaps the most serious. His comments are spot on."

—Buzz Aldrin, Apollo 11 astronaut

"The baseball essay certainly belongs with these other great takes on nostalgia. Wachhorst takes me back to the joys of the game, to the days when I played the game and why I loved it. Baseball. Nothing like it."

—Pete Rose

"Wachhorst sketches the pioneer figures and inaugural scenes of the folk revival of the nineteen-fifties in a way readers interested in it will recognize; but no other writer has so vividly recalled to life the excitement and delight, the romance and sheer transport we found in these singers and songs, in whom the old folk America seemed more real and immediate than the new mad America history had prepared for us."

—Robert Cantwell, author of *When We Were Good: The Folk Revival*

"I read Wyn Wachhorst's essays with a warm and melancholy feeling, reflecting on my own youth, feeling fortunate that I had grown up when I did, finding meaning to experiences that I had only thought of as good times."

—William H. Davidow, author of *Overconnected: The Promise and Threat of the Internet*

Contents

1. A State of Mind ... 1
 Radio Days ... 10
2. The Nature of Nostalgia ... 12

Motifs: Postwar America ... 22

3. Crossing the Wide Missouri ... 23
 Strange Attractor ... 43
4. The Romance of Spaceflight: Nostalgia for a Bygone Future ... 46
 The Inner Reaches of Outer Space ... 65
5. Come Back, Shane! The National Nostalgia ... 71
 Roy Rogers ... 84
6. The Last Locomotive ... 86
 Old George ... 99
7. Our Game ... 104

Mythic Nostalgia ... 116

8. The Greatest Generation ... 117
 Pieces of the Past ... 121
9. The Romance of Extinction ... 128
 Fragments of Eden ... 144

Reflections in a Rear View Mirror ... 146

Lofty Days ... 147
Detritus ... 154
Goodbye to Gramma Watchie ... 156

Appendix: On the Generational Theory of History ... 159

Notes ... 163

1
A State of Mind

The surrender of Japan and the assassination of President Kennedy bracket an era variously known as Pax Americana, Good Times, the Best Years, Happy Days—the American High. It was a time of solid families, effective schools, and reliable careers, a time when government and institutions were considered benign, streets were relatively safe, and America held most of the world's wealth and production. We lived in those years at the apogee, that weightless moment before an object shot into the sky begins to descend.

Just as personal reminiscence returns most often to adolescence, our collective nostalgia is drawn repeatedly to the mid-twentieth century as the end of American innocence, the last days of a world intact. Contrary to the countercultural myth that America in the 1950s was a sterile, soulless society, culturally and intellectually empty, it was an introspective era of innovation and creativity, the seedtime of the sixties. While many writers and artists in the fifties catalyzed the naïve idealism of the next decade, theirs was a more introverted sensibility, lacking the pseudo-spirituality, political posturing, and hedonistic self-indulgence that colored the otherwise genuine issues of the sixties.

The artistic and academic achievements of the fifties had a seriousness of purpose that make the decade look like fifth-century Athens compared to what came after. The countercultural rebellion of the sixties, presenting naïveté as idealism, narcissism as enlightenment, and elevating form over content in all the arts, conceived of freedom much as a bird might imagine its flight to be easier still in empty space. Though the counterculture is gone, too simplistic to survive the perspectives of aging, it seeded the cultural and educational catastrophe in which we now live. Rarely in history has a society had its beliefs about what is natural and proper so disrupted as did America in the sixties.

In the wake of that collective identity crisis, politics has become increasingly polarized. As with all living organisms, the ills in social systems are complex, interwoven, and multilayered. An intelligent approach to the issues requires a balanced mind, applying the values of both left and right while adopting neither as ideological orthodoxy. But a person's opinion on one issue will usually foretell his stance on most other issues, and the polarization of parties widens to the point of inaction. Liberalism, once the bold social conscience resisting the ills of industrialization, has become a pathological crusade to neutralize every conceivable stroke of ill fortune, faulting no one for his own fate and renouncing larger visions for an animal sense of well-being. Conservatism, once the repository of a traditional wisdom that knew the connectedness of all things, has grown increasingly reactionary, fundamentalist, and antiscientific, a cynical paranoia that disposes of uncomfortable facts with conspiracy theories and simplistic psychologies. With the diminishing middle class, the cultural and political polarization becomes material as well.

So our collective nostalgia looks back beyond the great divide of the sixties to a time when government seemed proficient and America's economy was preeminent. It was a time before direct contact was replaced by email, texting, Twitter, Facebook, and phone recordings, before vast numbers of youth, with their smartphones, iPods, videogames, and world-weary ignorance, retreated into solipsistic electronic bubbles. Ironically, it was one of those anonymous, perpetually circulating emails that bemoaned a post-sixties world that took "the melody out of music, the romance out of love, the commitment out of marriage, the learning out of education, the civility out of behavior, the pride out of appearance,

the refinement out of language, the prudence out of spending, and the dedication out of employment."

This perspective is reflected in the unprecedented rise of nostalgia in advertising and media over the last three decades. Critics of this trend argue that no era is really better than any other, that every era has its unhappiness, its romance, its beauty, and its messiness, and that the fifties in particular were darkened not only by the Cold War and McCarthyism (though these had little impact on the daily lives of most Americans), but by race and gender discrimination (though the same decade launched desegregation and feminism). The nostalgic "fifties," however, lay primarily between the end of the Korean War in 1953 and the Kennedy assassination in 1963, between McCarthy's demise and the war in Vietnam. And while historians have painted the era as a conformist wasteland of Levittowns and organization men, most people saw themselves and their intimate circles as exempt from a cultural veneer that was in fact a phantom consensus.

Though every era has its forms of unrest, what varies is the degree to which the unease pervades private life. While living in the richest, most powerful nation on Earth, people are losing their jobs and their homes. While lives lengthen and medical breakthroughs abound, health costs soar out of reach. While the curve of innovation and discovery approaches vertical, stagnation threatens the very health of industry, science, and technology. While superstition and discrimination are in rapid decline in the developed world, we are terrorized by people who would be at home in the twelfth century. And just when we've so refined our habitat that the night-glow of our species is seen from space, nature, it seems, now sounds an alarm.

Beyond immediate ills, we live in a world shrunk by technology, one in which Jefferson's vision of self-reliant, civic-minded individuals in self-sustaining communities is inevitably compromised. Yet while we lament the loss of that vision over the last half-century, we are not blind to the breaches and inequalities that lay behind the great rift of the sixties; nor do we long for some literal return. In truth, the historical debate bears little relevance to our nostalgia, which sees the difference between past and present related less to issues and events than to a personal sense of well-being, of predictable values, common boundaries, and a faith in the bedrock of one's culture, all of which are presently dead or dying. More private than public, our longing is for

a kind of lost innocence, a sense of being at home in a slower, more intimate world, one still awash in the afterglow of Jefferson's vision.

The Best Year

Until the age of eight, I had always lived in the city, in old hotels and second-floor flats. During the war we had moved around with my father until he was shipped overseas for the invasion of France. When my mother died in the summer of '44, my father was allowed to return, just missing the Battle of the Bulge; and for the next two years we lived with his mother in a small apartment in San Francisco, my father sleeping on a bed in the closet. In 1946, on my eighth birthday, we left the foggy mists of San Francisco and moved forty miles south to sunny Palo Alto, a small, tree-shaded town spawned in the 1890s by Stanford University. Downtown Palo Alto was a six-block stretch on University Avenue. A few blocks north and south held most of its older residences—handsome wooden houses sporting the wide front porches of their era. I arrived with my father and grandmother on a bright August morning, the old Oldsmobile crunching up the gravel drive of my first real house and yard.

It was a white two-story house on Lincoln Avenue. On the empty lot next door were apple trees and chicken coops. The chickens were gone but feathers still clung to the bleached wood. Across the street, my friend Pete lived in an old house with a big front porch and a white picket fence. To go to school we walked half a block and hopped the fence onto the playing field. On winter mornings, before the first bell, we could slide on the patches of frozen grass. On May Day, after the parade, the public pool opened. The crowd of splashing, screaming kids and the picnics in the surrounding park were the first signs of summer—a time for building tree forts in the great oaks, for running in sprinklers, and walking fence rails from yard to yard, plucking peaches from a cranky neighbor's tree.

At Old Man Bolander's neighborhood store, a dime would buy Kool-Aid, bubblegum, and a candy bar. The only television was around the corner and down the block at Freddie Porta's. On Thursday nights the Portas let us congregate to watch *The Lone Ranger*. It was a time before children's days were booked solid with adult-supervised sports and lessons in every skill. We were free to invent our own games, improvise our own toys, and devise our own projects. There was idle

time to explore in depth and reflect on the nature of things. The toys and games, neither over-technologized nor mass-marketed, left room for creativity and imagination.

There was an aura about the late forties that seems like a vestige of all that was once good about life in this country. I grew up with the friendly streets, front-porch serenity, and small-town sanity of postwar Palo Alto, poised between rural and suburban, blending the best of both. I think of steam locomotives, radio serials, and Saturday matinees, of rope swings and the roar of roller skates, of long green grass in vacant lots, and hide-and-seek to the pulse of crickets in summer twilight. We are all nostalgic for the innocence of childhood, for that warm, parental world where anything seemed possible, but there is a sense in which America in the late forties was that world writ large—the last days of American innocence.

In that idyllic interlude before the Cold War, America enjoyed an explosion of technology and a flood of new-fashioned goods, free for that moment of future complexities and inevitable problems. With the rest of the world devastated by the war, America stood like a colossus astride the earth, with half the wealth of the world, more than half of the productivity, and nearly two-thirds of the world's machines. The average American's income was fifteen times that of the average foreigner's and most of the world's gold still lay in Fort Knox. We had an abundance of land, food, power, raw materials, industrial plant, monetary reserves, scientific talent, and skilled labor; and for that brief moment, we alone had the Bomb.

My childhood, which coincided to the year with that short interim, now seems a microcosm, a metaphor for the national temper of the late forties. The years from eight to twelve, often called the age of reason, might better be called the age of "worldly innocence"—perceiving the world as distinctly other yet still centered on oneself. The realm of the child, which renders the larger world irrelevant, is an intimate, personal universe, a blend of fantasy and reality. Rebounding from depression and war, the nostalgic, inward turn of American culture in the late forties captured something of this aura.[1] But we cannot escape history. Innocence fades like fresh morning dew, lost in the heat of the day. And we can never go home to the American High.

My own awaking was coterminous with that of a nation meeting the inevitable barriers to any naïve notion of a Pax Americana. One evening the two awakenings touched. I often joined my father for twilight walks

around the block, but only one fragment lingers in memory—a moment on Webster Street when something he was saying suddenly sank in. The Russians, he explained, had somehow gotten the atom bomb, and the future of those placid, tree-lined streets—perhaps of all life on Earth—was now in question. It was the fall of '49. I was eleven years old.

So perhaps the very best year was 1948. For the nation, it was the eye in the storm, the calm between postwar readjustments and the nuclear precipice, McCarthyism, and the Korean War. For me, it was the year I was invited by the family of a friend—whose eight-year-old sister I idolized—to spend a week in Palm Springs at the old Desert Inn. Basking in the dry desert heat, playing chess poolside over endless chocolate shakes, lazing on the sprawling lawns among palms and citrus, singing along on the hayride with the grammar-school girl of my dreams—it was a euphoric feeling of oceanic freedom and utter wellbeing that I hadn't known as a child of the war years. For America, 1948 was just such a time.

My youth paralleled the American High with such uncanny precision that the golden years of grammar school fell precisely between D-Day and the Korean War; and high school lay in that placid interlude of the mid-fifties with the first strains of rock 'n roll and the dawning of the youth culture that would seed the sixties. Fatherly Eisenhower presided into my college years, while the youthful Kennedy's New Frontier was backdrop to my postgraduate time of drift and self-discovery. I learned of his assassination as I was crossing the Bay Bridge to see my future wife. By 1965, as the nation awakened to Vietnam, I had gained a family. For me, and for America, the luxury of irresponsibility had ended.

The American High was an historical aberration. My generation came of age on the crest of a technological wave and a sense of boundless promise akin to the morning of the modern age four centuries before. But the rest of the world recovered from the war and modernization reached critical mass. Though still on the leading edge, America could no longer enjoy hegemony apart from the inexorable price. As the fruits of modernity spread over the planet, the world grew smaller and precariously interdependent while the leverage of the deluded and deranged grew ever larger. It is doubtful that any nation will ever possess such a disproportionate share of the world's wealth or dominate the globe as did America at mid-twentieth century. Like the innocence of youth, the American High recedes into history, a latter-day Atlantis, lost in the sea of time.

Lonely Crowd Redux

But perhaps the dream of global hegemony, like all such tribal conceits, has outlived its day. In truth, what is lost owes less to global leveling than to the acceleration, fragmentation, and ever-increasing overload of our personal lives. The attempt to find meaning amid kaleidoscopic flux requires ever more effort. To reflect beyond the moment, to keep the larger vision in perspective in a world hypersaturated with stimuli, one must swim against a rushing current of conditioned needs, habits, and obligations. We move through the day in lockstep with the clock, our lives a set of scheduled events, feeling ever in arrears. The flood of devices and diversions—the effluvia of consumer culture—blurs the focus and saps the intensity requisite to a sense of purpose and direction. As we lose the levels of difficulty that once conferred limits, we begin to lose contour, coherence, and self-definition. Even childhood, once a time of play and wonder, is no longer exempt. Parents impose the flurry of their own inertia onto children's schedules, while the digital explosion exploits teen compulsions, precluding the kinds of experience that build an aware and rewarding life.

Changes in degree become changes in kind. For better or worse, we stand on the threshold of profound transformation. At a finger's touch, everything is connected, global, instantaneous—a boundless universe of random data in an ever-expanding virtual reality. The distance between digital illusion and real life grows daily. Ever new and novel means become ends in themselves, while myriad entertainments fill time once open to discovery, creativity, or silent reflection. As the media compete for shrinking attention spans, offering the latest, fastest, least demanding stimulation, acceleration sets in; things must be made to seem ever newer and more sensational or the audience will take flight.

The irony of our feverish connectivity is that we feel cut off—from the primary world, from the distance that gives depth to experience, from something vital, something larger than ourselves. Studies have shown that expanding internet usage correlates with increased loneliness. A connection is not a bond. In the late 1940s there were 2,500 clinical psychologists and fewer than 500 marriage and family therapists in the United States. By 2010 there were 77,000 clinical psychologists and 50,000 marriage and family therapists, along with nearly a million social workers, life coaches, and mental-health and substance-abuse counselors. The contradiction between greater opportunities to connect

and lack of human contact has only accelerated the general decline in close relationships and evaporating sense of community.[2] Thus the mounting nostalgia for the coherence of a slower, more focused time, the last images of which haunt our remembrance of the American High.

"What's difficult about getting old," said Paul Newman shortly before his death, "is remembering the way things used to be."

> There were such things as loyalty. The community hadn't disintegrated. The individual had not been deified at the expense of everything around him. I don't think that's just an old codger, you know, wishing for the old days. Goddam, they were better. There was a lot of ugliness, but there was a lot more grace.[3]

Was the past really better or only destined to seem so? Are grumbling elders inevitable? One thinks of Plato's complaints about the "frivolous, reckless, and disrespectful" youth of his day. Yet the exponential rate of change over the past century may belie any belief in cyclic history. Perhaps humans will reach the Singularity and live forever; perhaps we will annihilate ourselves within the century. Or the trade-offs may simply continue, spiraling into eternity: with the clock we lost the natural rhythms, with the telephone, privacy; with the airplane, the romance of distance; with the aggregate benefits of technology, the isolated simplicity that nurtured community.

Though few would trade the benefits for the losses, we still long for that lost innocence, for an enchanted garden of forgotten dreams. Yet nostalgia is far more than a wallowing in fruitless regret. The subjects in this book, aspects of postwar popular culture, focus as much on the temper of nostalgia as on images from the American High—the comforting continuity of long-running radio shows, pulp dreams of alien civilizations on neighboring planets, the endless stretches of land to the West that once compelled the imagination, the heroes and vagabonds of folksong who roamed a simpler world, train whistles that brought the sweet sorrow of distance to small-town nights, and the lazy summers of baseball with its fathers and sons. The film genres that proliferated during the era combine all three forms of nostalgia. While Westerns and baseball are facets of our nostalgia for the period, the genres themselves embody a mythic purity, a simplicity beyond even that attributed to the American High. At the cinematic extreme were

romantic fantasies of time travel to the past and dreams of a new Eden in the wake of nuclear Armageddon.

But science fiction soon degenerated to horrific special effects and futuristic wars, radio was eclipsed by television, baseball surpassed by football, the steam locomotive by diesels and jet travel, space fiction by real spaceflight, Westerns by crime shows, and the depth of folksong by the screaming clatter and colorless monotony of most contemporary music.

Those who lived the American High can only smile at the social and political stereotypes that partisan historians ascribe to the era. What we remember most are unintrusive days, the luxury of exhausting a topic, or knowing how most things work. We long for the linear continuity, relative calm, and pervasive quiet of predigital life, the tangible world of real people and natural places, the simplicity that gave depth to complexity, the boundaries that gave meaning to freedom. We remember more than the topics of these essays. We remember a state of mind.

Radio Days

While my father trudged through the French winter, fearing he would not survive the war, it was my mother who died of lupus in sunny Pasadena where we had settled for her health. My grandmother, who had been taking care of her, was afraid to tell a five-year-old the truth. So she took me back to San Francisco, assuring me that my mother would soon follow. As the weeks wore on, I was left to piece things together for myself.

One rainy night, by a window in our small apartment, the truth surfaced in my mind. My grandmother struggled for what must have been an hour with my screaming rage and fits of crying. But then she had an inspiration. On the table was a wooden box that curved to a peak, looking almost churchlike with its ornately latticed façade, yellow-brown grill cloth, and soft amber light behind the tuning dial. Providentially, it was time for my favorite program, *The Great Gildersleeve*. Out flowed the familiar voices with their usual foibles and predicaments; and I began to dissolve into the perennial world of Gildersleeve's Summerfield—Mr. Peavey's drugstore, Floyd's barbershop, Birdie's kitchen, and Uncle Mort's living room. And with the rain at the window, the low lamp in the corner, and the room filled with my radio family, the ugly, war-torn, food-rationed world, where not even one's own mother could survive, seemed just so benign as to permit falling asleep.

To see my grandmother's remedy as incommensurate with the depth of the crisis would be to misjudge the transportive power of radio. At a

time when the world was still far way, radio was the nerve center of the nation, the hearth in every home. And if it brought the world into the home it also allowed the home a life of its own. Unlike television, radio was not only unintrusive but a warm companion for creative projects, allowing one to cook, paint, peruse magazines, play games, or paste scrapbooks. Yet radio dramas were no less gripping than their TV descendants. Free of incessant ratings, weekly characters could persist across two generations of listeners, becoming so familiar that audience laughter broke all records when a holdup man had to repeat "Your money or your life!" to the miserly Jack Benny, who finally replied, "*I'm thinking it over!*"

Television leaves little to the imagination, but radio tapped our personal imagery—our secret terrors and private dreams. Though I never saw them, I have vivid images of Nick Carter and Captain Midnight, while TV figures are soon forgotten. Television reveals the physical setting, but radio voices seemed to emanate from the very hub of the world. One imagined Bob Hope standing in a vast arena before thousands of people, eclipsing at that moment all other earthly events. The familiar voices filled drab days in suburban kitchens and long nights in lonely cities. The brief era of radio was a bridge between the isolated imagination and the advent of the mass mind, swallowed into the all-pervasive, homogeneous world of television.

In that transitory interlude, parts of an older more personal world could persist within a burgeoning technological society that had yet to reach critical mass. Poised between modern and postmodern, the heyday of radio spanned that moment in the twilight of innocence when we seemed to have it both ways, a brief balance of both worlds that can never be again.

"The Atlantic Ocean was really somethin' in those days. Yes, you should have seen the Atlantic Ocean in those days."

—Burt Lancaster as Lou, an aging ex-underworld figure sitting at a beachfront bar in *Atlantic City*

2

The Nature of Nostalgia

After forty years, I rendezvous in a restaurant with a childhood companion. An instant of nonrecognition, a few minutes of small talk, and our disparate worlds melt away to remembered moments. There is a mystic sense that we are something more than our provisional selves, that we share something pure and fundamental, that those distant fragments are who we really are and the still-familiar features of this person are the one gossamer thread to that root past. We long to retrieve that remnant, that pristine clarity. But we cannot.

Our childhood visions of the world fade like the morning star, lost in the light of day. They may be rekindled for a fleeting moment by an old song or familiar fragrance, but never recaptured. So misty is the memory that we cannot even name what has been lost. "Innocence" and "belonging" may describe the ambient conditions, as a physics text explains the color red, but they cannot recover the direct perception—the coloration of the world through the eyes of the child. There is a fresh-dawn clarity, a mountaintop purity to that magical time of first encounters. Once upon a time we were mythic beings, sired by gods, afloat in a frictionless world of warmth and wonder—an open space of infinite potential, all feats someday perfectible. In 1948, in my dim little

room where I sat by my radio and stashed away comics, I lived, like Leonardo, at the dawn of discovery. Outside, the frontier extended over fences, through grassy lots, and out long, quiet streets to oak-studded hills shimmering in summer heat. To explorers on bikes, those hills were as vast and distant as the lush continent that lay before Columbus. The little trials are long forgotten, the dark corners dissolved to crisp mornings and soft summer evenings, the afterglow of a world vanished into deep time.

Images of dawn and dusk epitomize nostalgia, a bittersweet looking backward to a time of looking forward. There was a time, said Wordsworth, when the world and everything in it seemed celestial, glorious, fresh, dreamlike. We lived on the leading edge, certain that no one before had ever had the same thoughts or committed the same acts. We see our childhood and youth as the root time, inchoate, aglow in mystery, a world of boundless horizons. There is a sense of lost possibility, the romance of could-have-beens. What is lost is not the past but the future. Clutched in the conventional confines of time and space, we pine for that Edenic time before narrowing choices diminished who we are.

Yet nostalgia is more than the longing for a lost future. That sense of once limitless prospect emanates from the autocentric, personalized universe of the child, a cozy, benign cosmos whose stars are phosphorescent stickers on the nursery ceiling, the mysterious world without as distant as the stars themselves. The domain of most children is a familiar, well-ordered place buffered by elders, an inner sanctum that renders the larger world irrelevant. It is the innocence of that benevolent realm, with its clear borders and values, that we miss as much as its horizons. The same aura infuses our collective past. When we envision the innocent morning of modern America—Tom Sawyer's Missouri or Teddy Roosevelt's turn of the century—it is not the aggressive optimism of a nascent technological society that elicits nostalgia so much as the image of a small-town world with its Fourth-of-July picnics and rambling twilight talks on the porch swing. What we really mourn is the loss of a constant context of meaning, the stable value consensus of a simpler yet heroically energetic age.

Nostalgia can be personal, cultural, or mythic. Personal nostalgia remembers one's youth, cultural recalls an era in which one lived, while mythic nostalgia is the dream of some Golden Age in the past—a primordial Eden, or rural small-town America, the "memory" of which

rests on images created by Disneyland or Norman Rockwell. Though the three forms differ, all have a personal function. There is always a core truth to the notion that something real and vital has been lost, allowing the cultural forms to color the private.

Nostalgia can have a negative connotation, enveloping all that may have been painful or unattractive about the past in a kind of fuzzy, benign aura. But nostalgia cannot be written off as mere sentimentality. More than a wallowing in pangs of regret, more than the wistful longing for a time without limits or responsibilities, nostalgia is less a refuge in the past than a healing in the present. We long for something changeless and eternal as reassurance that we are not just process. "Has it ever struck you," said Tennessee Williams, "that life is all memory except for the one present moment that goes by so quick you hardly catch it going?"

Sociologists Fred Davis and Janelle Wilson suggest that nostalgia is essentially a quest for meaning and identity, the sense of a "self through time," the continuity that makes us who we are. We are the sum of our memories. Nostalgia tends to focus on those transitional phases in the life cycle that demand the greatest adaption and shift in identity: childhood to pubescence, adolescent dependence to adult autonomy, single to married, mate to parent. Most abrupt is adolescence, which serves as the "prototypical frame for nostalgia for the remainder of life." What space-writer Frank White called the "overview effect"—the view from the air, or the whole Earth from space—applies as well to the story of our lives, bringing a sense of harmony, of going home. An event defined by its larger outlines comes to represent a whole era in the life cycle, much as one heartfelt truth overshadows the peaks and valleys with the death of someone close.[1]

Those who see nostalgia as naïve escapism may themselves harbor a naive faith in the future—or in change itself, an extraverted need for novel experience that sees nostalgia as dreadfully inward. But nostalgia is neither negative nor neurotic. Essentially therapeutic, it is less an escape from problems than a source of a continuity and identity that can enhance our ability to face them.[2]

Nostalgia returns us to moments intensely present-oriented, sensate, and fully engaged—the camaraderie of faces in firelight, a long-ago night on a faraway beach. Citing Emily's return to the past in *Our Town*, psychiatrist James Phillips sees nostalgia as a lament over our condition as spectators of life and a longing for the recovery of direct experience, of immediate contact with the world. For philosopher Ralph Harper,

nostalgia is a wellspring of "presence"—elusive but transcendent moments when our false personas fall away and we feel overwhelmed by the truth of our connectedness to significant persons and places, fleeting images framed by a world and time unfathomably larger than the muddle of our minute-to-minute selves. Both the remembering and the remembered may occur in the timelessness of presence—the paradox of being absorbed in the moment yet softly aware of the whole sweep of one's life. In the broadest sense, says Harper, such moments can arise in love, art, or contemplation; but in a mercurial, depersonalized world, nostalgia becomes a vital source, offering "an oasis of presence in a desert of loss."[3]

Nostalgia returns always to those moments—to something ideal and unchanging at the back of memory that says "Here is what I should have known, what I loved and lost compared to this false moment." Marcel Proust, the icon of literary nostalgia, confided that he lacked sufficient perspective to grasp important moments in the present, but that living retrospectively he could escape from time into a "knowledge of essences." Combining the bitter and the sweet, the lost and the found, the far and the near, nostalgia becomes regenerating, the moral sentiment of our time. "The end of all our exploring," wrote T. S. Eliot, "will be to arrive where we started / and know the place for the first time. / Through the unknown remembered gate."[4]

The Mythic Past

The term "nostalgia" derives from the Greek *nostos* (return) and *algos* (pain). Coined by Johannes Hofer, an eighteenth-century Swiss physician, it referred to homesickness displayed by Swiss mercenaries whose supposed symptoms included weeping, palpitations, anxiety, insomnia, and anorexia. Hofer believed the cause to be "the vibration of animal spirits through those fibers of the brain in which ideas of the Fatherland still cling." Others suggested that the unremitting clanging of cowbells in the Alps damaged the brain. Equated with homesickness throughout the nineteenth and early twentieth centuries, nostalgia continued to be regarded as a disorder involving anxiety and depression, common to such groups as immigrants and first year boarding students. Only in the latter part of the 20th century did nostalgia become associated with old times and childhood, shifting in focus toward positive and potentially therapeutic aspects.

Analytical psychologists suggest that we mourn the lost innocence of childhood because we forever seek to heal the split that accompanied the growth of consciousness. Each individual reenacts the evolution of the species. Just as humanity once saw itself at the hub of the cosmos, the child lives at the center of his world. Childhood and adolescence are essentially a process of self-definition, of becoming a separate individual. Lacking clear boundaries between self and others, the infant sees everything as a literal extension of herself. Gradually, through frustrating encounters with limits, she learns the boundaries between self and other. The sense that the warm intimacy of home extends into the world begins to shrink. *My* bed as an integral extension of me becomes simply *a* bed; and the ego grows ever more finite and detached in a world of impersonal and interchangeable objects.

In adolescence this individualizing process accelerates. The imperative is to break out of the parental cocoon and become a unique, autonomous individual. But in truth the adolescent is torn between the security of home and the promise of the world. If home prevails, the cozy parental aura is carried into the world and the cosmos, where the notion of a personal God replaces the parents, the sense of infinite possibility becomes belief in a hereafter, and the great mysteries are diminished, at worst, to fundamentalist fairy tales. Those, on the other hand, who do cut the cord may remain eternal adolescents, seeing the world not as an extension of themselves but as a persistent threat to their individuality. They may develop an obsession with power. The means—wealth, status, competitiveness—become ends in themselves. While the eternal child retains Paradise in fantasy, the chronic adolescent seeks the power to recreate it. In either case, the drive is to retain or recapture the primal sense of unity with the world and restore oneself to the center of that intimate, personal universe. Few of us ever lose that longing entirely. A core desideratum of human consciousness is to find some kind of oceanic meaning that reunites the self and the world.

In sum, the analytical psychologist sees nostalgia—whether longing for a golden age, the "good old days," or the innocence of one's youth—as the clouded memory of wholeness, of union with the maternal, with the world as extended self. The "fall" into consciousness (generating myths of a fall from paradise) is the descent, individual and collective, from immortality to mortality, from the nirvana of primal unity to the polar conflicts of a temporal, finite world.[5]

Expanding on this theme, psychologist James Hollis suggests that nostalgia is rooted in the "two great complexes that animate our lives," the dream of immortality and the fantasy of the Magical Other (mother, parent, soul-mate, God). "Nothing has greater power over our lives," says Hollis, "than the hint, the promise, the intimation, of the recovery of Eden through that Magical Other. The repeated loss of Eden is the human condition, even as the hope for its recovery is our chief fantasy."[6] This mythic, free-floating nostalgia, infusing but distinguished from particular events in the personal past, is so fundamental as to underlie all quests for meaning and continuity, all art, science, and religion.

While the scientist seeks reattachment through knowledge the artist cuts through the conventional schemata of the mundane social order in an attempt to restore the fresh, spontaneous perception and intense emotion we once knew. Religious belief is the result of many interrelated conditions—evolutionary, biological, psychological, and societal. But a constant factor in all religion, as psychologist Mel Faber argues in *The Psychological Roots of Religious Belief*, is the projection of the Edenic world of the child onto adult experience, restoring the "all-powerful provider, the big one who appeared over and over again, ten thousand times, to rescue us from hunger and distress and to respond to our emotional and interpersonal needs."[7] The etymology of the word "religion," from Latin *religare*, is "to bind back, to reconnect." Even the most sophisticated spirituality—holding that "God" is but a word for the mystery of being—is prone to perceive the cosmos as sentient, as the Magical Other. Projecting the mythic past onto a mystic present, one regains the parent in ideal form and remains immortal at the center of a personalized world. Religion as nostalgia, both individual and collective, is the default state of the psyche.[8]

The scientific worldview rides no less than religion on the yearning to reconnect. Beyond all the practical benefits, science is a spiritual quest in the broadest and deepest sense. At its heart is the attempt to complete a grand internal model of reality, to broaden the context of meaning, to find the center by completing the edge. The scientific quest comes most naturally to the skeptic, to those who, in their fervent search for root meaning, question all that convention holds sacred; it is the purlieu of the outsider, the quintessential nostalgist.

The overview perspective of nostalgia is more natural to the outsider, who seeks meaning by stepping back from the mainstream. For the insider, who is less likely to have cut the cord completely to the world

of parental authority, the drive to reconnect is less consuming. The outsider tends toward introversion, while the insider is typically more extraverted. At its extreme, the extravert's reality is simply equivalent to the path of his encounters as he moves through the world, whereas the more reflective introvert's reality is an evolving inner construct in light of which raw experience is selectively interpreted and incorporated. On the simplest level, the extravert is interested in who, what, where, and when, while the introvert cares more about the why. The extravert is more in tune with the left hemisphere of the brain, with detail and process, while the introvert is affiliated more with the right hemisphere, synthesizing global patterns, seeking the larger meaning. The extravert hungers for new experience and wants to be entertained; the introvert hungers for meaning and wants to be moved.[9] The introverted outsider is thus more prone to nostalgia than the extraverted insider, who finds his identity within the mainstream through the persistent absorption of new experience. While the outsider's quest is more isolated, single-focused, and temporal, the insider's is more communal, institutional, and spatial.[10]

Of course most of us lie closer to the middle, merely tending to one pole or the other. Nor is either pole categorically superior to its opposite. Like the yin and yang of all human dualities—masculine/feminine, isolation/communion, realist/idealist, extravert/introvert, left/right brain—the two are interdependent, each with its vital functions, assets, and liabilities. The incessant and intensive concern with meaning can leave the introvert hypersensitive and susceptible to overload, while the extravert is more stable and thus better equipped to multitask and perform the jobs critical to a functioning society. And while the outsider's quest to restore meaning may escape the illusions of the flock, that very freedom—often a flight from adult limits—can result in the self-destructive disconnection of a Jack Kerouac, Jackson Pollack, Sylvia Plath, or Charlie Parker. Yet there is always the search for authenticity, for a nostalgic return to some kind of primal truth.[11]

But there is a force at the heart of nostalgia that goes beyond the longing for lost youth, beyond presence, beyond even the quest for lost meaning and the yearning to return. If the nostalgic compulsion to reconnect engenders all art, science, and religion, it is because nostalgia itself is rooted in the awareness of death. As the ultimate overview, death puts the personal timeline in perspective. Like the night sky, death lies at the boundary between known and unknown. Death and the stars are

what sociologist Peter Berger called the "sacred canopies," one in time, the other in space, one inner, one outer. The notion of my nonexistence is as alien to my daily reality as the thought of a hundred billion galaxies, the finitude of self as unthinkable as cosmic infinity; and a true sense of either lasts but an instant. The dream of reconnection, of recapturing the passion and intensity of open-ended youth, is the distraction that delivers us from that terrifying instant; it is the haunting music ever behind the kaleidoscopic scrim of our days.

Awareness of death lies at the core of romanticism—the sense that there is some unknowable root-reality, some larger truth beyond space and time that underlies everyday existence, not the gods of theology but transcendent Nature itself, a pantheistic feeling that comes to rest on the ultimate mystery of why there is Something rather than Nothing. (Ironically, the romantic reaction to the Enlightenment now inverts as the mysteries revealed by science become the new romanticism.) But without the awareness of death, romantic perceptions reduce to intellectual exercise. The romantic savors those moments when the transcendent surfaces in art, music, or quiet reflection, resurrecting images that seem to define the whole sweep of one's life, returning always to the crossroads, those inflection points where futures were cast. Nostalgia is the realm of the romantic.

"Everybody needs his memories," said Saul Bellow's Mr. Sammler. "They keep the wolf of insignificance from the door."[12] There is an enchantment, a transcendence to nostalgia that is more suited to poetry and music than to exposition. An old song can recapture for an instant the gestalt feeling of another time—the enchanted world at nine years old, the boundless vistas at twenty-one. Nostalgia thrives on the sensate—music, aromas, and artifacts, imagination over analysis, feeling over thinking. We don't remember days, we remember moments, dreamlike images studding the panorama of our past like stars in the night sky, inaccessible, inscrutably remote. As the star-filled night stretches away into space, the frozen tableau of my past reaches back into time, a single seamless event in which the mundane fades and the marrow comes clear. Those moments of intense presence roll over us in a tidal wave of emotion, moments lived in a mist, yet more fundamental, more real. Receding in deep time like the galactic specks in Hubble's deep space, they become mythic.

Wyn Wachhorst

A Culture of Longing

History serves the community as memory does the individual. The past, wrote journalist Michael Malone, "is always a happier place. Agrarian people dream wistfully of the life of the hunter; democrats envy the sophistication of the aristocracy, and Americans forever relive the bandstand and barbershop quartet world of 1910. But while we look back and see stasis, our descendents will look back and see only the white noise of endless change."[13] There was a time, reflects John Updike's Rabbit, when "the world stood still so you could grow up in it." Our collective nostalgia is less a longing for the past than a failure to feel at home in the present. A world once known only through our senses is now so mediated by technology that we subsist in an ever-expanding virtual reality, a secondary world in which electronic displays become the center of human consciousness.

Like the ancient Hebrews, whose migrations uprooted religion from the concreteness of permanent space (the sacred grove, the hallowed mountain), removing it to the inner abstraction of time (a sacred history residing in stories or carried in a book), we now experience a similar but far more profound process of abstraction, becoming not only mobile and amalgamated on a global scale but ever more distanced from direct experience. The result, reflected in modern art and literature, has been a turning inward, a leap in self-reflexivity and narcissistic self-absorption. Like the Hebrews in exile, we find our sense of who we are increasingly removed from stasis and place and ever more defined by motion and time, lending the past a sacred aura.

Most enduring in that aura is the archetype of the American small town—Grover's Corners (*Our Town*), Bedford Falls (*It's a Wonderful Life*), or Mark Twain's Hannibal, Missouri—a place where

> neighbors greeted neighbors in the quiet of summer twilight, where children chased fireflies. And porch swings provided easy refuge from the cares of the day. The movie house showed cartoons on Saturday. The grocery store delivered. And there was one teacher who always knew you had that special something.

The passage comes from a Disney sales brochure for a $2.5 billion project called Celebration, creating the idealized small town outside

Disney World in Florida.¹⁴ The fact that we all share similar "memories" of the generic small town derives less from personal experience than from Disney parks, Currier and Ives paintings, and Norman Rockwell's covers for the *Saturday Evening Post,* injecting the images into our virtual world. As life becomes ever more abstract and depersonalized in a narcissistic, consumerist, global economy, the appeal of those ideal images can only intensify—in part because they harbor a core truth.

We have become a culture of longing, pining for the gods who went underground, for the connections of family and myth-sustaining institutions. Deep within the malignancy of modern individualism is a longing to restore some larger context, some meaningful end for runaway means. As a species, we stand alone at the leading edge, isolated by evolution, fallen from innocence. Stripped of the sacred, of consensus, of community, we are all outsiders.

"The longest distance between two places," said Tennessee Williams, "is time." Those faraway places are black-and-white stills, grainy images of defining moments—my grandmother standing in front of her house, waving her last goodbye; our children at play in eternal summer, before their metamorphic fall into time and truth. It is not the past as such that haunts us but the sad suspicion that we might have lived it better, that I might have seen my father's burdens or attended more to the hopes and dreams of the girl who took my hand at a crossroads long ago.

In the restaurant, I scrutinize my childhood friend for some trace of our world before the fall. But the distance is too great, the metamorphosis too complete. In the end, we are alone with our private ghosts—the song my grandmother sang, the sound of my father's laugh, nights of eternal youth on warm, sandy beaches. And that electrifying moment, a lifetime ago, when I met the girl in the dark blue dress, her voice as warm as the light in her deep brown eyes. And always the children—our first-born in a fresh ironed shirt for his first day of school; the shiny new fire truck he pedaled so proudly, rusting away in a shed; the bedtime music box, buried in a basement drawer. The wisps of remembrance flicker in a mist like old home movies, sad yet soothing—mystic chords of memory, echoing down the corridors of time, flooding the cathedral of the mind.

Memory always plays to music

Motifs: Postwar America

Old-time radio, the folk music revival, the golden age of science fiction, steam railroads, baseball, the Western—cultural images that not only loomed large in the postwar "state of mind" but were nostalgic in themselves.

3

Crossing the Wide Missouri

In the late fifties, San Francisco's North Beach lay at the edge of history, as though the half-millennium of westward migration had halted a few blocks from the Pacific to spawn this subterranean frontier. From doorways along the teeming sidewalks, the sounds came floating into the night—a cool sax, Dixieland, bawdy comedy, piano-bar opera, old-time banjo bands. We came up from Stanford, wearing our collegiate world like a space capsule, roaming the gaudy streets and smoky clubs, descending into dank, liquor-scented cellars in search of the edge, the boundaries of the self, the night-journey of the soul. We imbibed the sarcasm of Mort Sahl, the obscene bravado of Lenny Bruce, Beat poetry at City Lights Books, beer-drenched banjo singalongs at the Red Garter, Turk Murphy's Dixieland at Earthquake McGoon's, flamenco dancers at Casa Madrid, female impersonations at Finnochio's, the nightly New Year's Eve at Gold Street, and the famous 3 A.M. breakfast at Fack's.

But the real focus of our pilgrimage was the urban folk music revival that swept the collegiate scene in the late fifties and early sixties. On a summer night in '57, after my freshman year, I had discovered the hungry i, a small underground theater in the heart of North Beach. On the bare stage before a wall of old brick, a black man sat on a stool in

the narrow spotlight, his arms so massive it seemed they might crumple his guitar. But his fingers raced gently over the strings in a lilting yet driving rhythm, and the soft voice had a raw nonresonance that seemed to float on a wind off the wide-open land:

> O Shenandoah! I long to see you
> Far away, you rollin' river
> O Shenandoah, I long to see you
> Away, we're bound away
> 'Cross the wide Missouri.

It was a haunting melody, flowing through minors and sevenths until I too felt bound away—out of the bowels of North Beach, out of the world-weary city and the dreary disquiet of stone-cold streets—bound away to the banks of some wide Missouri, the last great divide between civilization and wilderness, origin and destiny, out of the gray mists of my past to a dream of vistas stretching away like the promise of that vast prairie.

Perhaps I sensed that college was itself the crossing of a great divide—my own wide Missouri. Perhaps the song appealed to the paradox of youth, the pain of departures and the promise of beginnings. I envisioned a man in a more innocent time poised at the edge of the great Missouri, gazing west into the limitless potential of the American land yet longing for the yellow fields of childhood on the wooded banks of a river that ran through the Shenandoah Valley, rolling across Virginia and down through the Carolinas.

The paradox of this rite of passage was implicit in the aura of the folk revival: on one hand, a yearning for the lost innocence of a warm parental world, and on the other, a driving need for independence, for radical self-expression and the romance of the heroic outsider. The simple melodies and lyric images suggested a time when one's connections to the world were familiar and direct—the childhood or adolescence of America—while the people in the songs and persona of the singer evoked the image of the footloose outsider.

The folk revival thrived on college campuses because it captured the conflicts of youth. Yet its two faces also reflected the paradox of the postmodern condition itself. The two tempers, nostalgia and alienation, rose with the displacements of urban-industrial life, accelerated during the first half of the twentieth century, and exploded into popular culture

in the 1950s—from the nostalgia of Westerns, Walt Disney, and MGM musicals to the alienation of Kerouac and the Beats, Lenny Bruce, James Dean, Jackson Pollack, and Charlie Parker. What made the folk revival unique was that it merged the two on both a personal and collective level.

Those of us who came of age in the fifties have been called the Silent Generation. Sandwiched between a generation that questioned little and one that questioned everything, we faced both directions, as befit a time of transition. Like those a century before who had trekked westward across the wide Missouri, we had a sense that our rites of passage reflected something larger, something epochal. Sitting in the smoky cellars of the last West in our crew-cuts, thin ties, and Ivy League coats, we were outsiders blending in, dimly aware that America itself was poised for a radical break with the past. For the fifties were the seedbed of the sixties, the last great watershed in American history, and the folk revival was the harbinger of that transformation.

Like America itself at midcentury, we were suspended between innocence and responsibility. Freefalling into the future, we found solace in the past, lured less by nostalgia than by the romance of the outsider. In our dorms, apartments, and party pads, lying on the floor in the late night listening to the Weavers, Odetta, Leadbelly, or Bob Gibson, we were all Woody Guthries wandering the land. We were the sailors, cowpokes, and prairie farmers who had tamed the continent to the stoic ring of the banjo or the lonesome howl of a lumber camp harmonica. And we sang into the night—songs of leaving and loss, of new life in new lands, of ineffable longing and rugged self-reliance, of train rhythms out on the open land when life was more than a borrowed script, of simpler times when the country itself was young, poised on the east bank of the great Missouri, looking west across a land that stretched away into futures unimagined.

The Vanguard

Carnegie Hall, Christmas Eve, 1955: The concert has been sold out for months. Blacklisted for their leftist leanings, the quartet is making their first appearance in three years. Most of the old fans from the Village are here, rising to their feet as the hall darkens and light washes the stage, bare but for four free-standing mikes. Four figures walk from the wings to an explosion of applause—a lanky young man with a

long-necked banjo, looking like a backwoodsman in a borrowed tuxedo, followed by a gaunt, balding man with a guitar, a plump woman with a Kewpie-doll face, and a stout, middle-aged man who looks like a labor boss. Suddenly the hall is electric with the raw staccato of Pete Seeger's banjo, frailing a tune that draws applause of recognition, and the four launch into "Darling Corey," the harmonies free and soaring, the four voices sounding like fourteen, piling above one another with a feeling of immense force. The applause following that song would have filled half a side of the classic album recorded that night. If there was a symbolic moment when the urban folksong revival was born, it was that Christmas Eve in 1955 when the Weavers returned from exile.

Balancing the raw purity of traditional folksong with the polish of professionalism, the Weavers had a down-home warmth, humor, and vitality, weaving their songs into a harmonic tapestry, trading parts midsong, looking all the while like random people at a bus stop. Under Seeger's split tenor and Lee Hays's "avuncular baritone," wrote historian Robert Cantwell, was the "bookish but mellifluous" voice of Fred Hellerman and the lush, protean alto of Ronnie Gilbert, "by turns gentle as a nursing mother's, innocent as a child's, lusty as the Wife of Bath's, and stern as a suffragette's."

The Weavers had survived a dark moment in American history—the McCarthy years, the rampant House Un-American Activities Committee, the boycotts, blacklists, and hate campaigns. Rising from Village songfests to the peak of musical stardom in 1950 (when their version of "Goodnight Irene" sold over a million records), they were targeted by witch hunters, banned by broadcasters, accused in headlines, struck from Decca's catalog, and scorned by clubs that had once fought to book them.

Forced to disband in 1952, they reemerged in 1955, recording for Vanguard and building new audiences, performing in concert halls and on college campuses. The irony of the blacklist is that it allowed the folk revival to develop free of media influence, preserving much of the raw originality along with the countercultural bent that would energize the protests of the sixties. While Decca had cluttered the Weavers' songs with large orchestrations, the small Vanguard label allowed them to return to their folk roots. As a result, they altered the course of mainstream American music.

While rock and roll had opened doors to the vernacular, bringing rhythm and blues across the racial line, by the end of the decade it seemed

watered down and overly white. The idealistic anti-commercialism of folk music not only filled the gap but better served the ambivalence of older youth, whose new collegiate independence was tempered by nostalgia for the warmth and innocence of home. The Weavers spoke directly to that ambivalence, using the power of folksong to reimagine a lost America that lay behind the great wall of a depression and two world wars.

The folk revival made popular music literate, more substantial than adolescent infatuation and rebellion. Folksongs were *about* something, the meat of human life—love and death and whiskey and going far, far away. Their hardheaded honesty moved beyond the merely sentimental to the truly tragic. They were songs of unfulfillment and restless dissatisfaction, of departure and distance, of a bittersweet sense of immense emptiness ahead and behind. The lyrics long for the indefinable, torn between the promise of the open road and pangs of haunting regret.

> I looked down that track, far as I could see,
> Little bitty hand was wavin' after me.

But unlike its country-western cousin, branded by resignation, folksong tempers its tragedy with the survivor's resilience. Under the raw, earthy realism is an unrelenting affirmation of life, and hardship becomes the ground of a heroic dignity.

Woven into the fabric of folksong are all the camp fiddlers, coal miners, cotton pickers, rock-drillers, and rivermen, all the wagoners and bull-whackers on the prairie schooner trails, and all the hard-handed, hard-drinking Irishmen who spanned the continent with ribbons of gleaming steel.

> In eighteen hundred and forty-seven
> Sweet Biddy MacGhee, she went to heaven;
> If she left one kid, she left eleven
> To work upon the railway.

The Roots

On the last day of 1934, John A. Lomax, the first to record folksongs in the field, arrived in New York City in his Model A Ford, chauffeured by a square-framed, barrel-chested black man with eyes white as

porcelain whom he had recorded in a Texas prison. Now freed, Huddie Ledbetter drove, cooked, and laundered for Lomax, who in turn brought him before New York audiences, probably the first genuine folk artist to reach urban Americans. He played a battered old Stella twelve-string guitar, painted green and partly held together with string. His booming metallic voice could be raw and raspy or clear and sweet like a jazz trumpet. Audiences dropped coins into his crumpled hat.

Huddie knew more than five hundred songs with roots deep in the southern past—slave dance tunes, spirituals, play songs, cotton-picking chants, reels, railroad and prison songs, field hollers, ballads, and early blues. He showed citified society that America had living folk music, said Lomax—"swamp primitive, angry, freighted with great sorrow and great joy." The image was intensified by his massive frame, fearsome countenance, and snow-white hair. There was a natural bravado about his introductory stories, delivered in his thick, soft-spoken Louisiana dialect, sometimes in rhythmic rhyme. He could make up songs on the spot, playing with his eyes shut, rocking to and fro, his huge hands galloping over his big guitar in a chuffing or rushing locomotive rhythm. Sometimes he danced. Years of hard labor in cotton fields and road gangs had built muscles of steel. He could pick more cotton than any two men, wear out two teams of mules in a day, work fourteen hours in the broiling Texas sun, and sing and dance in the barrel-houses all night, a repute that had earned him the nickname Leadbelly.

Born in 1888 to a son of slaves and a half-Cherokee mother, he grew up in a log cabin on a vast, brooding lake in a far corner of Louisiana. He spent his youth in the muddy streets and rough saloons of Shreveport's red-light district, eventually trekking through bars and bordellos from New Orleans to north-central Texas, in and out of jails, boozing, gambling, and whoring. He met Blind Lemon Jefferson, who taught him the blues, and the two sang together in the streets, shanties, and honky-tonks of East Dallas. Sent to prison after a vicious brawl, Leadbelly escaped and was recaptured. But Texas governor Pat Neff, who had sworn never to pardon a prisoner, was moved to free him after hearing him sing "Goodnight Irene," one of his many original songs. Arrested again after killing a man in self-defense in a scuffle with two men who tried to steal his whiskey, he was sent to the notorious Angola State Penitentiary, where he was shackled day and night and often lashed.

In 1934, after nearly twenty years in prisons, he was freed for good behavior. He went to work for Lomax in New York, married Martha Promise, a childhood sweetheart, and became the core figure in the nascent folk movement. Leadbelly's little apartment became a gathering place for singers like Woody Guthrie, Pete Seeger, Burl Ives, and Josh White, many of whom met there for the first time. The entrance fee was a bottle of whiskey, and the singing went on all night. While in prison, Leadbelly had missed the Jazz Age and retained his own music from a time before the blues. Many of his songs, like "Rock Island Line," "Midnight Special," and "Cotton Fields," became folk standards. With his positive spirit and galvanizing stage presence he began finding larger audiences, and he especially loved playing for children. But he could be silent and brooding between sessions, sometimes disappearing in search of whiskey and women. Other folksingers had their leftist agendas and folk facades, but Leadbelly, who cared little for politics and always appeared in his tight-fitting double-breasted suit, starched collar, and polished shoes, was ironically a genuine folk.

He died penniless in Bellevue Hospital in 1949 at age sixty-one, never knowing what fame would follow. Though the Weavers' version of "Goodnight Irene" topped the charts a year later, he had never made any money from the song, nor had he made much from his singing. Under contract to Lomax, Leadbelly seldom saw more than a third of his earnings, and Martha worked as a maid in a New York hotel. He seemed happy, wrote his biographer, only when holding his Stella guitar, the "music and stories flowing like good liquor." Though robbed of his youth by the brutal southern caste system and deprived of the recognition he craved by the callous northern music industry, he never gave up. It took the slow paralysis of Lou Gehrig's disease to bring him down. The day he found he could no longer play his Stella, he cried.

The Legend

Pythian Hall, March 17, 1956: The entire cast, all the folk notables of New York, had gathered to celebrate the songs of a dusty man from Oklahoma. They closed with "This Land Is Your Land," and the spotlight swung to the first box, stage right, settling on a gaunt, tabescent little man with bristly graying hair, his face furrowed by sun, wind, and misfortune. Clenching a pack of cigarettes, Woody Guthrie struggled to his feet and managed a slow wave, his body wracked with

a degenerative disease. Onstage, Pete Seeger began "This Land" again, his eyes tearing, while the whole audience rose up, cheering the man in the box and singing his song. It was the night that Woody Guthrie passed into legend.

Born into a middle-class family in Okemah, Oklahoma, in 1912, he had seen his father lose everything, had watched his mother sink into insanity, and had witnessed the sister he idolized burn to death. Leaving home at fifteen with nothing but his harmonica, he wandered through Texas, hitching rides, hopping freights, and taking odd jobs—sign painting, soda jerking, sometimes passing himself off as a seer and faith healer. He taught himself guitar and sang for change in bars. At twenty-one he married a sixteen-year-old girl and settled in a shotgun shack in the oil boomtown of Pampa on the Texas panhandle. But he felt restless and trapped and would take off suddenly and roam for months, sleeping in alleys, boxcars, and skid-row flophouses.

On April 14, 1935, a wall of black dust a thousand feet high rolled over Pampa, turning day into night. Coming from as far away as the Dakotas on sixty-mile-an-hour winds, curling and seething, it covered crops, trees, and machinery under thousands of tons of dust, and it banked in great dunes against houses and buildings. People covered their faces with wet towels in the pitch dark, hoping to survive. A journalist visiting the Oklahoma and Texas panhandles after the storm called it the Dust Bowl. By 1940, dust and drought had driven 2.5 million people out of the Plains states, most heading west. It was the largest migration in American history.

Woody, too, headed for California, his guitar slung over his back, leaving his wife and child behind. He sang in saloons and haunted the hobo camps, overflowing with unwanted migrants, listening to their stories, feeling their pain and anger, sensing that they were his people, that they were "*the* people," a phrase that became his political religion. "I met swarms of migratory workers," he wrote, "squatted with their little piles of belongings in the shade of the big sign boards, out across the flat, hard-crust, gravelly desert. Kids chasing around in the blistering sun. Ladies cooking scrappy meals in sooty buckets, scouring the plates clean with sand. All waiting for some kind of chance to get across the California line."

At a time when hokey cowboy singers were a novelty, he got a daily fifteen-minute radio show on a local station in Los Angeles, refashioning traditional songs into vehicles for social protest, and interjecting his

romanticized philosophy of "the people" in a feigned Oklahoma drawl. By 1939 he was writing a column, "Woody Sez," for the Communist *Daily Worker* and singing in tent camps, picket lines, and union halls, faulting wealthy capitalists for destroying America, just as his father's land schemes and political ambitions had destroyed his family.

By 1940 he was doing radio shows in New York and singing at union meetings and strike demonstrations with Pete Seeger and the Almanac Singers, the precursors of the Weavers. But when sponsors told him to depoliticize his songs and clean up both his language and himself, he took off again for California, turning down a number of lucrative offers, seeing artistic refinement as a mark of bourgeois elitism. Every time he began to make good money he would send for his wife and three children, only to disappoint them by walking out on opportunities and hitting the road again. Tiring of his disappearances, womanizing, and drunken scenes, his wife finally left him. After a stint in the Merchant Marine he married again and had four more children. The oldest, Cathy Ann, to whom he was uncharacteristically attached, died in a fire at age four.

His roaming began to alternate with obsessive flurries of writing, while his behavior grew increasingly violent and alcoholic, due largely to the onset of Huntington's chorea, the degenerative disease of the central nervous system that had killed his mother. It seems possible that his political agitation may have reflected the paranoia associated with that disorder, and that his restlessness, promiscuity, and even his compulsive writing—thousands of pages of undisciplined, unpublished prose and poems—may have been intensified if not activated by the latent disease. Though he wrote some fourteen hundred songs—on napkins, on paper bags, traditional melodies reworded to his proletarian message—only a handful are memorable.

In the summer of 1954, his deterioration accelerating, Woody took his last trip across America. Riding freights, lurching along highways, sleeping on sidewalks, he was picked up nearly every night, drunk and disorderly. By fall he had checked himself into Brooklyn State Hospital. Hospitalized for twelve years, in constant pain, his mind trapped inside his flailing body, he died in 1967 at fifty-five.

With his songs of hardship, resilience, and hope, and his drawling defense of the downtrodden, the tense, wiry little man with a mop of curly hair and perpetually dangling cigarette had become, said one journalist, "the embodiment of gritty American authenticity, the

plainspoken voice of a romanticized heartland." Rising out of the Dust Bowl and roaming across America on highways, byways, and boxcars, he came to represent the determination of a people, uprooted by drought and disaster, to endure. If his image was largely self-invented, his guitar work ragged, rudimentary, and often out of tune, his dry, nasal voice harsh and indifferent to pitch, it only enhanced the myth of the romantic agrarian survivor, the blunt, ingenuous outsider.

Disillusioned by his father, scarred by the loss of his mother and sister, Woody Guthrie wandered into the world with a childlike perspective on love and life, reaching out to a romantic abstraction, feeling the victim of forces he never understood. A paradoxic, contrapuntal figure, he was a regressive progressive, an irresponsible moralist, and sincere pretender. A well-read political naïf who loved "the people" in general but no one in particular, he was a hack artist on a vast canvas, censuring and celebrating America, drawing hope from despair.

"There was an innocence to Woody Guthrie," wrote Bob Dylan, "a kind of lost innocence. And after him it was over." In the chronicles of America, Woody Guthrie is more an idea than a reality. His life spanned a time of transformation from rural and local to urban and national. Revolutions in communication, transportation, and manufacturing redefined work and reordered everyday experience. A flood of incompatible immigrants and waves of migration from the South remade the fabric of American society. Depression and war weakened the faith in progress, while many felt somehow removed from reality, sealed safely in urban bubbles like terrestrial astronauts, never directly touching the world on which they walked. There arose a nostalgic sense that the "true" American heritage was preserved by those isolated from modern culture. Exemplified in the films of Frank Capra and the novels of John Steinbeck, it held that the less sophisticated the expression the stronger were its roots, the greater its moral truth, and the more authentic its reality.

In the wake of modernization, the "natural" man became the emblematic outsider, while cowboy heroes overran popular culture. Rapid change and mobility destroy the sense of place, the familiar territory that becomes a vital part of one's personal connection to the world and the past—knowing where the old road went before the new one was built, or passing the tree where one had carved initials as a child. In the same way that place devolves to mere space for the uprooted, accelerating change enervates the collective identity of a

whole people, who romanticize the primitive and ennoble the antihero, reaching out to a dusty little man from Oklahoma who sang of hope in a dark decade and rode the boxcars into history.

The Bridge

Forrest Theater, New York, March 3, 1940: It was the first folk music recital before a mainstream audience, bringing together noted performers like Burl Ives, Leadbelly, and Guthrie in a concert to benefit California migrant workers. Late in the show, a twenty-year-old unknown named Pete Seeger walked onto the stage, blinking at the lights. New to the five-string banjo, his fingers froze and he fumbled, forgot words, and finished to polite applause. But it was the night he met Woody Guthrie.

Guthrie took him on a boxcar tour of the South, sang with him at union rallies, and became the exemplar of Seeger's proletarian idealism. But it was the dynamism and synthesis of the more sophisticated Seeger that bridged the gap between the urban audience and people like Guthrie and Leadbelly. From his songfests, concerts, and "People's" projects, to the Almanacs, the Weavers, and over one hundred record albums, it was Pete Seeger who fathered the folk revival.

He was born into a musical family in 1919, his mother a concert violinist, his father a musicologist who believed that music's primary purpose was communal. He describes his childhood as "very cold"; he was sent to boarding schools from age four, and his parents divorced when he was eight. At sixteen he went with his father and stepmother to a square-dance festival in Asheville, North Carolina, where he first encountered the five-string banjo and glimpsed another side of America. He left Harvard at the end of his second year without taking exams and rode a bicycle across New York state, painting barns and houses and joining other musicians for concerts and rallies in support of a dairy farmers' union. But it was while he was assisting his father's friend, Alan Lomax, who was organizing a Library of Congress Archive of American Folk Songs, that he met Guthrie and his life took a decisive turn.

After hitchhiking with Woody, bumming meals, and "doing everything Americans are supposed to do while searching for the national soul," notes biographer David Dunaway, he developed a "bad case of proletarian chic," renting a town house in Greenwich Village and

turning it into a "frat house of musical revolutionaries." They formed the Almanac Singers and held parties to pay the rent. Drafted into the army, he served in the Pacific and returned home to resume his dream of a singing labor movement, using music to foster a sense of community and class solidarity. He married Toshi Ohta, a half-Japanese woman whose tolerant devotion enabled him to pursue his lifelong commitment to singing for social causes.

The commitment had its price. When the Ku Klux Klan attacked his car with rocks at a left-wing concert in 1949, his family was showered with glass, leaving countless slivers in his children's hair. In 1955 he was interrogated by the House Un-American Activities Committee. Rightly implying that his patriotism went deeper than that of his interrogators, he refused to answer personal questions and was sentenced to a year in jail but got off on a technicality. Banned from mainstream media, he went underground, pioneering the college circuit, playing twenty-five-dollar dates at schoolhouses, auditoriums, and campuses. When he surfaced a decade later, he had become an American icon.

If the Kingston Trio's "Tom Dooley" took the folk revival to a mass audience, it was because founding member Dave Guard had bought Seeger's book *How to Play the Five-String Banjo* and launched yet another group imitating the Weavers and their songs. But when the dust settled and all the collegiate, matching-shirt groups had disbanded, it was Seeger who abided, an exemplar of something larger than his music.

Seeger would amble onto the stage with his banjo, wearing, perhaps, a brown flannel shirt with rolled-up sleeves and a sunshine-yellow tie, looking like a lumberjack on Saturday night. Facing the mike without a word, he would leisurely strap on his banjo, as though dressing in the privacy of his room, and begin picking, his work shoes clumping out the rhythm. Tall and sinewy, he might seem awkward and self-conscious at first, looking, said one writer, "like a gaudy scarecrow." But as he begins to play, he transforms. "Sing it with me!" he calls, as if to his congregation, and the whole audience is soon in tune with him, picking up his enthusiasm, and for the moment all the world seems in tune. With his sense of commitment, his boundless vitality, sincerity, and good spirits, he conveyed a fundamental decency and integrity. He believed passionately in the causes he sang about—unions, integration, nonviolence, the environment. In the American tradition of Mark Twain and William Jennings Bryan, he was perhaps the last of the great platform personalities.

Seeger lived what he believed. The man, his beliefs, and his art were so amalgamated that one was but an extension of the others. He turned over the copyrights on many of his songs to integrationist organizations, and he was probably the only artist who has ever asked to have his fees reduced because he felt he was being paid too much. Uncomfortable with his renown, he reminded us that "there are people in every community more extraordinary than any celebrity; their neighbors know who they are—heroic people who never get publicized."

His aversion to fame reflected his need for solitude and his reverence for nature. Shopping for a house after getting married, he found they were all too expensive. "What can you afford?" asked the agent. "How about just some land?" asked Seeger. He bought a patch of woods on the side of a mountain set back from the Hudson River, chopped down trees, and built a log house. He and his wife lived for the first years without electricity or running water, collecting water from a stream for cooking and washing. In 1968 he built a sloop big enough for songfests and spent much of the next twenty years campaigning against the pollution of the Hudson River. By the late 1980s, it was again fit for swimming and fishing.

Like his father, Seeger always regarded music as more means than end, seeing it as a way of binding people to a cause. Ascetic as a monk, a preacher with a banjo, he was more comfortable with ideas than with intimacy, reflecting a Calvinist line of New England thinking and abstemiousness that descended through Emerson and Thoreau, an attitude that fellow Weaver Lee Hays called "arrogant modesty." In his later years, Seeger's modesty had long displaced any condescension. "Songs won't save the planet," he granted, "but, then, neither will books or speeches. Participation is what's going to save the human race. We've all got to be involved. It won't be done by big organizations but by millions of little organizations, often local. You can think globally, but act locally. I still prefer to sing in the schools than in almost any other place. You can't feel completely like giving up if you see all those little faces. You can't say there's no hope. You've gotta keep trying."

Though losing his voice, he continued to sing into his nineties. It was enough for us just to see him up there, giving us the song to sing with him. "When Pete walks onto the stage," said Guthrie's son Arlo, "the whole audience rises—not just because he showed up, but because he *means* something." A voice of the collective conscience, he was one of those uncommon souls who make our species seem just a little more

than it may be. Seeger once said of television that "life is meant to be lived, not watched." The song of most lives is fixed, as on a phonograph record; the needle is placed in the groove and the record does the rest. But Seeger made his own music and spent his life trying to get others to do the same—to step outside, to dwell in spirit in a patch of woods on the side of a mountain set back from the river while staying passionately connected, caring about "those little faces," abiding in hope.

The journalist Alec Wilkinson tells of driving on Route 9 near Seeger's home on a freezing winter day during the war in Iraq and seeing him standing on the side of the road in a hood and coat holding up a big piece of cardboard:

> Cars and trucks are going by him. He's getting wet. He's holding the homemade sign above his head—he's very tall and his chin is raised the way he does when he sings—and he's turning the sign in a semicircle so that the drivers can see it as they pass, and some people are honking and waving at him, and some people are giving him the finger. He's eighty-four years old. He doesn't call the newspapers and say, "Here's what I'm going to do, I'm Pete Seeger." He doesn't cultivate publicity. That isn't what he does. He's just standing out there in the cold and the sleet like a scarecrow getting drenched. I go a little bit down the road, so that I can turn around and come back, and when I get him in view again, this solitary and elderly figure, I see that what he's written on the sign is "Peace."[1]

The Crossing

The young protest singers of the sixties, sometimes called Pete's Children, were less modest and more arrogant. While it's true that songs spread more easily than journalism and have a larger audience if successful, the new protest songs were ponderous and pretentious with their hack lyrics and grating music; few singers seemed aware that message and style are inseparable. The preoccupation with politics had always discounted the true appeal of the music, which lay less in social communion than in self-definition. The golden era of the folk revival was the introspective fifties, not the self-dramatizing sixties.

Yet it would be easy to view the folk fandom of the fifties as no less symptomatic of youthful naïveté than the narcissistic sixties. A pervasive theme in the lyrics is the outsider's rejection of personal limits. On the open road, riding the rails, sailing the seas, he wanders a mythic past, a sunnier time when all options were open. Identifying with the lyric, one becomes the exotic outsider. Performing it, one becomes charismatic. Leaving the haven of home and groping for identity, the youth in passage sees his new freedom, his romantic outsiderness, as the base of a higher awareness. He undergoes a personal renaissance, becoming everything in potential, transcending all conventional bounds. Carried into adulthood, this becomes what Jung called the *puer aeternus*, the eternal child, narcissistic and self-aggrandizing.

But the deeper themes in folk lyrics suggest that there is more to the appeal than personal exceptionalism. The outsider's self-romanticizing is often inseparable from a sincere quest for meaning. If the insider lives in the cultural mainstream, accepting its authority, revering its conventions, and striving to perfect some conforming role, the outsider feels alienated from the consensus, seeking always some larger meaning. It is this dimension of the lyrics and their plaintive melodies—the mysteries of life, death, love, and loss—that appeal at the deepest level. It can be mournful,

> Eyes like the morning star, cheeks like a rose,
> Laura was a pretty girl, God almighty knows.
> Weep all ye little rains, wail winds wail,
> All along, along, along, the Colorado trail.

longing,

> Alberta, let your hair hang low.
> Give you more gold than your apron can hold
> If you'll just let your hair hang low.
> Alberta, what's on your mind?
> You keep me worried most all of the time.
> Alberta, what's on your mind?

abiding,

> I've wandered all over your green-growin' land.
> Wherever your crops are I'll lend you my hand.
> On the edge of your cities you'll see us and then
> We come with the dust and we go with the wind.

disquieting,

> What will you give me?
> Say the sad bells of Rhymney.
> Is there hope for the future?
> Say the brown bells of Merthyr.
> Even God is uneasy
> Say the moist bells of Swansea.
> And what will you give me?
> Say the sad bells of Rhymney.

despairing as the "Kentucky Moonshiner,"

> I'll eat when I'm hungry,
> And I'll drink when I'm dry,
> Greenbacks when I'm hard up,
> And religion when I die.
> The whole world's a bottle,
> And life's but a dram.
> When the bottle gets empty,
> Well it ain't worth damn.

or celebrating childhood wonder:

> Once I found a little glass
> Color it was green.
> In it were all the wonders
> Man had ever seen.
> Put it in my pocket
> Tied up in a cloth,
> Cried and cried the day I found
> That it had been lost.[2]

These lyrics, however, cannot stand alone. Without their melodies they remain cerebral, sentimental, even trite. Only the music can communicate the depth of feeling behind them. The belief that words alone can carry a song is manifest not only in protest songs but in much contemporary music. This is especially true of country music, while rap dispenses with music altogether. The misfortune is that bad music and mere rhythm mislead the musically challenged to believe that bad poems are good lyrics.

Often as important as melody is the instrumentation, or even the nature of the instrument itself. Listen, for example to Bob Gibson's wistful banjo beneath the lyrics to "Alberta." What better instrument to express the contrapuntal themes of folk lyrics than the long-neck five-string banjo, the icon of the folk revival? Hard and shrill yet soft and melodic, it evokes both the stark realism of its Appalachian origins and the romantic myth of the old South—the anti-modern yearning for an authentic self in a purified past. Harsh and simple as the lives and people in the songs, the intense staccato of the finger-picking pattern is punctuated by the unchanging pitch of the relentless fifth string—the rhythm of the boxcar, the mettle of the survivor. In slower, minor keys, the hard metallic ring seems eerie and alien, yet ethereal as the haunting strains of a music box, as though coming through light years out of some cosmic heart. Like the wildflower that breaks through asphalt, the banjo wrings beauty from harshness.

A similar paradox colored the settings of folk performances—underfunded high school auditoriums, dank cellars, makeshift stages, converted-Laundromat coffeehouses in deteriorated inner cities. The harsh interiors, chairs stacked at the side of a bare stage, implied borrowed time in borrowed space, reinforcing a sense of outsiderness. Yet the straightforward performance, the singer's marginality, and the profound simplicity of the music conveyed an authenticity that deprecated the pretentions of more conventional events.

The outsider-insider spectrum that divided folk fans from the mainstream is comparable in many ways to introversion and extraversion. Chapter Two explained the difference between the extravert's hunger for raw experience and the introvert's need for processed meaning. If the impetus for the folk revival came primarily from the more introverted youth in transition, the attraction went beyond politics and rebellion to the outsider's quest for some larger context of meaning that might both assuage and ennoble his separation and isolation. To reconcile an

irretrievable past with an uncertain future the youth in passage must replace the lost illusions of childhood with a new context of meaning to confront a world grown suddenly more real. Folksong served this need in a number of ways. It invited identification with the authenticity of the "natural man" in a mythic past, one whose direct contact with the world was free of postmodern restrictions and utter dependence within a technological bubble. The sweeping lyrical images of trains, deserts, mountains, rivers, and ocean, which leave the conventional life of the insider seeming narrow, trivial, and impure, reduce life to its simplest terms—returning to some point of creation when all meaning was inchoate. Running the film backward, out of history's cul-de-sacs—to poise once more before the great Missouri—becomes a metaphor for the need to get behind, under, and *prior* to the confusion of the present, to be *open* to whatever true meaning may lie beyond that shadow world.

Since the image of the outsider in a storied past is emblematic of the listener's lost innocence and imagined independence (communion and isolation), it functions on different levels, the simplest being much like that of the Western or superhero—the good outsider who defeats his bad counterpart and saves the insider community. He shares their values while remaining free of their limits. He is the powerful innocent, what Leslie Fiedler called the "good bad boy." Or like the heroes of folksong, or Seeger and Guthrie themselves, he is the American Adam, rejecting the Old Order to build a New World in the wilderness.

The problem, of course, is that one can't really find communion in isolation, power in innocence, or the ideal in the real. Imagine sentient chess pieces feeling constricted by the rules and the monotony of the board and walking off into the great outdoors. What they find is not meaning or identity but that neither exists outside the game. In the end, the meaning sought by the outsider lies not in isolation but in communion. The singer is lamenting, not lauding, his separation. There is more drift and distress than comfort and joy in the rough crossing from the communion of childhood to the community of adults. The mood and imagery of folksong thus serve in a way like the "transitional objects" of object-relations psychology, the teddy bears and puppy loves that function as substitute bonds while aiding the break, first from mother, and later from home.

The real need of the Seegers and Guthries is to restore the good and defeat the bad memories of childhood—Seeger's early immersion in nature, his connection to his radical father, the "cold" years of boarding

schools and a split home, or Guthrie's halcyon time before his father's bust, his mother's insanity, and his sister's fiery death. What they need most is for the world, "the people," to sing with them—to love them.

The folksong revival of the fifties was largely responsible for the creative explosion that redefined American popular music in the sixties. Together with rock and roll, the folk genre rejected the orthodox training and conventional standards of Tin Pan Alley, instilling the notion that songs are something anyone can sing and everyone can write, that performers, in fact, *should* write their own material. While sometimes making popular music more literate, the legacy has had conflicting results, elevating rhythm and words (easier to write than good melody) over music, and bringing a plebian insensitivity to style—the belief that depth of feeling is proportional to volume and that emotion is best feigned in a whining, grunting delivery, or in one littered with gospel-like warbling (now extended even to the national anthem). In truth, the quieter the song, the simpler the instrumentation, and the more melodious the music, the more profound the emotion. Compared to most contemporary music, folksongs survive as default classics.

But they are seldom played. And today's music venues have moved from intimate settings like the hungry i to vast arenas where performers are essentially watched on television. By the 1970s North Beach had become a jungle of fast-food and strip joints, a cultural rendition of the precipitous edge feared by fifteenth-century sailors. A chain-link fence enclosed a deep pit where the hungry i once stood, the litter clinging to dry weeds in the wind.

Now and then I dig out the old LPs—the bare simplicity of Mississippi John Hurt, the deep soulfulness of Odetta, the wistful banjo of Bob Gibson, the robust warmth of the Weavers in their prime, before Lee Hays lost his voice, his legs, and his life. The raw voices and ring of metal picks on steel resound across the half-century, rushing down corridors of memory like a flash flood. And I'm nineteen again, rapt in the songs of sunny days long gone, of brisk spring mornings when all things seemed possible. Perhaps "Shenandoah" remains my favorite. Teddy Roosevelt said, "We don't remember days, we remember moments." Some abide like freeze frames, defining our past—part of the marrow of what our lives have meant. On that summer night a lifetime ago, the burly black man still sits on the stool in the narrow spotlight before the wall of old brick, his fingers racing softly over the

strings, the pathfinder poised forever on the bank of the wide Missouri, the new land stretching away into futures yet untold.

> For seven years I courted Sally,
> Far away, you rollin' river.
> For seven more I longed to see her.
> Away, we're bound away,
> 'Cross the wide Missouri.

> Every day is Spring, while we're young.
> None can refuse, time flies so fast!
> Too dear to lose, an' too sweet to last!
>
> —"While We're Young," featured in
> Barry's Hollywood Bowl show

Strange Attractor

For two thousand years wealthy Romans have fled the summer heat of the city for the cool breezes of the Circeo peninsula, which juts into the Tyrrhenian Sea with miles of rock and sandy beaches. The emperors Domitian and Tiberius had villas there. In 1947, a mile west of the village of San Felice and some sixty miles south of Rome, Godwin Spani created Club Spani, a retreat for his Roman and American friends. The luminous white villa sat on the side of a hill, its long terrace looking out under grape vines to the deep blue of the sea, stretching away to the edge of the world. Narrow steps led down to a reach of warm, flat rocks awash in the tide. Down the road was a lighthouse and a long sandy beach on which one could walk, we were told, all the way to Rome.

Tim and I had met Barry that summer of '59 on a ship packed with students headed for Europe. With Tim's five-string banjo and our three acoustic guitars, we formed a folk trio on the boat, entering the talent show with an ill-chosen "Sinking of the Titanic," a dour captain perched in the front row. Debarking at separate ports, we agreed to meet Barry and his friend Jerry in Zurich in three weeks. Meanwhile, a message from their friend Doug, who had worked his way to Italy on a freighter, lured them to Club Spani, where the advantage of retrieving the trio became immediately clear. So they fetched us in Zurich and the four of us headed south.

In return for our nightly imitations of the Kingston Trio, Mr. Spani found us sleeping space and provided meals at the long communal table

on the terrace. The warm Mediterranean nights, the good food and wine, and a young exuberant audience were far more than we had expected of our offhand notion to spend a summer in Europe. By day we went down to the sea, wandered down the road to an ice cream shop, or off to the sandy beach with our instruments and a group that included the Spani daughters, Mila and Maghi, and a Norwegian girl named Tove who was a friend of the Spanis and the reason for Doug's long trek to Italy. Song-filled, sun-drenched days by the ocean now seem a core image of that summer of '59, a world apart, a dreamscape outside of time.

Neither Tim nor I could have carried the audience at Club Spani. Their enthusiasm mirrored the affable energy and endearing humor of Barry himself, who seemed pivotal to everything memorable about that summer. But having just graduated from USC and conducted a hugely successful choral show before ten thousand people in the Hollywood Bowl, Barry was at what would sadly remain the apogee of his life.

His father insisted that he forego law school and come to work for his insurance company. When his father died in 1966 the partners turned against Barry, who managed to start his own company. But in 1976, when his wife of fourteen years took their three children and left, he began drinking, lost his business and his friends, and drifted through the next twenty-five years on borrowed money and failed schemes. At age sixty-eight, he went into recovery and tried to launch a clothing business that never got off the ground. His depression and drinking returned, a suicide attempt in 2010 failed, and he died the next year in a Los Angeles parking lot. In his last years he had contacted Mila Spani and begun an email romance, his near-daily notes idealizing a girl he had barely known those long years ago. Fixated on finding the money to go to Italy, it was a fantasy that time had stood still, that the mythic aura of Circeo awaited only his return.

In the flurry of emails after Barry's death were some old photos of our group in Circeo. There was Barry a half century ago, on the beach in his prime, holding up something indistinct, and Mila Spani in her risqué get-up for the Ferragosto festival. But photos could never capture the time or place that was Circeo, which endures only in our heads— fugitive memories, fleeting images carried into old age as the measure of all remembrance.

Barry's fantasy was only an acting-out of what we all carried with us across the decades: a yearning, a loss of what seemed in gauzy memory some vital center of our youth. Through the years and in different

ways—like the "strange attractor" of chaos theory (a system toward which things evolve regardless of starting conditions)—we all seem to have been drawn back to the place and the people, brought together again in lifelong or life-changing ways. Doug and Tove, who had broken up after that summer, actually achieved what Barry had fantasized, finding each other again after thirty-four years and marrying. Tim and I became lifetime friends, while Jerry, with his detailed recollections, cache of old photos, and even a copy of Barry's expense record, seems to have become curator of that legendary summer.

Perhaps it was simply the music and the place. Perhaps it was the camaraderie of like souls, in limbo for a glorious instant between innocence and responsibility. Perhaps it seemed the defining moment in that interim of youth when the future lay open to infinite possibility. For whatever reason, Circeo became the strange attractor to all nostalgic memory, drawing the whole span and aura of our youth into a single image.

The luminous white villa still stands on the side of the hill, the long terrace still looking out on the sea. Mila Spani, the radiant young girl now a grandmother, still summers there. But the mythic summer of '59 recedes in the mist of time as the players age and die. On an old reel of tape, Barry, Tim, and I still sing. The old songs soften the insistent present, and for a moment we're back with Barry on a sun-baked beach, the future reaching away to forever.

> Whither has fled the visionary gleam?
> Where is it now, the glory and the dream?
> —Wordsworth, "Ode on Immortality"

4

The Romance of Spaceflight

Nostalgia for a Bygone Future

Soon there will be no one who remembers when spaceflight was still a dream, the reverie of reclusive boys and the vision of a handful of men. Most of those who met in ardent little groups in small cafés between the world wars, planning voyages to the moon and planets that they never hoped to witness, are no longer living. And the last lonely youth to lie in a cricket-pulsing, honeysuckle night and gaze at a virgin moon is now in the latter half of his life. On the yellowed pages of boyhood books the silver ships still poise needle-nosed on the craggy wastes of other worlds—on moonscapes bathed in the stark light of some monster planet whose ring-shadowed hemisphere fills the horizon, looming behind space-suited specks who wander across the incandescent night.

The dream had burned beneath the cold and solitary vigils of mountaintop astronomers like Percival Lowell, and in the visions of lone inventors like Robert Goddard. The fantasy had fueled the science fiction of Verne and Wells, of Serviss and Smith and their pulp successors; it filled the monthly pages of Campbell's *Astounding*, the early novels of Heinlein, and the popular science of Ley and Clarke; it radiated from the covers of *Fantasy and Science Fiction*, the paintings of Chesley

Bonestell, and the films of George Pal. It was a dream of visible planets impossibly distant, of fantastic alien surfaces, awaiting for eons the beaching of man's boats. It was a vision of steaming Venusian jungles and fine soft days on the green hills of Mars, cooled by coastal breezes from the Great Canal, looking over a far desert where ruins stood half in sand.

It is not that the dream has disappeared; we may in fact be approaching a scientific watershed even more profound than that of Galileo and Newton. But with the coming of spaceflight, as with all change, there was something gained and something lost. Perhaps the public apathy surrounding the space program has reflected in some measure the discrepancy between dream and reality. For though more meaning may lie in one message from the Mars lander than in the most exalted fantasy, the images of spaceflight that proliferated at midcentury arose from oceanic interiors more remote and mysterious than Mars itself. The romance, in short, had a reality of its own. Acquiring its familiar outlines in the pulp subculture of the twenties and thirties, it exploded into mass culture in the late forties and early fifties.

Perhaps I will be one of the last to have known this credulous dream in pre-*Sputnik* form. I was seven when the first American V-2 rocket roared off of White Sands Proving Ground in 1946; I was ten when it boosted a small sounding rocket across the threshold of space, and nineteen when the first artificial satellite shocked the world. The romantic dream of space reached its apogee in those postwar years, when the fantasy of spaceflight and the promise of reality seemed almost in balance. Into this midcentury moment stepped a few writers, artists, and filmmakers who would epitomize the dream of other worlds. Giving final impetus to a science-fiction boom that had been trying to happen since the twenties, they educated the man in the street to the possibility of spaceflight, bringing to mass consciousness the classic dream of the modern age.

Starry Days On the Coast of Saturn

Leafing through *Life* magazine in the last week of May 1944, one found familiar wartime fare: soldiers napping in foxholes amid the rubble of Italy, American boys with their English girls in London's Hyde Park, awaiting the invasion of France. But the tide of the war had turned, and in the time between Hitler's retreat and the coming of the cold war, a

fresh breeze blew across America. One sensed it in the record success of *Oklahoma!* with its aura of youth, hope, and new beginnings, and in the spate of plays and novels set in the sunnier days of turn-of-the-century America. But like the paradox of adolescence, torn between the security of home and the promise of the world, the new optimism often sought the simpler past within a wondrous future. Thus that May 29 issue of *Life* included not only ads out of Currier and Ives and a long piece on *Oklahoma!*'s lyricist, but a large, singular painting, leaping out in vivid color amid black and white pages, depicting Saturn as seen from the surface of Titan, its largest moon.

Since Titan is the only satellite in the solar system with an atmosphere, the giant Saturn looms low in a dark blue sky like an alien ship, a thin, gleaming crescent bisected by the glowing edge of its rings, afloat between jagged cliffs that jut from a frozen sea. Warmed by the distant sun, the rocky cliffs and scarps rise sheer into the cobalt sky, casting a dark shadow on the icy sea. There is an eerie beauty in the incongruity of light. One feels that a storm has passed on a late November afternoon, yet the sky is specked with stars. A hint of dawn lights the far horizon; and beyond a lofty pinnacle, out under the glow of the great crescent, lies a distant patch of noonday plain. The painting could pass for a photograph in the era of *Viking* and *Voyager*, but on the eve of the invasion it was one man's vision of the future, later recalled by astronauts, rocket men, and science-fiction fans as their first encounter with a dream about to take wing.

On the same page are two smaller views of Saturn as seen from its farther moons Phoebe and Iapetus. Since neither moon has an atmosphere, the distant Saturn floats in a black sky on the phosphorous mist of the Milky Way. The absence of haze and dust gives the landscapes such clarity, the light such purity, that rocky features remain sharp in the distance. The scene has the feel of a great indoor arena, of a room so large that one cannot see where the dark ceiling begins. The paintings were intended to show the changing aspect of Saturn as seen by a traveler hopping toward it from moon to moon. On the next page one finds a gargantuan segment of the planet as seen from its near moon Mimas. With its stark slash of ring shadow, the yellow-banded Saturn balloons into the blackness. Sheer cliffs and jagged mesas meander the red-brown desolation of Mimas, strewn with rocks and ragged craters, stretching away to the hazeless horizon that slices across the monster Saturn.

The Best of Times

The six paintings were the work of an architect who spent nearly three decades helping to design landmark buildings across the United States. He went to Hollywood in 1938 at the age of fifty and became the highest paid special effects artist in the business. The notion of rendering astronomically accurate views of Saturn came not only from his architectural focus on realistic detail but also from his skill in achieving the continuity required for matte paintings representing different camera angles on the same scene. In 1944 he took the paintings, unsolicited, to *Life*, which bought them immediately. Though crude images of spaceflight had been the staple of pulp covers in the thirties, the leap to a larger audience was almost completely the work of this one man. Among those who grew up in the forties and fifties and later became prominent in space fact or fiction, there are few who would not cite the art of Chesley Bonestell as a significant personal influence.

His photographic realism gave the readers of *Life* a new perspective on the night sky. According to the best science of the time, this would have been their view had they actually stood on the moons of Saturn. Bonestell did for the heavens what the microscope did for our perception of life, opening worlds within worlds, inviting adventure, converting points of light into real places. "You may roam about here," his paintings seem to say. "This mysterious island, fresh from creation, is made a place by your mere presence." Bonestell put tiny space-suited figures in most of his scenes, for which one could search like a signature, a perspective reminiscent of the sublime landscapes of nineteenth-century romantics. In painting the planets of other suns, where the setting of a red giant might span the whole horizon with an ethereal arch of deep orange fire, Bonestell expressed his faith that light-years would not forever imprison us in the solar system; for in the late forties, even Mars seemed so remote that whoever could touch it would surely reach the stars.

For those who grew up with Bonestell's painstaking accuracy in light, shadow, perspective, and scale, the reality of spaceflight seemed a foregone conclusion. In March 1946, *Life* published twelve more paintings by Bonestell depicting a hypothetical flight to the moon; and in the next two years, his space illustrations appeared in *Scientific American, Coronet, Pic,* and *Mechanix Illustrated.* For the October 1947 issue of *Astounding Science Fiction* he did the first of his many covers in that genre. But it was *The Conquest of Space*, a book published in 1949 with text by German rocket expert Willy Ley, that was primarily

responsible for bringing Bonestell's planetary landscapes to a new generation of spaceflight enthusiasts.[1] It included the paintings from *Life* and many more: fairy-tale landscapes laced with castlelike rocks carved by drifting dust; lava spilling over the icy cliffs of Jupiter; the rocky green hills of Mars, rolling like the coast of Maine along the great canals; and on the near moons of enormous planets, knife-edged peaks and needles of rock stabbing into a star-filled sky. Together, the scenes suggest a kind of cosmic shoreline, a composite of stark and eerie beaches on the near edge of the starry deep.

It is not surprising that the most popular of Bonestell's paintings, the view of Saturn from Titan, resembles a rocky coast in the frozen reaches of the far north. For the image of the beach is not incidental. Like the dream of spaceflight itself, the appeal of *The Conquest of Space*, which went through four printings in the first three months, owed much to the archetypes of the seashore. My discovery of that book on Christmas night of 1950 had an impact very similar, in fact, to my earliest memory of the beach.

The Only Real Place

I was four years old in 1942 when the army sent my father to Fort Ord on California's Monterey Peninsula. We left a dreary flat in the gray mist of San Francisco for a sunny cottage near the cypress-lined, white-sand beaches of Carmel. As if to ritualize this rebirth, my mother took me for a walk that wound through a dark grove of those great brooding cypress—leaning and reaching with their gnarled, windswept limbs, growing ever more foreboding—until the path opened suddenly onto a long stretch of pure white sand and a vast expanse of silver-blue water that sparkled and shimmered to the edge of the world. It was my first waking encounter with the Pacific Ocean. I ran barefoot over the hot sand, stopping at a safe distance to gape at the bellowing breakers, feeling the cold foam on my feet. As vivid still as the smell of ice plant on the dunes, it is a moment burned into memory, like an astronaut's image of Earthrise from the shores of the moon.

We went often, through the dark trees to the sunlit beach. I built sand castles while my mother sat on the grassy bank with the salt-kelp breeze in her hair, watching boat specks on the horizon. Her death, shortly after we left Carmel the following year, seems to have merged my sense of the mother with that of the ocean—Great Mother of all,

mystery of origins, milk of the world; the Good Mother, nurturing a silent undersea fantasy of living things; the Dark Mother, swallower of worlds, the black sea-bottom of death itself, strewn with *Titanic*s, digesting Atlantis and Lemuria.

The epilogue came a few years later at a summer camp in the high mountains. I awoke one night in a sleeping bag under a wilderness of distant worlds, recalling Asimov's story about a planet with six suns, where "Nightfall" occurs but once every 2,050 years and the sudden appearance of a soul-searing canopy of stars plunges civilization into chaos. Gazing out into the immense ocean of light I reexperienced my encounter with the Pacific, though there was no odor of ice plant on the breeze, no sound of breakers nor wind in the cypress, only the silence of those trillion worlds, waiting, eyes within eyes, coming through a million lifetimes to meet mine—which glanced away, struck with what we all come to know: that each of the unfathomable immensities—Mother, Ocean, Death, and Stars—share the barrier between known and unknown, enfolding the familiar world like the pre-Columbian gods and monsters, bounding all beginnings, all ends, all meaning.

Perhaps it was gods and monsters, not gold and glory, that inspired young Cristoforo Columbo on the shores of his boyhood Genoa, gazing out on a sea that encircled the known world like the night sky—a fathomless enigma, fading off into forever. Men once looked out over the melancholy wilderness of water as we now look to the stars, knowing it to veil some great mystery of unknown size and origin. Though the sea no longer bounds the universe, it remains a vast, inscrutable presence, growing darker and deeper in the distance, the darkness of a world before man, unchanged through eons of continental evolution, yet ever restless, relentlessly pounding the land, through all lifetimes. The rush of the surf echoes the ancient Earth—the wind in the once great forests, the thunder of free-running herds—while the sea alone remains truly free, the last untamed remnant of Earth's tempestuous youth. And out beyond the breakers abides the silent face of the Great Mother, an effervescence of light, flashing like countless suns.

Though the archetype of the ocean shapes the aura of Bonestell's paintings, the root metaphor is more precisely the shoreline itself. The interface of known and unknown, civilization and wilderness, conscious and unconscious, the beach is that narrow band of equilibrium where the city meets the sea. To go down to the sea-scented shore on a cold, gray day and wander amid the wrack and debris of both worlds, to sit

on a half-buried whiskey box, watching the birds dip and hunt with their small sad voices, is to enter sacred space, to walk the razor's edge between time and eternity, matter and spirit, isolation and communion. The seashore is a sanctuary, the eye of the storm, where our polarities are momentarily balanced. It is where the temporal realm of the hot street—even the rundown hot-dog stand—is bathed in transcendent energy, touched by the breath and pulse of the sea.

The transformation is reciprocal. With each mortal breaker the eternal sea dies a momentary death, descending into time as it licks the sands to the soft cries of gulls. Yet the beach is a place of rebirth, where each wave erases the tracks of life and time, leaving the broad sand flats gleaming like glass. It is a place where false selves are shed and companions transcend their separateness. It is a holy place, perhaps the only real place.

Islands at the Edge

The same paradoxic polarities are at the core of Bonestell's appeal. To feel the lure of the seashore is to know why the near planets still beckon, even when the hope of inhabitants is lost. By 1950, humanity itself had become the city on the shore of the cosmic ocean—a growing cancer of disconnected egos living in the shadow of the bomb. For an eleven-year-old awakening to that larger reality, the barrier between known and unknown first encountered on the coast of Carmel now became the pristine beaches of Bonestell's planets (it is fitting that Bonestell himself lived in Carmel). Like the seashore, his alien landscapes domesticated the transcendent while elevating the mundane, familiarizing the mysterious and mystifying the familiar. His most popular painting, the view from Titan, with its giant Saturn afloat in a blue sky over sunlit peaks, seemed the ultimate marriage of strange and familiar.

In the hidden heart of science fiction had always been the hope that the moon and planets promised a personal adventure akin to my encounter with the Pacific—a transitory, enchanted moment when man, like Fitzgerald's Dutchmen, would hold his breath before the fresh green breast of some radiant new world. At that moment, the cosmos would become a place. This was the promise of Bonestell's beaches—that those peaceful points of light in the night sky are *places*, that virgin rocks, asleep for a billion years, await my touch no less than the cup that

sits here before me, that there is a "transcendent mundaneness" abiding in parallel time and space, one that somehow merges the cosmic and the personal. A Bonestell moonscape is a sacred place at the edge of the known world—an altar set before the barrier, a piece of the mundane bathed in oceanic mystery.

We think of the boundaries of the known, the outer rim of our reality, as somehow harboring the answers to our "Why" questions. Whether it be Aristotle's geocentric spheres, Columbus' ocean-sea, or our own space-time continuum, we conceive of this Larger Context as ultimately separate from and alien to our everyday experience simply because it is assumed to mask the unknowable, the meaning of all meaning, as inaccessible to us as cosmology to an ant. To encounter the blue skies of Bonestell's Titan, or to find that the reddish, rock-strewn desert of Mars looks hauntingly like the American Southwest, suggests that the near edge of the Larger Context is a reality as familiar as our own back yard. Just as the beach is perceived as the edge of an otherwise boundless sea, Bonestell brought the edge of infinity out of the abstract and into the realm of direct experience.

The two realms, abstract and direct, are quite different. In one, red is a designated wavelength of light; in the other, red is a color. In one, the Earth rotates on its axis and revolves about the sun; in the other, the sun rises and sets. The photographic realism of Bonestell's cosmic beaches brings the realms together at their point of tangency, allowing one to experience the heliocentric reality from a geocentric perspective, giving the Larger Context a tactile immediacy. The paintings had a disorienting effect, similar to that experienced by astronauts seeing Earth from the moon. Standing beneath the blue swirl of Earth, said Gene Cernan, "I had to stop and ask myself, 'Do you really know where you are in space and time and history?'" To believe, with a foot in each world, that one can retain an earthly reality yet stand on *another* ground under *another* sky, has the transforming impact of an out-of-body experience, or an encounter with the doppelgänger, a duplicate self.

The lack of inhabitants allows Bonestell's barren astroscape to become an extension of oneself. The image suggests a colossal stage set or a giant playroom, a toy world of one's own. There is a timeless stasis about these bright islands, offering safe passage through the void as one might ride a cozy car through the Tunnel of Horror. A virgin purity, untouched by everyday life, not only makes the place one's own but beckons in the way that tiny islands lure the canoeist. The scenes,

like the islands, invite one to become a world unto oneself. It is the narcissistic fantasy of infusing whole societies, planets, or universes with one's own nature and agenda—an utter absence of personal limits. But unlike the way of the mystic, the ego is not sacrificed; it is merely romanticized. For Bonestell's landscapes, like the canoeist's island, remain pieces of the real world, filled with those craggy shadows, hidden caverns, and pristine horizons that are natural to the romantic imagination.

Such romantic flights from personal limits were more than the marks of innocent youth. For as long as spaceflight was far from reality, one could immerse oneself in the subject with the intensity and resolve of real exploration—the exhilarating sense that one stood very near the leading edge simply by combing musty libraries or gluing balsa models in a cluttered garage. Such mundane pursuits seemed to merge with the ultimate quest and adventure on its realistic timeline. Lying in the hammock and gazing at the moon, viewing the larger craters through Dad's binoculars—so close, yet so impossibly remote—one reached another world by the same means to which even the most heroic adventurer was then bound.

Yet one took the risks without leaving home, gained the world without losing the soul, pursuing the real adventure in a context as warm and secure as reading comics in bed while mother nursed the common cold. For space travel, like all mythic visions, was paradoxic, containing at its core the very polarity most peculiar to adolescent males. The parental womb—the inner solipsistic world of childhood—became the secret spaceship, while the external world was removed to outer space, where one's omnipotence was safely assumed. One eluded the looming world of adult responsibilities, the messy arenas of peer conflict and opposite-sexed enigmas, withdrawing to a larger realm that encircled those lesser things. There one finds Bonestell's planets inhabited by other childlike beings, or by benevolent and omniscient Cosmic Parents. Substitute for the parental womb the technological society, where the illusion of infinite leverage compensates for a state of abject dependence, and one has an inchoate hypothesis with which to explain the rise of science fiction itself over the past century.

Before I sentence all science-fiction fans to schizoid adolescence, however, I should note not only that all neuroses merely exaggerate facets of normal behavior but also that the progressive/regressive polarity is common to all transition, individual and collective. The

adolescent is in fact a microcosm of the modern condition, wandering the beach between two worlds. His isolation is that of humanity itself, a species cut off from its traditions, its instincts, its animal forebears, even its home planet, while riding the momentum of history like a runaway train.

Ironically, while Bonestell's island beaches are stepping stones to the discovery of higher life, they also intensify this sense of isolation. Looking out over the ocean or gazing back on the home planet, one feels the solitude of humanity, a species cast up from the ancestral seas and forests, standing alone at the leading edge, like an old man who has lost all those from whom he issued. Just as whole cultures reach a zenith of awareness and creativity when old and new are in polar tension, so awareness itself may be the product of the "bicameral mind," the hemispheric tension which allows the stereoscopic, three-dimensional thinking that is consciousness. This reflexive self-awareness, the ability to think about thinking, differentiates us from other animals. It is the source of all good and all evil, all cruelty and all compassion. It is this reflexive tension that pervades the shoreline, terrestrial or cosmic. It is the fragile polar balance that defines the human condition, bringing both heightened awareness and the concomitant solitude of separation. On the beach, faces flicker in the firelight—creatures marooned on the shores of evolution, gathered to mourn and to celebrate their loss of innocence.

Destination Moon

In one of Bonestell's paintings for *The Conquest of Space*, a sleek silver rocket towers on its gantry against the stars. Men move about in light and shadow as though huddled around a great silver flame, a signal fire warming the night at the edge of the cosmic ocean. In a second painting, the same ship rests on its fins in a valley of the moon against black sky, sunlit mountains, and the distant Earth. Light radiates from the hatchway as the crew explores the site, a rugged outpost on the frontier of evolution. In the hearthlike glow of these scenes lies a communal longing, life reaching out for some indiscernible secret, some wormhole to the long forgotten Source, the heartsong of creation.

The paintings, along with additional moonscapes, became the basis for visual effects in *Destination Moon* (1950), the film often credited with launching the cinematic science-fiction boom of the fifties. Film

historians traditionally note that *Destination Moon* was the first science-fiction film worthy of the term since *Things To Come* (Britain, 1936) and that its success led to the boom that followed. Written by Robert Heinlein and Rip Van Ronkel, directed by Irving Pichel, and produced by George Pal, with panoramic matte paintings by Bonestell, *Destination Moon* depicts a trip to the moon, true in almost every detail to the scientific projections of the time. The result is a docudrama surprisingly close in particulars to the flight of Apollo 11 nearly two decades later. Although it was Eagle-Lion's top moneymaker for the year, earning enthusiastic reviews and an Oscar for special effects, the film has not worn well. Film historians lament the absence of plot, women, and depth of character, dismissing the film as dated and dull.

The problem with this kind of film history, of course, is that it lacks historical perspective. Not only do many film critics seem bound to secular realism, but most of the writers are too young to have seen *Destination Moon* when it was released. When the long silver ship set down on the surface of the moon and the crew descended in silence, it was as though irrelevancies dimmed and essentials came clear. Viewing the first realistic depiction of a visit to another world (also the first in color) had an effect similar to the televised landing of Apollo, or to the dazzling NASA footage projected onto the five-story Imax screen in *Blue Planet* (1990). The one previous attempt at an accurate representation of space travel, *Woman in the Moon* (Germany, 1929), was far less compelling, not only because its moon sequences reverted to fantasy but also because it was silent at a time when most films had incorporated sound. The degree to which *Destination Moon* escaped hack concessions to Hollywood formulas is a credit to Heinlein and Pichel. With the help of Bonestell and Pal they conceived a prophetic film, an ode to the romance of spaceflight that retained, even in its pedestrian moments, an aura of transcendence.

But was it responsible for Hollywood's spate of science-fiction films? In truth, the producers of almost all of the significant SF films released in its immediate wake had conceived their ideas and purchased their properties prior to the contracting of *Destination Moon*. Along with the surge of SF magazines, the notion of filming serious science fiction was in the air in the late forties. Although the optimistic and visionary *Destination Moon* was virtually first in the cycle, its impact was confined to demonstrating that expensive SF could be profitable.[2] Most succeeding SF films fell into the Gothic mode, embodying the

mutated monster and evil alien themes of *King Kong* (1933; rereleased in 1952) and *The Thing* (1951).

In the end, *Destination Moon* was less a beginning than a culmination. Epitomizing that balance of fantasy and reality that characterized the dream of spaceflight itself at that transitional moment, it was the confluence of three historic careers: Bonestell, the first realistic space artist; Heinlein, whose gritty realism depicting life in space had made him the first science-fiction writer to break into a mainstream magazine (with his *Saturday Evening Post* stories in 1947); and Pal, the first science-fiction filmmaker to show concern for scientific credibility. Pal's bias toward realism had been evident in his Puppetoons, which were not only the first socially-minded cartoons but also first to use stop-motion photography of real figures in place of animation.

Pioneers in fantasy and innovators in realism, the three men surfaced at a time when the developing facts of spaceflight had begun to reshape the nature of the dream. *Destination Moon* perfectly bridged the romance of the dying pulps and the coming realities of Apollo. After *Destination Moon*, in fact, spaceflight on film suffered a fate similar to that of the real thing after Apollo. In the public mind, the deed had been done. Pal retreated to traditional science fiction, turning first to the destruction of the Earth, in which the same sleek ship from *Destination Moon* became a planetary Noah's Ark (*When Worlds Collide*, 1951, with artwork by Bonestell), then to alien invasion (*War of the Worlds*, 1953), time travel (*The Time Machine*, 1960), and finally back to fantasy from whence he came. Pal tried a second docudrama (*The Conquest of Space*, 1955), but its success fell short of *Destination Moon* to about the same degree that public interest in the space shuttle fell short of attention to the moon landing. Heinlein attempted another script (*Project Moonbase*, 1953), expanded from an unsold TV pilot and rewritten by the producer, with results that forever soured Heinlein on Hollywood. His later books, like Pal's films, moved away from the pure extrapolative realism of earlier SF. Bonestell, on the other hand, moved toward the emerging realities with his illustrations for Wernher von Braun's famous *Collier's* articles in the early fifties. Thus the romantic vision receded with *Destination Moon*, where it abides like an old daguerreotype, the finest and final hour of a dream now faded and transformed.

Wyn Wachhorst

Yellow Brick Road to Redrock Corners

Perhaps the images of unencumbered human flight that preceded the realities of the airplane included winged torsos hovering high above trees and houses, soaring like eagles over hill and forest, swooping like hawks down rivers and valleys. During the first half of the twentieth century, the romantic vision of coming adventures in the solar system compared in spirit to just such reveries. The depersonalized, mechanical reality of astronautics was never a part of the dream. When we finally went to the moon it was not on a wing and a prayer but on a pyramid of mathematics and technological expertise. Every move was part of an exhaustively detailed script. Should the left or the right hand pick up this piece of equipment on the moon? Should the knuckles point up or down? With simulations more novel and rigorous than the actual flights, the moon's only surprise was that it held no surprises. In our business, said Apollo 11 astronaut Mike Collins, "boring is good because it means that you haven't been surprised, that your planning has been precise and your expectations matched."[3] "Adventures," said polar explorer Amundsen, "happen to the incompetent."

What faded in the years following *Sputnik* was not the dream itself but its naïve forms. The astronomical interests of most rocket pioneers were superficial, romantic, and unscientific, while few professional astronomers took spaceflight seriously. Even rocket research had once been romantic. Robert Goddard's telemetry in Roswell consisted of a pair of binoculars, an old alarm clock to drive a recording drum, and Esther Goddard's movie camera. She was photographer, secretary, and parachute seamstress, among other titles. It was an intensely personal quest. Goddard and fellow rocket pioneers Konstantin Tsiolkovsky and Hermann Oberth all devoured the science fiction of Verne and Wells, with Oberth's interests extending even to the occult. Like the masses who panicked during Orson Welles' 1938 "War of the Worlds" broadcast, early spaceflight enthusiasts not only took seriously Percival Lowell's insistence on Martian canals but envisioned a lush, tropical Venus and solid, surrealistic surfaces on the outer giants. Drawing on the primitive state of astronomy, pulp fantasies seemed to confirm that if one could somehow hurl oneself off the Earth, one would encounter myriad yellow brick roads to an infinity of Emerald Cities.

Today the moon and planets are not only inhospitable but have undergone a certain desacralization. The romantic, mysterious,

inaccessible moon that made the water silver, the swollen tangerine Allegheny moon, the "ghostly galleon tossed upon cloudy seas," the moon that only cows in nursery rhymes could jump over—that moon is gone. The once holy ground of myth and magic is now a barren, hostile desert.

It has been suggested that there are seven zones of human experience: (1) the area of sensation immediately touching the skin, (2) the area within two or three meters in which most social interaction takes place, (3) the maximum area of social interaction, reaching out a few hundred feet, (4) the area that extends as far as one can see or otherwise gather information from any one location, and (5) an irregular and varying area made up of all the zone-four areas that a person experiences during a lifetime. Beyond these five natural zones are two conceptual constructs: (6) the surface or biosphere of the Earth and (7) the universe as far out as one can conceive.[4] Our extraverted, Newtonian culture has viewed the outermost zone as the realm of transcendence, the literal locus of ultimate answers to all our "Why" questions. In the course of one lifetime, this zone has expanded at least three-hundred-thousandfold. With the discovery in 1921 that our galaxy was not the sum total of existence, the solar system moved from zone seven to zone six. In the new cosmos, the planets seem to lie less on the near edge of infinity than on the far edge of the Earth.

Yet just as the beach is bathed in the aura of the sea, Bonestell's planets could still symbolize that unfathomable immensity. It was not until we viewed the Earth from space, left our spoor on the moon and Mars, and intruded on the timeless solitude of the outer planets that we began to experience what we had known. The rolling gray lunar hills have belied the jagged, craggy wonderland of *Destination Moon*; and the rocky red desert of Mars is more like a spherical New Mexico than the home of Wells' doomsday machines. Now a part of "where we are," of zones four and five, given the disorienting impact of electronic media, they become Grayrock Junction, Redrock Corners, and Gasball City, associated less with the Land of Oz than with Steinbeck's flat-country truck stops—those dilapidated diners with a gas pump in front, where flies strike the screen door with little bumps and drone away.

To conceive of the transcendent requires a symbol. One cannot worship "God"—a word, a vague feeling, an intellectual abstraction; one needs an image: Jesus, Buddha, a bearded man in the sky, a painting, a statue. Yet the natural tendency is for the image to literally become

God, and the larger, elusive feeling that empowered the symbol fades, eclipsed by a host of this-worldly connections. Finally demystified, the statue reverts to its status as mere artifact. Thus every symbol contains the seeds of its own desacralization. The millennial nature of Christian theology generated the idea of spiritual progress, which spawned the notion of salvation through success in this world, which led to the secular idea of material progress, which in turn began to desacralize Christian theology. The last stage of this process is fundamentalist dogma, in which symbols have lost their numinosity and have degenerated to mere signs.

The Cartesian-Newtonian worldview, which has deferred its "Why" questions to the empirical edges of space and time, faces a similar cycle. Like the instruments of Christianity, discoveries at the leading edge of science desacralize the very things that compelled the quest in the first place. The sense of wonder surrounding those objects suffers the fundamentalist fate: the mythic moon becomes a wilderness of cinders and ash, and the red star of evening becomes a barren, rocky desert. The bright light of science dissolves the mysteries that animate its objects; the observer alters the observed, and the aura of wonder recedes with the horizon. We pine for the lost images demystified by modernity, and the innocent dream of spaceflight joins the romance of the railroad in coffee-table nostalgia.

The Archimedean Point

Now that we have touched a heavenly body, the rockets themselves no longer seize the imagination. In a field near the Houston Space Center, the last Apollo lies like a beached whale amid a trickle of visitors. It was once enough merely to escape the Earth, but now the core motive comes clear: cosmic communion. "Even the traveler's mind," wrote a post-Apollo poet, "now shoots quicker than a gecko's tongue beyond the sun for the sweet stars, thrilled by demons, by impossible virtue and impossibly wise old men."[5] Like Bonestell's planets, the moon was once as remote as the stars; just to stand on it would unmask the night sky, rendering the whole cosmos as accessible as the worlds of science fiction. But the realities of reaching the moon drove science fiction from the "hard," mechanical extrapolations of *Destination Moon* to the "soft" phantasms of *2001, E.T., Starman, Cocoon,* and *Contact.* Forced inward to the promise of Christlike aliens, paranormal realities,

and mystical resurrections in space, science fiction no longer pretends to paint the near future.

Perhaps the new dream is less naïve than the old. Arthur Clarke has noted that we tend to overestimate what we can do in the near future and grossly underestimate what can be done in the distant future. This is because the imagination extrapolates in a straight line, while real events develop exponentially, like compound interest. Perhaps communication is not limited by the speed of light; perhaps there are "wormholes" in space-time; perhaps we will receive some mind-altering message from superior beings. Such hopes were the subject of Clarke's 1968 film *2001: A Space Odyssey*, the first film of any consequence about spaceflight since *Destination Moon*, and the only other such film scripted by a major science-fiction writer.

2001, in fact, capsulized the transition from the old dream to the new. When the ape-man spins his bone tool into the air, where it dissolves to a wheeling space station complete with pay phones and a Howard Johnson's restaurant, the message is that the colonization of space will be no more than an extension of man's tool-making nature. In the first half of the film space is presented as essentially more of the same, a bland, anonymous world set to the "Blue Danube" waltz, a Howard Johnson's in the sky, where means remain ends in themselves. The second half of the film moves from the "how" of spaceflight—the rockets, space stations, synthetic foods, and supersophisticated computers—to the "why," symbolized by the inscrutable aliens who transform the astronaut into the mysterious star-child, drifting toward Earth to be born. The two halves of the film depict the shift from the old dream, terminating in the simple act of escaping the planet, to the new dream of discovering some clue to our meaning and destiny, of finding life, and of launching the long journey in which man may evolve into a new galactic species.

What, then, is the lure of the near planets? Why dedicate a life to a landing on Mars? Like the spice islands envisioned across Columbus' ocean-sea, Mars was once the mystery of the cosmos incarnate. Now it is only the near edge of the night sky. Yet the red sands of Mars, now part of our reality, still lure us to the shore of the cosmic ocean.

Although Mars is no longer shrouded in mystery, it remains what Hannah Arendt called an "Archimedean point" (it was Archimedes who said that with a long enough lever and the moon as a fulcrum he could move the Earth). Applying the term to the tendency of modern science

to substitute its heuristic constructs for direct experience, Arendt suggested that man increasingly encounters only himself. Viewing spaceflight as an attempt to reach a literal Archimedean point, one that must always require a still further point, she saw the leap into space as a flight from the human condition. But as the vision animating all forms of exploration and discovery, the Archimedean point *is* the human condition.

Physicist Philip Morrison tells a story about the Bushmen of the Kalahari, Africa's last society of hunter-gatherers, who forever move about the desert, carrying what little they possess, living in bands of extended families, each staying within a region about the size of Los Angeles County. They meander through life, "stopping now here, now there, to sleep in a kind of nest, to try the fruit of this tree, to scratch up that waterhole," or to meet for a "ritual encounter with their wandering friends." Their wants are so well controlled and their skills so well developed that they need not work any harder. Their one need,

> as they wander through the cool mornings, the cool evenings, and as they rest in the heat of the day, is to know exactly where they are. They discuss it always. They note every tree, they describe every rock. They recognize every feature of the ground. They ask how it has changed, or how far it has been constant. What story do you know about this place? They recall what grandfather once said about it. They conjecture, and they elaborate; their minds are filled; their speech elaborates exactly where they are. You see they have built an intensely detailed, brilliant, forever reinvigorated internal model of the shifting natural world in which they find their being.

Morrison suggests that our language, myth, ritual, tools, science, and art are all symbolic expressions of a "grand internal model" that every human makes, and that is always in need of completion. The essence of human exploration is the attempt to fill in the margins of that model so that it will not "fade off into the nothing or the nowhere."[6]

All such terms—Arendt's Archimedean point, Morrison's grand internal model, space writer Frank White's "overview effect"—are aspects of the reflexive thinking that is the hallmark of our species.

If the essence of exploration is to touch the boundary—the beach, the mountaintop, or the moon—the core of the human condition is the attempt to see the self in context. To stand on the moons of Saturn and see the Earth in perspective is to act out the unique identity of our species.

The Star Thrower

That it is humanity's fate to live alone at the leading edge was a point often made by evolutionary biologist Loren Eiseley. In "The Star Thrower" he describes a wave-beaten coast, littered with the debris of life—upended timbers, "sea wrack wrenched from the far-out kelp forests," and long-limbed starfish strewn everywhere, "as though the night sky had showered down." A hermit crab is tossed naked ashore, "where the waiting gulls cut him to pieces." Along the strip of wet sand "death walks hugely and in many forms. Even the torn fragments of green sponge yield bits of scrambling life striving to return to the great mother that has nourished and protected them."

> In the end the sea rejects its offspring. They cannot fight their way home through the surf which casts them repeatedly back upon the shore. The tiny breathing pores of starfish are stuffed with sand. The rising sun shrivels the mucilaginous bodies of the unprotected. The seabeach and its endless war are soundless. Nothing screams but the gulls.[7]

Among the competing collectors, clutching their bags of beautiful voiceless creatures, was a human figure framed beneath a distant rainbow, spinning starfish far out over the surf. The star thrower, "whose eyes seemed to take on the far depths of the sea," represented for Eiseley the furthermost reach of humanity. Shipwrecked on the shores of evolution, he is unique in his compassion. He is the catcher in the rye, protecting the innocent from the abyss, doomed eternally to explore the margins, chasing his reflection down an infinite regress.

Like the immigrant wife, alone on the howling Kansas prairie with her Sears catalog and her secret dreams, those who settle the red sands of Mars will know that some of their roots must die on that barren shore. Gazing back on the soft blue dot in the Martian sky, perhaps they will

dream of dance music drifting over a moonlit lake, of twilight talk in a turn-of-the-century town, or the dark wet soil of the sunflower forest from whence we emerged like life from the sea. But pioneers on the plains of Mars will no longer debate whether that pale blue point is the center or the edge, for the center, as Joseph Campbell has said, will be man himself, finally aware that he lives in the stars.

The imperative to see the self from afar, to see the present from some external point in the future, is neither Promethean, as Newtonians assume, nor Narcissistic, as Arendt suggests, but closer to the task of Sisyphus, who was condemned to roll the rock up the hill only to have it roll down and eternally begin again. For the succession of Archimedean points—whether metaphoric, as in art, or literal, as in science and exploration—spirals through history. Though we return always to the same point, there is a new perspective with each cycle, and we seem to know the place for the first time. The process is unending, but we *are* process; and our soaring aspirations are finally cathedrals of the mind. For latter-day Argonauts to return with the poster of the whole universe would in fact be a form of idolatry. Were we to awaken from the dream of space-time we might long for some eternal star thrower to return us from the center to the edge. For it is not the treasure but the voyage itself that is the central project of our species.

Again and again we come through the dark trees to the Pacific: the lookout on *Pinta*, spying a hint of white sand cliff in the moonlight; Amundsen, on a bleak, windswept plain of ice, reaching the pole with his few surviving dogs; and Apollo 8, in the hush of Christmas Eve, floating over the mountains of the moon. This was the promise of Bonestell's vision, that people from Earth would one day flow into the ancient river valleys of Mars, down the gorges four miles deep, out over desolate, wind-torn plains, out to the ice seas of Europa, the yellow skies of Titan, and the Great Wall of Miranda, out into the ocean of light, to those worlds within worlds where the star-children wait.

The Inner Reaches of Outer Space

It had been a dark and bitter year. The war languished in Vietnam, students rioted around the globe, the Soviets invaded Czechoslovakia, North Korea seized the USS *Pueblo*, a B-52 crashed carrying four hydrogen bombs, Chicago police battered demonstrators at the Democratic convention, Robert Kennedy was assassinated in Los Angeles, and Martin Luther King was shot down in Memphis. Discontent was epidemic, disillusion profound, as American families sat down to dinner on Christmas Eve, 1968.

Yet my most indelible memory of that evening is the hush of kitchen clatter as our gathering was drawn to the TV—children, grandmothers, cousins, in-laws, and old-maid aunts—to gaze through a spacecraft window at the mountains and craters of the moon, a phosphorescent world creeping across the screen, curving away to the black of space. "In the beginning," intoned a metallic voice across a quarter-million miles, "God created the heaven and the Earth ..."; and the poignant closing of those first men to circle to moon: "Merry Christmas, and God bless all of you—all of you on the good Earth."

And once again the Earth seemed good. *Time* magazine scrapped plans to feature "the Dissenter" as Man of the Year, substituting the three astronauts. Like a latter-day star in the east, Apollo 8 had risen over a world longing for epiphany. It seemed proper that the event occur at Christmas—the last living myth in a disenchanted world, archaic as Genesis yet compelling at the core.

Yet the mood was short-lived. After the first lunar landing, the public lost interest. Having beaten the Russians in the Super Bowl of space, we went back to business and Monday Night Football. When later moon shots were allowed to interrupt sports coverage the networks were deluged with angry phone calls. After six walks on the moon, the last three were scrapped, saving seven-tenths of one percent of Apollo's total cost. Yet the $24 billion Apollo program cost each American only a dollar a month for nine years, and this ignores exponential returns to the economy. The $38 billion spent on space between 1961 and 1972 was barely one percent of the national budget, three percent of the amount allotted to social programs, and half the figure for detected welfare fraud. Had even this moderate commitment to space persisted, we would have walked on Mars decades ago.

It has been nearly a half-century since the last man left the moon. Remnants of the great rockets now lie in the Smithsonian with the *John Bull*, the Tin Lizzie, and the *Spirit of St. Louis*. On the abandoned launch pad at the cape, dry grass bends in the sea breeze. In another decade it is likely that all twelve who walked on the moon will have passed into history. And there are now two generations who cannot remember when spaceflight was still a dream, who view Armstrong's leap as an archival event, another Lindbergh commotion.

Rationales for the abrupt ending of Apollo suggested that the scientific potential did not warrant the cost, that the program stole technical talent from other fields, that it had little military value, and that Apollo's dinosaur boosters were a dead end in the evolution of spaceflight, which must now consolidate a stepping-stone presence in Earth orbit. Historian Walter McDougall argues that the space effort was part of an ideological package that Americans purchased after *Sputnik* in the belief that the United States must adopt the technocratic model to get back on top. By the early seventies, with the relaxation of cold war tensions and the growing concern over domestic issues, "the original model for civilian technocracy, the space program, became dispensable."[1] This may well have been true, but it does not seem to justify scrapping three paid-up moon shots. It is far more likely that President Nixon watched Apollo's TV ratings drop and decided that the risks—especially after the near disaster of Apollo 13—outweighed diminishing returns.

A part of the problem was television itself. Ghostly images of astronauts on the moon revealed little detail, while the image of Earth in

the lunar sky was a blurred white fleck segmented by two or three picture lines. And beyond the technical limits of the media lay the confines of mass consciousness, restricting spaceflight coverage to hardware, technical routine, cost-benefit ratios, or the lifestyles of the astronauts, trivia that soon became boring. Like the iconic cars that dominate our ads and movies, journalism in a pragmatic, means-become-ends culture is expected to *get* us somewhere. Television, moreover, becomes the great leveler of experience. How far away was the moon? The same distance as Vietnam—across the family room.

But it is not the mass media that are finally to blame for public apathy toward manned spaceflight. If we lack the imagination to infuse the event with wonder, the fault lies in ourselves. A vast number of us are simply uncurious about anything we cannot perceive directly (making Mars even less interesting than the moon). Since the universe of modern science, with neither center nor edge, violates the archetypes we call common sense, many choose simply to ignore it. The alleged 15 percent who believed that the moon shot was an elaborate government hoax staged for television exemplified in the extreme the widespread want of the most elementary concepts necessary to grasp the event. When the 1994 Los Angeles earthquake knocked out the power in the middle of the night, Griffith Observatory received numerous calls asking whether the quake was responsible for the sky being "so weird." The city-bound callers had never seen a star-filled sky.

Critics bemoaned Apollo's lack of utility, calling it escapism, military adventurism, fodder for technocracy, or a triumph of the WASPs, views often rooted in paranoid distrust of power and authority. For the same reasons that polls name the president of the United States the greatest living American year after year, the average citizen fears and reveres power above all else, perceiving the world as narrowly political and measuring most things by their instrumental utility.

In the long run, the whole politics of society is more profoundly changed by a new sense of human potential than by any amount of obsessive self-maintenance. Without a source of meaning larger than the ego or beyond mere survival, one is left at the center of a universe devoid of transcendence. The significance of anything derives from its larger context, one dependent in turn on still greater perspectives, until we reach what sociologist Peter Berger calls the "sacred canopy," the boundary where known and unknown meet. Any living symbol of the

boundary, left inchoate and mysterious, becomes an object of awe and wonder, veiling some great mystery of indeterminate size and origin.

Wonder, in its larger sense, denotes the *mysterium tremendum*, the aura of unfathomable majesty, utterly humbling and wholly Other, surrounding the sublime and terrifying unknowns that border our models of reality—the dark forest, the empty desert, the sacred mountain, the boundless sea, the black silence of cosmic infinity. Thus we gaze into the night sky and feel not diminishment but dilation. We sense the vastness and passion of creation and glimpse an equally vast interior—the "enormous geography of the soul," as journalist Edwin Dubb put it.[2] We are aware of the stars only because we have evolved a corresponding inner space.

Like Columbus, we enter space seeking the East in the west, journeying, as Joseph Campbell said, "outward into ourselves."[3] If there is a common thread through all world mythology and religion, it is that the nature of man and the cosmos are one. It matters not whether this is literally true in some holographic sense, or subjectively true in that consciousness must constellate experience within its own limited spectrum; for us, it is true nevertheless. In the gleam in my wife's dark eye burns the Great Galaxy in Andromeda, while somewhere out on its myriad worlds recur the sound of my father's laugh and the scent of my mother's hair.

A Candle in the Dark

So we dream of sailing a cozy ketch out past a million suns, across the dark sea of the soul, in search of the mirror lake in the soft green meadow, the secret center, the glint in the eye of God. Even if it is not *in* time or *in* space, there is still a sense, in the cathedral of the mind, that the journey toward the horizon will bring it closer. "Come, my friends, 'tis not too late to seek a newer world," cried Tennyson's Ulysses, "to sail beyond the sunset, and the baths of all the western stars!" From the dawn of recorded history, the westward course of the sun has been that of rebirth and moral regeneration. "The ultimate effect of the discovery of the new world," wrote historian Charles Sanford, was "to substitute for the spiritual pilgrimage of Dante and Bunyan the 'way West' as the way of salvation."[4] From John Winthrop's "City upon a Hill," the Puritan moral example to the old world, down to our own nostalgia for the purity of the frontier, the way into the wilderness has been the way home. As

with evolution itself, the way backward is lost—to the primordial sea, to the personal world of the primitive, to rambling twilight talk on a small-town porch, to our own elusive youth. As the western horizon recedes across oceans and continents and out into the cosmos, the quest goes forward and outward, seeking the center at the edge.

Joseph Campbell has observed that in countless myths from all parts of the world the quest for fire occurred not because anyone knew what the practical uses of fire would be, but because it was fascinating. Those same myths credit the capture of fire with setting man apart from the beasts, for it was the earliest sign of that willingness to pursue fascination at great risk that has been the signature of our species. Man requires these fascinations, said the poet Robinson Jeffers, as "visions that fool him out of his limits."

"From the moment the first flint was flaked," to borrow Auden's phrase, space was fated to be the final canvas for expressing in bold strokes the inexhaustible soul of humanity. We are alive at the dawn of a new Renaissance, a moment much like the morning of the modern age, when most of the globe lay deep in mystery and tall masts pierced the skies of burgeoning ports, luring those of imagination to seek their own destiny, to challenge the very foundations of man and nature, heaven and Earth. Like the sailing ships that incarnated the aura of the Renaissance, or the great steam locomotives that embodied the building of America, the spacecraft is an emblem of the human spirit, probing the cosmos like a "candle in the dark."

The phrase belongs to a man who passed into history just before Christmas, 1996. More than anyone of his century, Carl Sagan reignited the sense of wonder in a world increasingly content to simply exist. Wonder was the core motif in the complex fugue of Sagan's life, from the six-year-old at the World Exposition, awestruck by the utopian sights to *Cosmos*, the most widely watched series in the history of PBS television, and the proud ship *Voyager*, with its pictures of man and its heartfelt hellos from the people of Earth. Who but Carl Sagan would cast humanity's bottle into the cosmic ocean? It was his rare gift to walk that razor's edge between romance and reality. He was the dreamer and the doer, the theorist and the activist, combining lofty speculations with cold, hard logic, balancing soaring wonder with unrelenting skepticism.

Wyn Wachhorst

The Outer Reaches of Inner Space

Carl Sagan's memorial is that silent streak of light that arced out over the dark Atlantic one hot August night, bearing, at his behest, greetings from Earth in fifty-nine languages, music from many cultures, and pictures of life on a blue planet. Launched in 1977, *Voyager* would explore what may be the homelands of our descendants, returning breathtaking images of the outer planets before passing out of the solar system. Traveling a million miles a day, *Voyager* will leave the Oort cloud, the trillion or more comets that orbit the sun, in 20,000 years. After hundreds of centuries, it will cross the line where the sun can no longer hold an object in orbit and will enter the open sea of interstellar space, the great dark between the stars—to sail forever, as Sagan said, "through the starry archipelagoes of the vast Milky Way Galaxy." It seems appropriate that the last voice on the *Voyager* recording is that of Sagan's five-year-old son: "Hello from the children of planet Earth!" For we are a species still in childhood, only now becoming aware of the true immensity and complexity of the cosmos. Carrying the hopes of humanity, the dreams of millennia, *Voyager* reaches out to life in a universe turbulent and mysterious beyond anything imagined by our forebears. And if odds of entering another solar system are very small, perhaps eternity is time enough.

Voyager was inevitable from the first gleam in the eye of the hunter-gatherer, from the first fire, wheel, and furrow; it was latent in the stirrup and the longship, in the creak of every caravel, the ring of every railroad spike. *Voyager* is the distillation of our essence, our offering in the cosmic cathedral, the voices of millennia echoed in the vault of night.

Generations will come and go, civilizations will rise and fall, and long after Earth is vaporized by the sun and humanity is either extinct or evolved into other beings, *Voyager* will drift silently onward, carrying the message through countless eons: that there was, at our time and place in the cosmos, an *awareness* that knew something of its world and something of itself, an imperfect people of irrepressible spirit, of mathematics and music, of love and wonder, who dared to dream of reaching the stars.

"The Old West is not a certain place in a certain time, it's a state of mind. It's whatever you want it to be."

—Tom Mix (1938)

5

Come Back, Shane!

The National Nostalgia

In the last half of the nineteenth century, the journey of a hundred-millennia came to a close on the plains of North America, the last expanse on Earth open to civilization. Thomas Jefferson had viewed that vast wilderness as a dark continent harboring mastodons and other primordial beasts, but the settling of the West removed the last great mystery from the map. With that terminal chapter in human migration, the long childhood of our species came to an end, and the story of the West became the American Epic. The belief that the ordeal in the wilderness created the American—optimistic, free-thinking, self-reliant—superseded the Revolution as America's creation myth, the national nostalgia.

We look back on the West not only as the last wilderness but as the last locus of freedom from social responsibility. There is a wistful sense that the Old West, like childhood innocence, was a halcyon age of open options, an untamed expanse where a man controlled his own destiny. The myth of the West nurtures a dream of escape from myriad minor obligations in a depersonalized society, a hunger to touch something more pure, more authentic and intense, something utterly real. The passing of the Old West, wrote historian David Davis, was like the

coming of adulthood. "When we shut our eyes and try to remember, the last image of a carefree life appears. For the nation, this last image is the cowboy."[1] The cowboy is the myth of the West compressed to a stock formula, forever replayed in film and pulp fiction:

The Western

The Western dates from the late nineteenth century when a wave of escapist fantasy swept through popular culture in response to kaleidoscopic change—industrialization, urbanization, immigration, and revolutions in transportation and communication that shifted organization and control away from the local and personal. An early sign was the dime novel, the earliest of which were Westerns, idealizing the cowboy as the last areas of free land disappeared. To make its messages more conventional for an ever more heterogeneous society, the new mass media developed familiar formulas that one could follow like a game, with a clear set of rules, goals, and opposing players, the entertainment lying in the subtle nuances.

The Western formula, the myth of the free, natural man who comes out of the frontier, establishes order for a new society, and rides back into the sunset, dates from James Fennimore Cooper, whose Leatherstocking hero was modeled on Daniel Boone. But it was the dime-novel tales of legendary figures like Kit Carson and Buffalo Bill Cody that spawned the genre. The unprecedented popularity of Cody's Wild West Show, which toured the nation and the world, established most of the themes and images that still shape the myth of the West, from whooping Indians in head feathers to heroes in Stetson hats, neither of which were common in reality. In her study of the Western myth, Jane Tomkins notes that "Buffalo Bill comes to the child in us, understood not as that part of ourselves that we have outgrown but as the part that got left behind, of necessity, a long time ago, having been starved, bound, punished, disciplined out of existence. He promises that that part of the self can live again. He has the power to promise these things because he represents the West, that geographical space of the globe that was still the realm of exploration and discovery."[2] But it was Owen Wister's novel, *The Virginian* (1902), that gave the formula its classic form—from Bronco Billy, William S. Hart, and Tom Mix to John Wayne and Clint Eastwood.

A conservative estimate is that Westerns accounted for 25 to 30 percent of all American films from the inception of movies to mid-twentieth century. As many as two hundred B-picture Westerns could be turned out in a year. The first "long" (nine-minute) movie, *The Great Train Robbery* (1903), was a Western. Its lead, Broncho Billy Anderson, launched the star system and made 376 short Westerns in a like number of weeks. The Western's popularity peaked in the 1950s, a time of transition when postwar America suddenly found itself faced with global responsibilities. The nostalgia for a simpler, more personal time was manifest throughout popular culture, from books, plays, and musicals set near the turn of the century to Bible epics and Disneyland. In the fifties, Western paperbacks were selling at annual rate of 35 million copies; and in 1959, eight of the top ten TV shows and thirty prime-time programs were Westerns. Crime shows, focusing on immediate concerns for law and order, have been more popular in such unstable periods of political and economic uncertainty as the 1930s or the present, yet the spirit of the Old West lingers ever below the surface, from the rise of country-western music to mechanical bulls in bars and accountants who spend their weekends dressed like John Wayne.

Like all great myths, the Western formula resolves fundamental opposites. Our reality is a pattern of polar tensions, like the note in a vibrato, or the rhythms and cycles that define all things. Though the actual settlement of the West lasted more than a century, most Westerns are set in the period between 1865 and 1890 when frontier tensions—civilization and wilderness, nature and culture, individual and community—hung in precarious balance. The mining boom, the building of the railroads, the Indian wars, the great cattle drives, the coming of the farmer, and the exploits of the western badmen all fell within that tumultuous era from the end of the Civil War to the closing of the frontier. On one side of the balance was the wild land—the plains, deserts, mountains, and their primitive inhabitants; on the other were the ranches, forts, and small towns, each with its saloon, store, bank, sheriff's office, and sometimes a school or church. The open land seemed to promise individual freedom, new beginnings, and national greatness, while the town demanded cooperation and compromise, and was often corrupt. Yet the harsh land was also seen as a treacherous desert threatening agrarian progress and community values, while the town seemed a haven from anarchy and savagery. The paradox inhered in figures like Daniel Boone, Kit Carson, and Buffalo Bill, seen as both

rough innocents in flight from society's artifice and as enlightened pathfinders for the new nation.

The Hero

Mediating these opposites, the classic Western hero has a physical allegiance to the wilderness on one hand, and a moral commitment to civilization on the other. He is the powerful innocent, the good bad boy, who saves the town by defeating the evil outsider, his own counterpart. Transcending the limitations of both, he brings the regenerative power of the wilderness to civilization. The Western was the original model for an "American monomyth" that has pervaded popular culture, the fantasy of an innocent community where evil villains from outside are defeated by an equally violent superhero, also from outside, defending the helpless citizens.

But the hero's dark side can never coexist with communal innocence. Caught between the townspeople's need for his savage skills and their rejection of his way of life, he must finally ride into the sunset, just as the Lone Ranger cannot wait for thanks, Superman must conceal himself as Clark Kent, and Captain Kirk must always head out of orbit. Fathered by the Western in those turbulent last decades of the nineteenth century, the monomyth has since assumed countless forms.[3] The paradox of the superhero is that the poles are mutually dependent, neither viable alone. The helpless citizens need the power of the good hero to save them from his evil opposite, while the hero needs the community to give his power purpose and his life meaning.

The monomyth tends to escalate with a growing sense of individual impotence in times of closing options—the late nineteenth century or the 1930s, the latter spawning Superman, Batman, and their comic book clones. More recently, the web of postmodern frustrations, along with exaggerated threats depicted by the media, contribute to the mentality of the *Death Wish* films, in which a gang of hoodlums torture and murder the family of the hero, who becomes a vigilante, luring muggers in order to kill them in cold blood. The dream of destroying the evil people we believe to be rife in society through a superior power and callousness of one's own has always been part of the monomyth's appeal, from the first Western to Dirty Harry and Steven Segal.

A variation on the impotence theme is Jane Tomkins' suggestion that "the Western is really about "men's fear of losing their mastery, and

thus their identity." The Western, she argues, "owes its popularity and essential character to the dominance of women's culture in the nineteenth century and to women's invasion of the public sphere between 1880 and 1920." The Western brands "most features of civilized existence as feminine and corrupt, banishing them in favor of the three main targets of women's reform: whiskey, gambling, and prostitution." It is a world "without ideas, without institutions, without what is commonly recognized as culture, a world of men and things."[4] It is the world of John Wayne, speaking in his methodical, rawboned voice, his arm around some "li'l lady" in a bonnet.

If Tomkins' thesis is sometimes polemic, there is still a sense in which the Western, at its peak in the 1950s, offered not only an image of individualism in an age of togetherness and conformity, but also a counter to the so-called "Dagwoodization" of the American male. The Western suggests that real men are by nature simple, pure, and forthright, with a deep-seated longing for the clean, uncomplicated life of the wide open spaces, and that the failure to master the castrating complexity of urban society is due only to its contrived and unnatural state. This is the Western as the idyl of a Man's World, inarticulate and emotionally numb, where sex is taken care of by saloon girls who can meet men on their own terms and threaten no permanent engagement.

Nostalgia

But while the *Death Wish* mentality and masculine anxiety may contribute to the hero's appeal, the myth of the powerful innocent is nostalgic at the core. What the hero defeats in the villain is evil as mortal limits—the loss of carefree childhood innocence to the complexity and corruption of adult life. The paradox of the powerful innocent is most pronounced in the adolescent, whose fantasy is to transcend the parental world while remaining safely within it, to perpetuate moral innocence into the real world of power and aggression. The sense of personal limits in an abstract society is assuaged by combining the hero's childlike moral purity and social isolation with the power of the adult, resolving complex problems in a single action. It is a fantasy of white and black hats, uncomplicated, unencumbered by mental conflict or uncertainty.

But the nostalgia is not confined to adolescence. The hunger Westerns satisfy, as Tomkins notes, is not for adventure but for meaning: "Life on the frontier is a way of imagining the self in a boundary situation—a

place that will put you to some kind of ultimate test." What distinguishes the hero from the rest of us is that "he never fritters away his time. Whatever he does, he gives it everything he's got because he's always in a situation where everything he's got is the necessary minimum." Ordinary life and work "never embodies what the hero's struggle to get out of the blizzard embodies: the fully saturated moment."[5] It is to such intensely engaged and present-oriented moments that nostalgia most often returns, moments that define our lives.

Behind all nostalgia, all transcendence, driving all art and science, is our awareness of death. As the leitmotif of the Western, the specter of death belittles our everyday preoccupations, prodding the nostalgic quest for meaning. The arid landscape of rock, sand, and scrub, where nothing seems to thrive, suggests that life must be seen from the perspective of death. Even the dusty towns, with names like Deadwood and Tombstone, isolated on the limitless land, their ramshackle sidewalks and storefronts rising, as Howard Fast wrote, "out of the short-grassed prairie like a rickety mirage," wavering in the heat haze, underscore the tenuousness of civilization, of life itself. In the vast scale of the land, with its great extremes of light and climate, its majestic upthrusts of rock, steep bare canyons, forested plateaus, lonely rivers, snow-covered peaks, flat red deserts, and huge nights of stars and silence, we feel our sublime isolation and the mindless indifference of nature. Yet it is this backdrop that lends transcendent meaning to the powerful innocent, who appears again and again to defend our fragile mortality, resurrecting our immortal child, tempering the present with the purity of the past.

Overlaying that personal nostalgia is our collective retrospect, a romantic ideal, notes David Thomson, that "caters to our yearning to get up there on the screen, into the picture and into the warmth of its day."[6] But the heroes are gone, the times unpropitious. In the deep nostalgia of an industrial society, the Western hero is a counter image so perfect that if he had not existed he would have been invented. The apogee of the fifties and sixties—the last great American watershed and the Western's golden era—was a coming of age, like a collective college interim, drifting between child and adult, projecting fantasies of heroic self-sufficiency.

Shane

In 1953, the classic Western reached its epitome in George Stevens' *Shane*, based on the novel by Jack Schaefer. With four Academy Award

nominations, it was the top Western of the decade, so popular that it was rereleased in 1957. Set in Wyoming in 1889, one year prior to closing of frontier, *Shane* reduces the myth of the West to its essentials: the tale of the mysterious stranger who wanders into a farming settlement and must finally defend it against the ruthless cattle rancher who controls the town.

Shane (Alan Ladd) is the familiar gunfighter with a violent past whose determination to avoid a showdown is at first misconstrued as cowardice. Hoping to break with his past, he accepts farm work with the Starrett family—Joe, Marian, and young Joey—but is soon embroiled in the conflict between the farmers and cattleman Ruff Riker. When Shane sheds his buckskins, puts on work clothes, and heads to town with Starrett for supplies, he is insulted in the saloon by the Riker boys and backs down. On a second visit, he and Starrett defeat them in a fist fight, causing Riker to send for a hired gun. The gunfighter, Wilson (Jack Palance), kills one of the farmers in cold blood and Riker burns one of the farms. Shane and Starrett convince the families to stay in the valley, but when Shane learns that Riker is luring Starrett to town to be killed, he dons his buckskins and rides into town that night, outdrawing Wilson and killing both Riker brothers. Wounded, he rides into the blue mysterious hills from whence he came, while little Joey, who had followed him into town and witnessed the showdown, yells into the mist, "*Come back, Shane!*" his voice echoing off the mountains.

While the plot is standard, Stevens' treatment is not. His talent lay in combining the purity of myth with meticulous realism. He did extensive research on Wyoming life and towns of the time, down to how firewood was stacked, and filled the kitchen with authentic antique western kitchenware. The sounds of birds, horses, cattle, and spurs are intentionally exaggerated, and the weather—sun, lightning, violent torrential rains—always fits the scenes. Stevens studied Remington and Russell paintings, giving the whole film a radiant Bierstadtian tone, even in moonlight. The town has none of the gilded saloons, can-can girls, debonair gamblers, or singing cowboys that were so common to early Westerns. The plain-board frontier saloon is dismal and dimly lit, with characters slinking in the background. The Rykers are not stock villains but real people whose conflict with the farmers is one between incompatible groups, each with plausible justifications. And the film breaks with the Western's long-standing convention that death is clean and without cruelty: The actor playing Wilson's helpless victim

was wired from the back and yanked when shot to show what actually happens when a high caliber slug hits the body.

The realism extends to the everyday lives of the little group in the valley. There is a fleeting moment of togetherness and respite when Shane, the farmers, and their wives enjoy a festive gathering, dancing and singing to "Goodbye Old Paint." The scene lingers in memory long after the film is forgotten, echoing some simple truth—the pith of the pioneer saga, the communal bonding of those who braved the mountain winters and windblown prairie, who left lives and loved ones behind to begin anew on the far ends of a vast and virgin continent. Another epiphanic scene, the funeral for the slain farmer, takes place on a hill overlooking the lonely town, a tiny row of frame buildings on the vast plain, the Grand Tetons, luminous in perfect light, rising up in the distance. The adults say their words while Joey wanders off to pet a colt.

Throughout the film, the mountains are visible in the background when Shane is in the frame, but are never seen with the villains. Majestic and remote, isolated and lonely like Shane himself, the mountains are the haven from which he descends and to which he ultimately returns. The melancholic stranger with no last name, no past, no family, and no friends, he is the fastest gun alive, his blank face and flat, expressionless eyes the wilderness incarnate. Serene and unworldly, as if no experience can really touch him, he is the mythic Spirit of the West.

While Starrett needs Shane's intervention to protect his farm, and Shane depends on Starrett's community for the sense of purpose he had lost, the opposite of both is Wilson, the black-clad hit-man with steel-cold eyes and a sardonic grin, who enjoys killing even those who are no match for his skill. When he walks, panther-like, his spurs jangling ominously, even the dog slinks out with his tail between his legs. Radiating menace, Wilson is a Spirit of Evil as metaphysical as Shane's embodiment of virtue. Yet Shane, with a past as dark as Wilson's, contains all the opposites inherent in the Western myth: nature and culture, freedom and limits, independence and connection, past and future, West and East, material and spiritual, the anarchic world of male savagery and the civilized world of woman and home. In the Western hero's attempt to bridge wilderness and civilization, there is always the implication that the backdrop of epic magnitude—the "yawning distances that seem to swallow sound and time," as William Athern put it—have some sort of regenerative power for the hero; while frontier

society, the limitations, the bareness, the pressures of obligation, leave him lonely, alienated, and suffering.

Shane comes, as Jane Tomkins said of Buffalo Bill, "in the guise of a redeemer, of someone who will save us," who will "lift us above our lives, out of the daily grind, into something larger than we are."[7] Yet the complex realities of modern life dictate that the hero of simple solutions, after giving us our moment on the screen, must ride off, having outlived his time and usefulness in both fact and fiction.

"Your days are over," Shane says to the cattleman.

"Mine?" says Riker, "What about yours gunslinger?"

"The difference is, I know it."

Like Shane, the West he represents is gone or never was, mourned in myth as the last moment in history when innocence and hope could carry the day.

The Real West

"What they dreamed we live; what they lived, we dream," wrote T. K. Whipple. But in truth the myth is an idealized representation of a small segment of American history. The brief moment of equilibrium between civilization and wilderness when outlaws and Indians posed a threat to the community's stability has been erected into a timeless epic, compressing the several wests—plains, mountains, desert, and Great Basin—into a stock formula town, Tombstone or Dodge City, with outlaws and desperadoes roaming the streets or engaged in saloon fights. In fact, most towns were places of peaceful monotony, the lone gunman a rare psychopath.

Writers fastened upon a few pockets of lawlessness—the cow towns, mining camps, boomtowns, and work camps that dotted the West—picturing them as typical when in fact the great mass of true pioneers were small farmers, ranchers, and entrepreneurs. Western mythology has attached its melodramas to a comparative handful of outsiders who sought quick money. Always ahead of the agrarian advance, hunters, trappers, cattlemen, miners, and squatters populated towns with names like Leadville, Chance, Tin Cup, Whiskey Spring, Royal Flush, Horseshoe, Hard Rocks, and Horsethief Basin. Such towns were more often an accident than a formed community, appearing overnight and disappearing almost as rapidly, "an eddy in the troubled stream of

western immigration," wrote Jenni Calder, "that caught the odd bits of drift wood and wreck, the flotsam and jetsam of a chaotic flood."[8]

At the core of the mythology stood the cowboy, yet the cattle towns were a minor chapter in western history. When Texans returned to their impoverished homes after the Civil War, there was nothing but the vast land and six million head of roaming longhorns. In 1866 they drove some 260,000 of them north in search of markets, launching a boom that lasted twenty years before it collapsed. The real cowboys, hired for the drives from Texas to the railheads in Kansas, were illiterate, uncouth, unwashed, unglamorous, and often so bored that they memorized the labels on tin cans and played games to see how well they could recite them.

Out of these drab historical figures, writers recast mythical icons, omitting the manure, the punching of postholes, the stringing of barbed wire, the branding, castrating, dehorning, dipping, and horseshoeing that filled the laborious and unromantic lives of real cowboys. As Robert Warshow noted in his seminal essay, "The Westerner," even the legendary names enshrined in myth turn out, in the grainy photographs of the nineteenth century, to be "blank, untidy figures posing awkwardly before some uninteresting building."

The Real Heroes

The true epic of the West is the story of what happened when ordinary people moved into an extraordinary land, the last migrants of the hundred-millennia journey, a massive wave moving westward at ten to forty miles a year—farmers planting the land, raising their shelters against the wind, building a continental nation from sea to sea. The settling of the West is the story of a drab and grim frontier, of people living in isolation, eking out an existence as ranchers and subsistence farmers, heroic only in their dedication to building a better life. The courage of the mythic cowboy becomes camp when compared to that of pioneers who left home and loved ones forever to trek westward with their covered wagons.

From 1840 to 1870, some 300,000 emigrants followed the Oregon Trail, walking most of the 2,000 miles beside wagons packed solid with food and belongings. Few but the sick would ride in the wagons, which had no springs or cushioned seats and shook so vigorously over rough, roadless terrain that balls of butter formed in the milk. The wagons

squeaked and groaned across the vast, uncharted sea of grass, a great empty waste devoid of shade or shelter, of trees or greenery, of houses or any sign of civilization. Water was hard to find and more often polluted, killing oxen and spreading cholera. To lighten the load for sick or exhausted oxen, many treasured possessions were left on the trail. The top-heavy wagons tipped over easily and broken wheels were near impossible to replace. One detoured for miles to find a tree large enough to replace a splintered axle. Crossing the water, wagons were wrecked on hidden boulders and quicksand, or broke loose from the team and floated down river. To eat anything but hardtack and bug-ridden bacon required hunting for food, digging a shallow ditch for a cooking fire in the relentless prairie wind, and burning buffalo chips for lack of trees. Mired in mud or choking on dust, weathering drought, sand storms, prairie fires, blizzards, and hail the size of apples, parties were besieged by snakes, mosquitoes, stampeding buffalo, and marauding Indians. Many were bitten so many times by mosquitoes that the blood could no longer clot. When they gathered at night, the songs were about home, love, and death.

One in ten died along the way. Children fell from the wagons and were crushed beneath the massive wheels. Hundreds were swept away and drowned while trying to cross raging rivers. Most deaths were from starvation or disease—typhoid, dysentery, smallpox, scurvy, malaria, and above all, the dreaded cholera. The vomiting and diarrhea from polluted water could mean death in a single day. Wagon trains sometimes lost two thirds of their people. Often the sick were abandoned in their beds on the side of the trail to die alone. Some diaries speak of almost nothing but death and burial. "It was no unusual sight, wrote one traveler, "to see a wagon or a small group pull out to the side of the trail and begin to dig. Sometimes we joined the sad little group that stood shivering and sobbing in the spring sunshine. After a few minutes, a silent form would be carried from the wagon. Sometimes there would be a rude, box coffin; more often, only a blanket or patchwork quilt." A short prayer, a shallow grave filled in, and the mourners and wagons would go on their way.[9] Gravestones were signposts to the way west.

Those who survived the trip faced hard first winters with no summer crops to live on and little money left. The towns had names like Wagon Wheel Gap, Mud Butte, Loco Hills, Lost Cabin, Lone Tree, Cactus Flat, Bitter Creek, Chalk Buttes, Skull Valley, and Hell's Canyon. Thousands settled in sod houses on the Kansas-Nebraska prairie, leading solitary

lives of hard labor in a vast and vacant wilderness. The isolation and ceaseless howl of the wind brought depression, insanity, and death to many women. In the sorrow and courage that created the West, there were no teacup tragedies. Yet most pioneer women were tough and resilient, holding on to hope, seeing the frontier as a new beginning. These were the true heroes of the West, along with the farmers who tamed the wild land in the wake of legendary frontiersmen like Kit Carson.

As a major agent of western expansion, Christopher Houston "Kit" Carson embodied the frontier in the American mind. "When the West was still a mystery to most of his countrymen," wrote Michelle Ferrari, "few white men knew the vast landscape so intimately or understood the ways of its native peoples so well." Born in Kentucky, he set out at age sixteen from Missouri territory, then the western edge of American civilization, beyond which lay another world. He spent ten years as a mountain man and trapper, eventually guiding John Fremont's expedition to map the overland route to the Pacific that would later become the Oregon Trail. In the end, he had surveyed some 5,000 miles and it was said that there was "no trail he hadn't traveled and no wilderness challenge he couldn't meet."[10]

He knew how to find water, read the terrain, and deal with the Indians, many of whose languages he spoke, having lived among the Arapaho and Cheyenne and married an Arapaho woman named Singing Grass. He sided with some tribes but saw others as enemies. He was called "Father Kit" by the Utes but carried out an order to conduct a scorched earth campaign against the Navajo, driving them from their homes in a long march on which hundreds died, an event he soon realized to have been a terrible mistake. A man both violent and compassionate, Indian fighter and Indian protector, he later became an elder statesman of Indian affairs, insisting that relocations be confined to tribal homelands.

Fremont's extensive praise of Carson in his best-selling accounts of the Oregon Trail, which were used as guides by settlers, made Carson a romantic figure in the public mind. Trapper, mountain man, explorer, frontier guide, cross-continent courier, and soldier in the Mexican and Civil Wars, Carson became the greatest living example of the American tendency to mythologize the West. *Kit Carson: The Prince of the Gold Hunters*, written by an Eastern hack, the hero bearing no resemblance

to the real Carson, was the genesis of the dime novels and the first of seventy popular romances about him. He was like the West itself in that people projected their own images and beliefs onto him. In his late fifties, exhausted and near death from the constant string of missions assigned to him, and longing to return home, he visited his newborn child only to have his wife die in his arms.

There was a moment in the life of Kit Carson when myth and reality met. He was on a mission to rescue a woman named Ann White, who had been kidnapped by Apaches, but who was killed when they spotted him approaching. Near her still warm body was that first dime novel about Carson. In it he rescues a woman from Indians. Carson, who couldn't read or write, was unaware of the novel and was stunned when it was read to him. Feeling that it had given her false hope, it haunted him for the rest of his life.

His death in 1868 at age fifty-nine, as his doctor read to him from Carson's first biography, was perfectly timed. He had no place in the new West—the west of the railroads, the slaughter of the buffalo, the Indians last stand—yet he was critical in creating a continental nation. His life reflected all the contradictions of western expansion; and if his legacy is at times uncomfortable for Americans, it is because he is an inherent part of who we are.

If the legend of the West is in many ways overly romantic, shallow, inaccurate, and racist, why, if not for those very reasons, does it still appeal? We romanticize a mythical West that never was, longing not for the hard facts of pioneer life but for the infinite potential of open land and unlimited option beyond the labyrinths of bureaucratic and technological constraint. We long for a sunrise over mysterious mountains and uncharted rivers, for the exhilarating adolescence of America, when the future stretched away to forever. We long, that is, for the lost clarity of our own youth, for a time when innocence and hope could carry the day.

Roy Rogers

He was born Leonard Franklin Slye in a Cincinnati tenement to a part Choctaw-Indian shoe-factory worker and his wife. He grew up on a houseboat in Portsmouth, Ohio, and on a farm in rural Duck Run. In 1930, the Slyes migrated to California in a '23 Dodge, *Grapes of Wrath* style. He drove a truck, picked fruit, and sang around campfires. He barnstormed the Southwest with country-western bands, and by the time he made a movie, *Under Western Stars* in 1938, he had become Roy Rogers.

He became, as *People* magazine said, "the gentlemanly, plainspoken hero with virtues as solid as the fists he used in fights he never started—and never lost—and a smile as ready as his six-shooters." His boyish backwoods grin graced 86 films, 100 TV episodes, and more than 400 products bearing his name, racking up $1 billion in sales. In the course of it all, he lost his first wife and three of his ten children to illness or accident. "Well, Lord," he said as he lay dying, "it's been a long, hard ride."

I heard the news and thought, "My God! Even Roy Rogers is gone!" Jack Benny and Red Skelton were gone, and Eddie Cantor, and Bing Crosby with his "White Christmas." And Gene Kelly singing in the rain, and Durante, exiting from spotlight to spotlight with his "Good night, Mrs. Calabash, wher*ever* you are!" And now—my God!—even Roy Rogers was gone. One by one, we lose those familiar lights and

romantic heroes, the fires of our youth that linger like embers through the "long, hard ride."

They stuffed Trigger and put him in the Roy Rogers museum in Victorville, California, to rear up forever. I thought, "maybe they'll stuff Roy."

We were immortal, Roy and I. He made his first movie the year I was born. And now he was dead. Even Roy Rogers was dead.

It wasn't just somebody's name. It was RoyRogers.

RoyRogers.

RoyRogers.

6

The Last Locomotive

Like the giant reptiles, the great steam locomotives no longer roam the earth. Those massive hulks of sooty iron, cluttered with snarls of piping and valves, were the consummation of crude mechanical power. Though technology, like evolution, has since turned from quantitative to more qualitative experiments, many still recall boyhood treks to the station to watch the snorting monster come wailing out of the night like a stricken beast, its swivel-eye flashing and the beam darting crazily about. As it coasted the last quarter mile, its dark shape looming ever larger, one was aware only of the earth's tremor, then the pounding side rods, a fierce hiss, and an insane symphony of squeals. Suddenly it stood motionless against the stars. The earth strained against its weight. A slow and even panting—*pam-pah, pam-pah*—whispered enormous tension, fantastic power. And with a glow of hellish fire from the very soul of the machine came a rhythmic surge and release, like the sub-bass of a cathedral organ—whohhh-*whump*. They were impatient sounds; one felt the monster must move on or explode all over to the countryside. Perhaps an endless stretch of rails lay ahead, rising and failing over hills and valleys, through all the cities, hamlets, and outposts of the world.

Small-town boys snuck off to the depot to see the machine's great dark mass paused against a moonlit landscape, to hear the hiss of the injector, the roar of the flames dancing in the firebox, and the uneasy rhythm of the compressor. It was as if the iron spirit of Yankee know-how had taken mortal form somewhere out on the dark land—a firey, black behemoth of uncertain intent—bursting on the town like some nightmare visitation, only to vanish again into the night.

If the symbol of nineteenth-century England—with her princely isolation from the squabbles of Europe, her long tradition of self-government, and her dominion over the sea—is the clipper ship under full sail, the image of nineteenth-century America is the steam locomotive, careening full throttle across the open plains. Not only did this noisy iron brute, with its fire, soot, and belching smokestack, personify the Age of Steam, but the energy, bigness, and intensive work, the obsession with time, and the straight and narrow practical mission made this ultimate crude machine—the apotheosis of barnyard tinkering—the classic American icon.

In 1825, when the seventy-six-year-old John Stevens built the country's first locomotive in his back yard, America was a society of informal, locally autonomous, island communities. To reach the outside world, one traveled in clumsy wagons over path-like roads and drifted down broken stretches of waterway. By the 1870s, a vascular system of rails had created a national market, and the term "United States" was no longer plural. By speeding the pace of westward movement, and by creating vast new markets for mass produced goods, the railroads, more than any other factor, accelerated industrialization and urbanization in nineteenth-century America. The railroad not only created the new economic order but was itself the first oligopoly, and thus the first object of federal regulation and the first major battlefield for organized labor. The railroads raised cities in the wilderness and left bypassed towns in economic ruin. Preferential freight rates produced oil and steel barons while keeping the South in preindustrial poverty. And at every point where the railroad touched and transformed the nation, its symbol was the steam locomotive, personifying not only the headlong advance of the railroad empires but the unbounded force of industrial expansion itself.

As though aware of their allegoric function, the locomotives grew ever larger and more powerful, Union Pacific's "Big Boy" reaching three quarters of a million pounds, while the Mallet Triplex, with its 24 driving wheels, produced nearly 200,000 pounds of tractive force; and

the wheels on some stood seven feet high. Out of the huge foundries of the Baldwin, American, and Lima locomotive works rolled these titanic machines, embodying a new breed of businessman, a new civilization, reaching westward, driven by the Puritan vision of the New World "City on a Hill."

The locomotive incarnate was James J. Hill, builder of the Great Northern Railroad, a violent, rough-hewn, thickset, one-eyed man with a massive head and long, shaggy hair, alternately called the "Empire Builder" and the "grim old lion" of the great West. Born with nothing, Jim Hill became an intolerant despot with incredible energy, a frontier character in a frock coat who died with fifty-three-million dollars. The last and greatest of the railroad Titans, Hill was no armchair mogul. He had an encyclopedic knowledge of the harsh, desolate, northern regions spanned by his transcontinental rails. When Great Northern's twentieth-century streamliners whistle "for two thousand miles across the top of the United States," said Stewart Holbrook, "the echoes scarcely find a swamp nook or a mountain valley that Jim Hill himself did not know at first hand." He would climb down from his private railroad car in a blizzard to crawl under a stalled locomotive, or to relieve one of the older shovel-stiffs, all of whom he knew by first name. And when he said "Give me enough whiskey and enough Swedes and I'll build a railroad to Hell!" he captured the romantic image of rugged American expansion.

But on the underside of the vision, the railroads dominate the imagery of American folksong, representing the restless mobility of the uprooted souls who drove the spikes only to ride the boxcars of Hill's "railroad to Hell." Deep in the national memory is the clickityclack of frantic migration, and the long, lonesome whistles fading into the distance, leaving the countryside in eerie silence. "The blues," wrote Alan Lomax, "might be said to be half-African and half-locomotive rhythm."

> The blue-noted whistles made a man miss pretty women he'd never seen. Boys in hick towns, lost on the prairie, heard the locomotives snorting and screaming in the night and knew they were bound to small-town stagnation only for the lack of a railroad ticket.... Americans had always had an itching heel. When railroads came along, they began to travel so far and so

often that, in the words of the old blues, "their feet got to rolling like a wheel, yeah, like a wheel."[1]

Railway songs reflect the two faces of railroad history. The blacks, coolies, and hard-drinking Irishmen who laid the rails are long forgotten. Their memorials, as Lomax said, are the ribbons of glistening steel that span the continent like a great harp; and their epitaphs are the wisps of song that linger over the land: "In eighteen hundred and forty-seven / Sweet Biddy MacGhee, she went to heaven / If she left one kid, she left eleven / To work upon the railway."

The archetypal hero of the railroad's underside is John Henry, "the steel-drivin' man," a six-foot, two-hundred-pound black who helped build the Big Bend Tunnel on the C&O road. In the early 1870s, the C&O was pushing its line through the most rugged part of the mountainous West Virginia wilderness. The mile-and-a-quarter tunnel, cut through solid rock, is only a minute of lost reading time when flashing through on a modern train. But at the time it was the most difficult tunnel ever cut by man. Tunnel blasting was a dark, hot, murky, foul-smelling process. The high ring of hammers on steel echoed through the cave above the work chants of hundreds of blacks, their bodies gleaming in the dim flicker of burning lard oil and blackstrap. Such infernos could kill four hundred horses and half as many men, and the ring of steel hammers was said to haunt the tunnels.

Using a twelve-pound hammer, John Henry sunk six-foot spikes into the rock to make holes for the explosives. Witnesses said he could out-sing and out-drive any man on the job, and could go ten hours without missing a stroke. "I'm throwin' twelve pounds from my hips on down / Jes' listen to the cold steel ring!" When the foreman brought in the newly developed steam drill, John Henry challenged it to a race—a black David against the industrial Goliath. John Henry "drove fourteen feet while the steam drill was drivin' only nine," and he cried, "You can't drive steel like me, Lawd, Lawd, you can't drive steel like me!" "He drove so hard," says the song, "that he broke his poor heart, and he laid down his hammer and he died." In truth, he was killed sometime later, crushed by a slab of falling rock, and probably dumped with the other dead men, mules, and horses into the fill between the mountains.

They took John Henry to the tunnel
And they buried him in the sand

And every locomotive come roarin' by,
Says, "There lies a steel-drivin' man."

As the hero of the railroad's underside, it is appropriate that John Henry triumphed over a steam-driven machine. But on the upbeat side, where success stories like that of Jim Hill and his Great Northern reflect American energy, optimism, and faith in technology, the archetypal folk hero is Casey Jones, the "brave engineer," who must "bring her in on time" or die at his post "with the whistle in his hand." If John Henry was the victim of industrial society, Casey Jones was its champion. In his blue, pin-striped overalls, with a solid gold watch chain, a red bandanna around his neck, and a wad of tobacco in his cheek, the brave engineer was once the hero of American youth. Keen-eyed, his soot-lined face tanned to leather, he risked washouts, defective rails, and bad bridges in an age without modern signaling systems. Supplanting the soldier and the sea captain, and anticipating the astronaut, he was the man with "the right stuff," racing his great machine through the stormiest night to bring her through on time. Farmers set their clocks by the train whistles. It was the railroads, in fact, that divided a reluctant nation into four time zones. The obsession with punctuality makes little sense unless one grasps the extent to which the train became the symbol of time as America sought to impose order on its new urban-industrial sprawl. It was as if the country were forever checking its steel pulse, fearing for the vitality of the great industrial golem wrought by the railroads. To be "on time" was the engineer's sacred mission. He put her through or failed spectacularly, to fade into folklore with the cowboys, sailors, loggers, and bandits of American balladry.

John Luther Jones, called Casey because he came from Cayce, Kentucky, drove the Illinois Central's crack passenger run, the Cannonball Express, between Memphis, Tennessee, and Canton, Mississippi at the turn of the century. A lanky, black-haired, gray-eyed, six-foot-four Irishman, Casey loved to lean out and see the side rods of his engine moving so fast they looked solid.

Little more steam an' a little more coal.
Put your head out the window, see the drivers roll.

Engineers were known by their whistles, and Casey could make his talk. The country blacks along his route loved to hear the shrill, minor

The Best of Times

keyed "KAAAAAAAAA SEEEEEEEEE JOOOOOOOOOONES" moan across the Mississippi night. The big, laughing Irishman, roaring recklessly past their fields, was the image of power and freedom.

> The switchman knew by the engine's moans
> That the man at the throttle was Casey Jones.

Late on a spring night in 1900, Casey finished his run into Memphis and was asked to return the 188 miles to Canton, replacing a sick engineer on a train already 95 minutes behind schedule. The bighearted Irishman agreed, provided he could use his own locomotive. Roaring south in a heavy rain, he made up 60 of the 95 minutes in the first 100 miles.

> I'm going to run her till she leaves the rail,
> Or make it on time with the southbound mail.

Heading for Vaughan, 14 miles north of Canton, he had cut his lost time to two minutes. He stood up and hollered to his fireman over the boiler head, "Oh, Sim! The old girl's got her high-heeled slippers on tonight. We're going into Canton on time!" It was the last thing he ever said. At Vaughan, a southbound freight moving onto a 1000-yard passing track had lost a coupling hose and left four cars on the main line. Casey's Cannonball thundered into the curve approaching Vaughan, his drivers pounding the polished steel at 70 miles an hour.

From his side, fireman Sim was first to see the red lights of the caboose up ahead. "Look out! We're gonna hit something!" he yelled, and swung down low off the locomotive, jumping for his life. He heard Casey kick the seat out from under him and grab the air brakes, slowing the train to 50 miles an hour when Sim leapt. By the time the engine plowed through the caboose, Casey's engine-handling skill had slowed the train to a speed which left no passenger seriously injured. Only Casey was dead, lying in the overturned engine with one hand on the air brake, one on the whistle, and an iron bolt through his neck. "The marvel and the mystery," wrote one reporter, "is how Engineer Jones stopped that train. The railroad men themselves wondered at it." It was left for Wallace Saunders, a Negro engine wiper who cleaned up Casey's cab after the wreck, to put the event into song.

Fireman jumped, but Casey stayed on;
He was a good engineer, but he's dead and gone.

Yet it was John Henry and not Casey Jones—the hobos, drifters, and steel-drivin' men rather than the dutiful engineers—who inherited the music of the rails. American folksong has always leaned toward tales of the common man beating the raw land into shape.

If I die a railroad man,
Go bury me under the sand
With a pick and shovel at my head and feet
And a nine-pound hammer in my hand.

The "insistent hammer of steel wheels is the bass note in the fugue of the American struggle," wrote Kenneth Allsop; it has shaped and colored American music itself, "the train rhythm boogie of wandering saw mill and turpentine camp pianists, the desolate rasp of a hillbilly harmonica blowing like a whistle."

More common to railroad songs than steel drivers and track liners are the solitary migrants, haunted by the sound of "a lonesome freight at 6:08, comin' through the town." Sometimes unloved ("The longest train I ever did see / Was a hundred coaches long / And the only woman that I ever did love / Was on that train and gone"), sometimes lost to those who loved them ("I looked down that track, far as I could see / Little bitty hand was wavin' after me"), their lyrics longed for faraway places, for things lost, for the inexpressible. They were songs of restive discontent, of that "bittersweet sense of immense emptiness ahead and behind," songs to accompany the rhythm of the wheels and the long, lonesome whistles, lost on the wind.

Heeeeeeeaaarr the whistle blo-oooow
Clickity-clack, clickity-clack,
The wheels are sayin' to the railroad track,
If y' go y' can't come back,
If y' go y' can't comeback.

It is ironic that the railroad became the icon of the alienated, having begun as the image of cultural progress. Allegorizing the rapid invasion of industry in the nineteenth century, the sudden intrusion of

the locomotive upon an idyllic, arcadian landscape has been a common theme in American literature. "But, hark! there is the whistle of the locomotive," wrote Hawthorne, "the long shriek, harsh, above all other harshness.... It tells a story of busy men, citizens, from the hot street, who have come to spend a day in a country village, men of business; in short of all unquietness." The whistle penetrated Walden "like the scream of a hawk"; "we do not ride on the railroad," complained Thoreau, "it rides upon us." But if Hill's "railroad to Hell" was taken literally by romantic dissenters, as in Hawthorne's "The Celestial Railroad," most nineteenth-century Americans saw the locomotive not as a hissing serpent defiling Eden, but as the snorting steed astride which man would triumphantly reenter Paradise. The ultimate compromise between these visions of Paradise-lost and Paradise-to-be- regained was to view the Machine not as the invader but as the creator of the Garden. From the outset, the myth of the virgin American land as the New Eden—a new beginning for mankind—was threatened on one hand by the reality of a hostile wilderness, and on the other by the encroachment of technological society. The salvation of both the Machine and the Garden lay in the view that technology had in fact imposed an Edenic order on the wilderness, inaugurating a pastoral "middle way" between savage nature and decadent civilization. The theme of the "machine in the garden," as Leo Marx calls it, has been rife in American art and literature, where the machine has most frequently been the locomotive. One of the better examples is George Inness' painting *The Lackawanna Valley (1854)*, where an unobtrusive little train puffs through an arcadian landscape like some benevolent robot come to administer the millennium.

The evolution of the railroad from the object to the icon of alienated dissent parallels the cultural shift from the age of steam to that of electricity. The former, associated with coal and iron, was based primarily upon the steam engine, while the latter, associated with such things as alloys, synthetics, elasticity, electronics, and automation, was born with the dynamo. In the steam age, the machine was a super-beast of burden requiring the physical degradation of men for its operation; the tasks accomplished were primarily those which could have been achieved by a sufficient quantity of manpower; most machines were but an extension of man's larger muscles. Early in the electrical age, on the other hand, machines began to do things that no quantity of men could do, becoming not only extensions of the finer muscles, but of the

eye, ear, and even the brain itself. Mammoth mechanical brutes like the locomotive, the essence of which did not extend much beyond the valves, pistons, and vapors visible to the eye, gave way to small and delicate contrivances with obscure magical powers such as the ability to duplicate the human voice, capture living motion on a two dimensional surface, or dispel darkness at a finger's touch. In place of the traditional image of crude power achieved through complicated snarls of tubing, valves, and cogwheels, was a new concept of the machine: the achievement of spectacular ends through inconspicuous means. The heat, sweat, and grime of the steam age gave way to images of the electronic age: the glistening, flawless, indestructible, mathematically perfect shapes of mass-produced alloys and synthetics, the cool glitter of a metropolis at night, the ballet of the astronaut on the surface of the moon.

By the 1960s, the steam locomotive had become a quaint, nostalgic image, while the railroads themselves fought for survival in an age of internal combustion and jet propulsion. An irony of history is that the steam locomotive became a mechanical counterpart to John Henry, losing the race to the far more economic diesel, a coffin-shaped rectangular solid emitting a monotonous hum, probably designed by a no-nonsense, cost-cutting committee from a quick sketch out of some bureaucratic suggestion box. Resembling a real man's paper weight more than anything else, it represented the kind of functional outlook that might date the New Age from the inception of margarine or plastic flowers. In contrast, the steam locomotive had an individuality; each railroad designed its own engines, and the duties of each were highly specialized—from squat switchers, puffing and bellowing as they reshuffled cars, to the mighty freight locomotives, sending their smoke and steam to the heavens as they thundered out of the yards. There was something prim, delicate, and feminine about these powerful, rugged machines. "With a skillful hand at the throttle," reminisced one engineer, "a steam engine would almost seem to prance as it took off in a cloud of smoke." And like faithful horses, they were responsive to proper care, performing beyond their designed capacity in times of emergency. Yet the hard economic fact is that by the time the diesel took over, the steam locomotive had outlived its age by three decades.

Although the number of steam locomotives had peaked at 65,000 just before the first diesel was introduced in 1925, the real decline began in the late 1940s when wage-price spirals pushed the operating costs of the railroads beyond the rates allowed by the ICC. Then came the

coal strike, raising the price of coal to prohibitive levels and virtually shutting down the railroads. General Motors began to make diesels. Diesels neither burned coal while they sat nor hung a pall of smoke over the city. They had interchangeable parts and were all-purpose; one diesel could perform the tasks of every type of steam locomotive, which cut switching costs in half. The steam locomotive was a flailing wildly plunging mechanical monster, guided only by the rails. The massive side-rods churned and pounded the drivers against the track, requiring huge crews to repair the beat up rails and roadbeds.

In June, 1948, the American Locomotive Company built its last steam locomotive, becoming the first to produce only diesels. The last built in the United States for main line duty was delivered by Baldwin to the Chesapeake & Ohio in 1949. The prosperity of the mid-fifties brought a new wave of diesels, forcing the retirement of most steam locomotives by 1957. In long funeral processions bound for the steel mills, the old veterans of the rails were led over landscapes that had echoed their rhythms for as long as anyone remembered. "Now only the slow droning of the diesel at the head of the train could be heard," wrote a photographer of the event, "while the dead engines squeaked and groaned and swayed as the train moved slowly along."

The greatest of the steam locomotives were the 386-ton Union Pacific Big Boys, which ruled the Wasatch Mountains and the high plains of Wyoming for two score years. One day in July 1962, on the outskirts of Cheyenne, the last Big Boy, eating coal by the thousands of tons and evaporating water into steam by the millions of gallons, went to pasture. It was a symbolic moment. On the eve of a disastrous decade, America stood at her peak in the cycle of empires, transformed from a scattering of settlements in a few generations largely by this one simple machine.

Yet its passing was unnoted. Now the small boys watched shimmering jetliners float gently to earth. Or perhaps they only saw them on television. Like the astronauts who went all the way to the moon but could not touch it, TV has spawned a whole generation of terrestrial astronauts who cannot touch the world. Their elders, meanwhile, recall the steam locomotive as the last great crude tool that man held with his naked hand. One could *witness* the transfer of power from steam cylinder to pistons to straining side rods to six-foot driving wheels; one could *feel* the reverberations, *hear* the screech of the flanges on the rail, *smell* and *taste* the tang of smoke.

Suddenly they were gone. A mythic trace hung in the air, floating in the wind like the white feather of steam at the turret, or the side-rod rhythms of a hobo's harmonica. A few hundred were saved, making tourist runs from museums. But like the sterilized display in the Smithsonian, they are corpses polished and painted beyond recognition by the mortician. Model railroaders support a multitude of clubs, shops, and magazines; but the models will never chuff, belch, clang, and scrape through the mountains, pulling 130 cars from Omaha to Cheyenne. And there are no boys at the crossings with visions of faraway worlds as they watch the rumbling, clacking boxcars marked LACKAWANNA, ROCK ISLAND, ROUTE OF THE EAGLES, GREAT NORTHERN, DENVER AND RIO GRANDE, FEATHER RIVER ROUTE, TEXAS PACIFIC, and THE ROUTE OF THE PHOEBE SNOW.

Yet the old men in their engineer's caps run their model trains in the old mail room of the depot. The O-gauge locomotives go round and round and round and round. In and out of the tunnels. In and out, in and out. Here the meaning of things is frozen in timeless perfection—no surprises, no ambiguities—like the bright engine in the Smithsonian. They know that their iron idols have passed, with radio serials and traveling circuses, into the freeze frames of Americana, and that even the aura lost its life once the locomotive, like buffalo nickels and breakable records, was no longer a common fixture. And perhaps they agreed with Arlo Guthrie, when he sang farewell for the "City of New Orleans": "All the towns and people seem / to fade into a bad dream." But like the steel rail that "still ain't heard the news," they will never catch the conductor's line, "this train's got to disappear in railroad blues"[2]

As the engines gather rust in the long grass, the men who rode them pine away on the back porches of America, the old dreams dissipating with the smoke of cheap cigars, like that wisp of idle steam at the turret of the once-proud machine. In their youth they had lain awake listening to the whistles fade into the unfathomable expanse beyond small-town nights. The locomotive was to the continent what the moon was to the cosmos: a piece of the infinite mystery passing nearby. But just as the railroads had reached the Pacific only to close the frontier and spawn Los Angeles, so the monster Saturn rockets put man on the moon only to destroy its mystique. Both are examples of historical eversion—of a process reaching its extreme only to become its opposite. At the end of a four-hundred-year conquest of nature, the late twentieth century turned from outer toward inner space. From the barren, gray expanse

on the lunar Sea of Tranquillity, "Spaceship Earth," floating in the black sky, had been the only colorful object in sight. Perhaps that final phallic act, tearing man from Mother Earth, ended his adolescence. And as the astronauts looked back through space with a deeper sense of man's identity, we also looked back in time to a lost innocence at the dawn of that adolescence, when the locomotive engineer was every boy's hero and the moon was still far away.

Our idealized past was indeed an expansive, optimistic age—a product of the four-hundred-year boom produced by the per capita increase in land and bullion following the discovery of the New World. It gave man the audacity to tear the earth from the center of the universe and to impound both nature and society in a watchwork world. It was an age of rash confidence—the adolescence of the West—devoted to reason, progress, and the perfectibility of man, but obsessed finally with power, nationalism, romanticism, and revolution. What better legacy than the locomotive—dark, steaming hulk, builder of nations, yet powered by precise forces, paced by a pocket watch? It could have been conceived by Newton, designed by Franklin, and orchestrated by Beethoven, embodying both the spirit of Napoleon and the soul of the Jacksonian common man.

We long for the lost innocence of our collective childhood. By the 1950s, the fragmenting, depersonalizing effects of modernity had reached the man in the street and nostalgia permeated mass culture, from adult Westerns, biblical epics, and Disneyland's Main Street, to the dream of pastoral suburbia and the reemphasis on God, country, and family. Thus the locomotives loom out of the past, sent to the steel mills in the same decade that value consensus was being relegated to campaign speeches and children's literature, the antichambers to oblivion. When we try to recall the last twilight image of American innocence, it is the steam locomotive that looms largest in collective memory, put to pasture at the very moment when all our myths were fast evaporating.

It is the function of symbol and myth to resolve rationally contradictory cultural values into a single paradoxical reality. The "machine in the garden" remains the most apt description of an image in which the drive to power and the vision of technological utopia are harbored within the safe consensus of a universe familiar as an old song. It is the incongruous image of a millennial mission within an eternal Eden, the hope of escaping history while taking refuge in its

preordination. The aura lingers ghostlike in and about the abandoned piece of machinery, tombstone to a vanished age, gathering, as one mourner wrote, the "brown-red rust of many seasons, the wind out of a bleak fall sky flapping the remnants of its cab curtain, rustling the weeds around the driver flanges."

Perhaps she retains in her molecules some memory trace—some holographic image of sitting at the station awaiting her last run, alive with the whisper of leaking steam, the thumping talk of cross-compound air pumps, and the full-throated roar of her open blower. Then came the relentless hammering of her heavy bell, and a great, heaving *chuff.* And another. And another, and another, belching smoke to the heavens. She could be the last steam train pulling out of the modern age, hauling a hundred cars laden with the leftovers of an abandoned era: flat cars full of hulking iron machinery, hoppers heaped with wood stoves and washboards, a parlor car lilting with ballroom dancers, a club car crowded with corner druggists and country doctors. On the platform, a suspended old stationmaster peers over spectacles at this pocket watch as he enters the departure in his large logbook.

To the east, the first stars hang in the deep purple sky like the lanterns of some celestial stationmaster whose heavy ledgers hold the fate of each life. The Rotary band plays Sousa's "King Cotton" march as the caboose recedes with the old brakeman on its back porch, puffing his cigar and tapping his hightop shoe. Out from the town, past the scrap yards, onto the open land clatters the old train, rolling out under a harvest moon (big yellow moon, old devil moon, not gray desolation littered with NASA's debris), moving along a moonlit lake, out across the western horizon, bisecting heaven and earth against a red sky. Then inching into the dark hills, and gone. Vanished forever, like those fresh green forests along the Atlantic, and the buffalo on the plains. And far away, over the rustle of dry grass, a long, ghostly whistle, lost on the wind, leaving the land in desolate silence.

Old George

In 1946, the summer I turned eight, old Uncle George moved into our house in Palo Alto. He slept in the cellar, down steep wooden stairs descending to a cement floor below the dirt crawl spaces. A long chain of knotted string stretched from a bare bulb to his bed, where he slept in his long underwear and hat, ever ready, perhaps, for his departure from the world. We later built him a small house in the backyard. Though he seldom emerged, I would sometimes encounter him in his rumpled coat, high-top shoes, and fedora, sitting out on our porch under a red sky in a cloud of cigar smoke. He would tell me his bad jokes or his stories of old San Francisco and the Barbary Coast before the quake of '06; and on rare occasions when he was appointed my sitter he would talk on into the night about the strange habits of ants and the speed of the Earth through space. One night he told me about the canals on Mars. They might have been built, he said, by an older, wiser civilization heroically trying to delay extinction. It was a wondrous image, a fire in a small boy's mind.

George had been a locomotive engineer on a local railroad, living all his life with his mother and brother. When they died, he came to reside with his sister—my grandmother—who lived with my father and me in a two-story white house on Lincoln Street. Sometimes I walked with him to the train depot where he liked to sit on a bench in the sun, always stopping at Bennington's Cafeteria for lemon meringue pie. With his large nose, elephant-size ears, white whiskers, and scruffy clothes, the long underwear protruding at the sleeves and cuffs, it must

have looked to some like I'd been abducted by a street person. On those walks, he could be a fountain of facts, holding forth with his tinge of Scotch brogue on who the streets were named for, the origin of "okay," and the length of a day on Jupiter—talking always as if to himself for his own amusement. At the depot, the great steam engines came and went. When he was not interpreting the sounds they made at rest or offering a bit of local history, he sat cross-legged, silent and remote. Like those iron behemoths, his outer armor housed an inner tension.

In our garage was a battered suitcase filled with his old tools, the wooden handles charred from the great San Francisco fire. When I used them to build a crude train from wood scraps, it so offended his penchant for perfection and love of trains that he determined right then to instruct me in use of tools. By age ten I was a passable carpenter. One day, after lemon meringue pie, we bought a baseball and he taught me to pitch. His knowledge of the sport was encyclopedic. He passed many hours in our backyard on an old canvas deck chair with faded red, green, and yellow stripes, listening to the ballgames on the radio, the sound turned up to distortion. He loved the marches played between innings, especially Sousa's "Second Connecticut," with the drum interval followed by the whole band reprising the tune, cymbals clashing, horns blazing, and the piccolos running up and down the scale. I bought a 78 rpm album of marches, sometimes playing them out my upstairs window when he was in the canvas chair. He'd nod and puff on his cigar, perhaps recalling his boyhood, running with the parades down San Francisco's Market Street, whistling the tunes.

Some evenings he sat at a small table in the kitchen while my grandmother did dishes, always in his fedora. We'd hear the story again of how at age thirteen he struck out "fourteen fellas in a row" in a sandlot game with boys five years older, or how he'd invented the egg slicer, only to find that it already existed. He had a habit of "squaring" the ash trays and other items on the table, aligning them at right angles, which I loved to pass by and mess up, but he'd just nod, chuckle, and restore it.

We moved to one of the new houses on the expanding edge of Palo Alto in 1951, and George occupied what was intended as a maid's room, connected to a back pantry that led to the kitchen. He used the back door off the pantry and since there was no longer a table in the kitchen, we saw little of him. But by then he had also moved to a back room in my teenage mind. In fact, his eccentricities and curmudgeonous comments (anything questionable was "*use*less!") became a source of humor I shared with my friends. My friend Tom and I once came upon

him reinforcing a massive gate with a thin strip of balsa and two bent nails. "*That* oughta fix it!" he declared, his carpentry skills apparently in decline. Tom mimicked the phrase forever after. And when one of my out-of-town friends wandered up our driveway, suitcase in hand, he encountered the figure of George waving his arms and shouting a gritty, "*Naw!* G'wan! G'wan! Git *outta* here!" until my grandmother called him off like a dog, explaining that my friend was not an intruder. Doglike, too, was his reluctance to cross the kitchen threshold and set foot in the rest of the house. If he had something to report with no one in the kitchen, he would go to the threshold and call out in that tinge of brogue, "Yaahs! Yaahs!" hoping someone was within earshot.

One cold December morning I awoke to the sound of my grandmother's heels hurrying down the hall past my room to my father's door.

"I can't wake George!" she called.

My father went down the hall in his pajamas, my grandmother following and I behind her—through the kitchen and back pantry to where George lay in bed in his long underwear and fedora. I stood in the doorway while my father fetched a small mirror and held it to George's nose. It didn't fog.

"He's gone," he said.

I had never seen a dead person. The white-whiskered figure in frayed underwear, lying so still, seemed to belong with the dingy austerity of the room—the linoleum floor, the warped dresser he'd varnished in rough swirls with a ten-cent brush, the old side-loading toaster that often sent the aroma of burnt toast into the kitchen.

I downed a bowl of cereal and walked to the corner to wait for the school bus with my friend Tom, neglecting to mention George until the black hearse went by. "There goes old George," I said, my breath fogging in the icy air.

"*That* oughta fix it!" said Tom, watching in wonder as the hearse disappeared.

That night I awoke to a sound of footsteps shuffling down the long hallway and what sounded like "Yaahs! Yaahs!" I got up, turned on the light, and went into the hall. There was of course no one there.

I began a kind of ritual, digging a large, deep pit in our vacant lot behind the backyard to bury his belongings—the side-loading toaster, the warped dresser, the rusty rollaway bed. There had always been an inscrutable aura about him; and now I could take the drawers from the dark dresser in the dark room and dump them in the sun and discover

the secrets. But there were only sox, underwear, suspenders, nails, sandpaper, and some cans of condensed milk. I leaned a post against a battered garbage can so that it extended out over the pit, hanging his clothes to burn one piece at a time. Ashes rained into the neighbor's pool.

There was a brief service in a small chapel on a highway near the cemetery where George's brother was buried. The chapel had a bare room with a plank floor. There were only six of us there, including two men from the mortuary and George's niece, whom he had occasionally visited by bus. We sat there for awhile with the chapel's caretaker until an elderly man entered and walked up to a lectern that served as the pulpit. He had that withered look that comes with years of cigarettes and booze, and a shiny gabardine suit draped over his bony frame. The niece had notified the Brotherhood of Locomotive Engineers, which had sent him, he explained, to say a few words about George Ross. "George," he began, unfolding a piece of paper, "ran freight on the old Southern Pacific lines, driving the big 2-8-0 Consolidation locomotives along the East Bay. This was back in the early days when it took a lot of skill to handle the old steam engines, and he trained a lot of the younger men." He talked on about the old days of local railroading. George, he said, had pulled countless carloads of gravel from the quarries. "He moved all that gravel—millions of tons—down to the Bay. There are stretches of city along the east shore sitting on the foundations he built."

In that stark room, there was something about it, something more real than a high mass in St. Patrick's Cathedral or any gibberish about the blessings of an afterlife, something that penetrated even my fifteen-year-old mind—a sense that the true heroes are the anonymous millions who accept the dreary work that moves the world, who keep the shop, who lay the literal foundations for future cities and die in someone's back room, put to rest with a few words from a file read by some union stiff over noise from the freeway.

George's room was repainted and refurnished as a never-used guest room. I went to the room a few times, then never went back. I would get an almost electrical chill, a nauseous, suffocating sensation, like being in some eerie limbo outside of space and time. Maybe it was the stillness, the mustiness, or the residual scent of paint.

Looking back, I envision George with some difficulty. I can make out his whiskered face and strands of white hair, the large ears, the prominent nose, or the twinkle in his narrow blue eyes, but it never comes together. It's blurred like the one photo of him, taken with my childhood camera, sitting

in the canvas chair in the backyard with his hat and cigar, a finger over the lens obscuring part of the scene. The fuzzy image and indistinct face now seem an appropriate memento for a man I knew but never knew—emblematic of my lifelong inability to fully engage in the present moment.

Over the years, George's peculiarities became amusing reminiscences shared with my father, the rest of the family too young to have known him. But there always seemed something more to this man who had never traveled farther than the upstate town of Chico—an elusive depth I could never define. In the seventy years since those nights on the porch with old George and the Martians, he has become an almost mythic figure—the gadfly, the outsider, both wise and absurd, who dwells inside us all. I try, every dozen years or so, to capture it on paper, but I never succeed. Now and then I look at the fuzzy image in that photo, freeze framed in the sunlit silence of the past. It is one of those constants that gives the illusion of continuity to one's ever-changing self.

Perhaps there was never any real mystery about old George, only a crusty curmudgeon too wary to sign my fourth-grade autograph book, a recluse in a rumpled coat and fedora, the long underwear protruding at the collar and cuffs. The image abides, the leitmotif of my youth—from the Olympian elder with his wondrous stories of the red planet, to the butt of my adolescence, to the memory of a simple man whose only mystery lay in my own metamorphosis. He was remote, cantankerous, personifying the brusque assurance of his Sousa marches. It's hard to imagine him ever having hugged anyone. Yet if that murky photo in the canvas chair were set to music it would not be brass and piccolos but something plaintive, a solo cello, something more in keeping with an inner isolation, living on the periphery of other lives. And there are times—gazing at the red planet, sawing wood, or eating lemon meringue pie—when I glimpse the whiskered face, the glint in the small blue eyes, and feel that instant of continuity, that rush of lost roots, that elusive . . . something.

"The one constant through all the years, Ray, has been baseball. America has rolled by like an army of steam rollers. It has been erased like a blackboard and rebuilt, and erased again. But baseball has marked the time. This field, this game; it's a part of our past, Ray. It reminds us of all that once was good."

—James Earl Jones in *Field of Dreams*

7

Our Game

Sport has long been America's informal religion. The sacred spaces reserved for sport—cool green fields hidden in the bowels of Pittsburgh and Chicago—are hallowed ground, America's cathedrals, where the gray monotonies of mortal limits are forgotten and each moment is eternal. But it is Baseball, above all, that stands with the cowboy, the railroad, the log cabin, or the Lincoln Memorial as an American motif. Symbolic of youth and summer, of fathers and sons, of a simpler rural past, baseball has become synonymous with our American roots. Like the Western, it infuses our national nostalgia.

Baseball came into its own in the late nineteenth and early twentieth centuries with the same urban-industrial wave that spawned the Western. Buried among factories, warehouses, and truck depots, the baseball park has been a pastoral oasis, a wedge of green removed from the dreary squalor of urban existence. With its slow, unclocked pace, rational structure, and revered rituals, baseball is set apart from the muddled complexities of modern life.

The heat of the game should not be confused with the aura that emanates at a distance. The one is immediate and tangible, a noisy hubbub; the other is gossamer, still, and timeless, a wistful reverie.

"The game begins in the spring, when everything else begins again," wrote Baseball Commissioner Bart Giamatti, "and it blossoms in the summer, filling the afternoons and the evenings, and then as soon as the chill rains come, it stops and leaves you to face the fall alone."[1] The slow pace and green expanse, each man responsible for his own plot of ground, suggest the serene clarity of an older, agrarian America, a pastoral balance between wilderness and civilization.

Yet the nostalgia relates less to a game played in nineteenth-century pastures than to childhood memory. "The game of baseball has always been linked in my mind with the mystic texture of childhood," wrote Doris Kearns Goodwin, "with the sounds and smells of summer nights and with the memories of my father."[2] The theme of fathers and sons infuses baseball films and fiction, the best of which have a transcendent, near-mythic aura.

Until Samuel Goldwyn's *Pride of the Yankees* (1942), baseball films were invariably "B" pictures, rarely venturing outside comedy, farce, or light melodrama. It was Goldwyn's biography of Lou Gehrig that launched the serious baseball drama. The films of the forties and fifties touted the American success mythology, the belief that any honest, hard-working young man can begin as a newsboy or poor farmer and become president of the United States—or a great ball player. The films depicted unsophisticated heroes, rural rubes who overcome physical handicaps, poverty, racism, or delinquency, often with the support of an accepting wife.

The nostalgic appeal benefited from the great transformation of American culture that fell roughly between 1890 and 1920. With the shift from a rural-agrarian to an urban-industrial society, the Puritan work ethic was overshadowed by a greater emphasis on social mobility and rugged, rags-to-riches individualism. The nineteenth-century heroes of production (statesmen, inventors, industrial leaders) were displaced by twentieth-century heroes of consumption (mass-media celebrities). As a more complex and systematized society confined success increasingly to bureaucracies, feelings of individual powerlessness were assuaged by heroes who leapt to fame and fortune outside of the system. In the first half of the century, such success themes as the advantage of the "school of hard knocks" over formal education, the character-building nature of poverty, and the emphasis on natural over acquired talents, were especially suited to those disadvantaged by the new urban-industrial

conditions. Baseball reached into every class and region, binding them together in common loyalties and rituals, a secular congregation embodying the myth of the melting pot.

The new image of success found perfect expression with the emergence of the sports superhero in the 1920s—men like George Herman "Babe" Ruth, William Harrison "Jack" Dempsey, Harold "Red" Grange, Robert T. "Bobby" Jones, and William T. "Big Bill" Tilden. "The greatest thing about this country," wrote Babe Ruth in his autobiography, "is the wonderful fact that it doesn't matter which side of the tracks you were born on." The changing image within baseball itself was evident in the rise of Ruth over Ty Cobb as the reigning hero. Cobb was calculated and scientific, using the bunt, the placement, the steal, and trying for safe hits rather than long ones. For those who idolized Ruth and Gehrig, the home run, more than strategy, became the ideal. The home run symbolized a sudden break out of workaday frustrations through sheer power, inborn talent, and a willingness to risk it all on one shot. Ruth, in fact, was a boisterous carouser who spent every cent he made, while Cobb was a loner who carefully invested his money. The rise of the sports hero in the twenties, epitomized in Ruth and his home-run style, brought a new romantic sensibility to the game.[3]

"Monty Stratton," says the narrator at the end of *The Stratton Story* (1949), "stands as an inspiration to all of us, living proof of what a man can do if he has the courage and the determination to refuse to admit defeat." Although young Stratton is a poor farmer supporting his mother, he devotes all his spare time to pitching practice and walks miles to play in the only available games. As a major league pitcher he loses a leg but strives toward his ultimate comeback with an artificial limb. In *The Winning Team* (1952), pitcher Grover Cleveland Alexander (Ronald Reagan) rises from hayseed farmer to the major leagues, only to develop an eyesight problem that is misinterpreted as drunkenness. After sinking to the level of answering baseball questions at a carnival, he overcomes his handicap, makes his comeback, and pitches the deciding game of the World Series. In *The Pride of St. Louis* (1952), we find Jerome Herman "Dizzy" Dean pitching barefoot in the Ozarks in 1928, with cows grazing in the outfield. He grew up picking cotton, rarely attending school, rejecting alcohol and tobacco, and has an immediately disarming personality that combines childlike innocence with bad grammar. Dean takes the St. Louis Cardinals to the World Series but eventually destroys his arm and has to quit pitching.

Overcoming his disappointment and the temptations of alcohol and gambling, he emerges a successful sportscaster.

There is a pervasive sentimental romanticism to the baseball films of the forties and fifties—the steadfast wife, the humble, democratic hero with a heart of gold, and the inevitable crippled boy who walks from his hospital bed when his hero hits the promised home run. The heroes are modest, shy, self-conscious, almost bumbling folk figures; thus the choice of such Capra stars as James Stewart and Gary Cooper, embodying the American ideals of democracy, egalitarianism, optimism, agrarianism, and sanctity of family. But the stories lack the mythic associations and underlying archetypes one finds in such later films as *The Natural* or *Field of Dreams*.[4]

By the 1980s, the best baseball films had an aura of elegiac nostalgia, focused on mythic figures, pastoral fantasy, and fathers and sons. Three films in particular, *Field of Dreams*, *The Natural*, and *Bull Durham*, not only represent the best of the genre but fall on a continuum across fundamental dualities: the ideal and the real, the sacred and the profane, the temporal and the eternal.

The Natural (1984) was an entirely new kind of baseball movie and the quintessential nostalgia film. When Bernard Malamud published the novel in 1952 it marked a turning point in the history of American sports fiction. In *Dreaming of Heroes*, Michael Oriard notes that Malamud was the first American novelist to recognize that "the character of the hero, and the relationship of country and city, youth and age, masculinity and femininity in American sport are explicitly mythic concerns," that sport is "the most important and quite possibly the sole repository for myth in American society today."[5]

The Natural is the tale of a golden youth, born to be "the best there ever was" but shot down by a dark lady on the eve of his professional debut, resurfacing years later for one season of glory. The film opens with the middle-aged Roy Hobbs (Robert Redford) sprawled on a railway station bench, the wail of an approaching steam whistle, massive driving wheels moving across the screen, and one feels immediately that the film will be nostalgic. Flash back to a hill covered with golden grain, sloping up gently to clumps of soft trees against a dawn sky. The music is pastoral, pensive. A boy runs in slow motion, catches a ball in his mitt and falls out of sight into the tall grain. Cut to the father, playing catch, teaching him to pitch in a setting of barns, chickens, plows, and

windmills, always under a dawn sky. "You got a gift, Roy. But it's not enough. You gotta develop yourself. Rely too much on your own gift and you'll fail." Cut to Roy looking from the farmhouse porch as his father slumps to the ground in a fatal heart attack. That night, lightning flashes, illuminating the baseball pennants in his room, and a bolt strikes a large tree, splitting the trunk wide open in a mighty fireball. Cut to the boy chopping the wood in the light of day and fashioning a bat from it, the music now heraldic. On the bat, he carves a lightning bolt and "Wonderboy," the hero's Excalibur.

One scene later he is eighteen and about to depart for his major league debut. On a hill against the dawn sky, he and his girl, Iris, share the rush of anticipation. On the train is the "Whammer," a champion batter bearing a close resemblance to Babe Ruth. When the train stops by a small-town carnival, the Whammer gives a batting exhibition and challenges young Roy to pitch to him. He of course strikes out. A mysterious dark lady compares Roy to Sir Lancelot jousting with Sir Gawain, or a Homeric hero.

"You know what," he replies, "someday I'm gonna break every record in the book; I know I got it in me."

"And what," she asks, "will you hope to accomplish?"

"When I walk down the street, people'll look at me and say 'There goes Roy Hobbs, the best there ever was!'"

"Is that all?"

"Well, what else is there?"

That night she lures him to a hotel room and shoots him with a silver bullet.

The rest of the film takes place sixteen years later when he has apparently healed sufficiently to present himself to the manager of the Knights, a last-place major-league ball club. "We don't need no middle-aged rookies," says the manager, and Roy spends months on the bench. When finally allowed to bat, using his childhood Wonderboy, he literally knocks the cover off the ball. The outfielder picks up a handful of thread. He bats the team into first place but then falls for another dark lady, goes into a batting slump, and the team begins to slip. But when Iris surfaces from the past, rising in the stands with the sun shining through her broad-brimmed hat like a halo, he senses her presence and swats a homer.

Iris has a teenaged son who "needs his father." "Sure," replies Roy. "A father makes all the difference." In the end, of course, the boy

turns out to be his son. When he discovers this, in the middle of the championship game, he cracks the winning hit, shattering the stadium lights in a great shower of flashes and sparks that rain down over the entire field to the crescendo of Randy Newman's Coplandesque score. The victory destroys the scheme of the evil "Judge," who had tried to get Roy to throw the game. It is Roy's last game because his stomach, bleeding through his uniform as he comes to bat, is almost gone from years of carrying the silver bullet. As the last sparks from the exploding lights descend, we see the ball still climbing into the night, then dropping into a field of golden grain, where it is caught by his son. He is back on the old farm, playing catch with his son, while Iris looks on against the dawn sky.

Malamud's *Natural*, too innocent to survive modern-day evils—the dark ladies, soulless sportswriters, evil judges, and their racketeer henchmen—belongs with the fallen heroes and antiheroes of twentieth-century novels.[6] In the movie version, however, the hero does not succumb to the dark women, the city, or lost youth but maintains his saving contact with Iris, the angel of light, and his pastoral roots. He remains "natural." So the basic conflict of the film, the boundless potential of youthful innocence versus the fall into the real world of adult limits, finds the ultimate nostalgic resolution: the hero *can* go home again. The conflict that *The Natural* resolves in favor of nostalgia is actually one of idealism versus realism. The two extremes of this dichotomy are represented by two baseball films that appeared almost simultaneously, *Field of Dreams* (1989) and *Bull Durham* (1988).

In *Field of Dreams*, based on W. P. Kinsella's novel *Shoeless Joe*, Kevin Costner plays Ray, an Iowa farmer haunted by memories of his dead father, a minor league player. Ray had known his father only as a frustrated factory worker who dreamed of making his son into the ball player he could never be. As a rebellious teenager, Ray had refused even to play catch with him. At seventeen he had "said something awful" and left home, returning only for his father's funeral. (The father's early death is common to baseball films.)

After attending college at Berkeley in the sixties, Ray marries and buys a farm in Iowa, his wife's home state. No sooner has he planted his corn than he is compelled by a voice ("If you build it, he will come") to plow under a large section and build a baseball field. The completed diamond is a radiant green, surrounded by an expanse of tall cornstalks

that stretches out to rolling tree-lined hills and a deep blue sky, the colors almost cartoon-like in richness. Winter falls on the field, and summer returns.

Then one cricket-filled night Ray's daughter announces, "Daddy, there's a man out there on your lawn." The great Shoeless Joe Jackson (who died in 1951) is seen kneeling on the diamond as though in a cathedral, picking blades of grass, his luminous white uniform casting a long shadow in the eerie moonlight. Ray introduces himself, and there is a sound of hickory bats tapping together as Joe pulls them from a bag and inspects them.

"I'd wake up at night," says Joe, "the smell of the ball park in my nose, the cool of the grass on my feet—the thrill of the grass." (Ray pitches to him; there is a crack as the bat meets the hard ball, which drops against a black sky into the distant cornfield.) "Man, I just love this game! I'd've played for food money. It was the game. The sounds, the smells. Didya ever hold a ball or a glove to your face? I used to love travelin' on the trains from town to town. The hotel—brass spitoons in the lobby, brass beds in the rooms. There was the crowd, rising to their feet when the ball was hit deep. Shit. I'da played for nothin'."

"Is this heaven?" he shouts before fading into the cornfield. "No, it's Iowa," says Ray. Later Joe reemerges with seven others, cautiously testing the ground, stirring up summer insects. As in *The Natural*, the sky always suggests a blend of dawn and dusk. They begin playing, to the accompaniment of baseball chatter and jazzy music from the twenties. As evening falls and the team drifts back into the tall cornstalks, the white farmhouse with its lighted windows sits under a purple sky, where orange clouds reflect the last glow of twilight.

Ray is led by the voice to seek out a reclusive writer suggestive of J. D. Salinger, and the two are then led to a wistful old country doctor named Archibald "Moonlight" Graham (Burt Lancaster) who, though deceased, is encountered in what seems the misty night of some earlier time. He had played one game in the majors but had never gotten to bat. That moment, says Doc Graham,

> was like coming this close to your dreams and then watching them rush past you like a stranger in the night. At the time you don't think much of it. You know we just don't recognize the most significant moments in our lives when they happen. Back then I thought, well,

there'll be other days. I didn't realize—that was the only day.

Doc gets his chance to play with the others on Ray's field—but now as a boy, picked up hitchhiking by Ray and the writer on their way back to Iowa. But the boy's diamond debut is interrupted when he spots Ray's little daughter in trouble. As he steps from the field, he transforms to the old doctor with his black bag and prevents her choking on a hot dog. Unable to go back, but happy to have had his moment, he fades away among the cornstalks.

Ray's brother-in-law wants to buy out the bankrupt farm. The little daughter objects, suggesting that "people will come" to see the ball players. The writer (James Earl Jones) agrees:

> They'll come to Iowa, for reasons they can't even fathom, and they'll turn up your driveway, not knowing for sure why they're doing it. They'll arrive at your door, as innocent as children, longing for the past. . . . They'll walk out to the bleachers, sit in shirt-sleeves, on a perfect afternoon; and they'll find they have reserved seats somewhere along the baselines, where they sat when they were children and cheered their heroes; and they'll watch the game; and it will be as if they'd dipped themselves in magic waters. The memories will be so thick they'll have to brush them away from their faces.

"Ray, when the bank opens in the morning, they'll foreclose," says the brother-in-law.

"People will come, Ray," says the writer.

"You're broke, Ray."

"The one constant through all the years, Ray, has been baseball."

At the end, Ray finds his father standing on the diamond in his old baseball uniform. "My God," Ray says. "I only saw him years later when he was worn down by life. Look at him. He's got his whole life ahead of him and I'm not even a glint in his eye." Yet there is an unspoken recognition and the film ends with the two playing catch under the dusky sky. In the distance, moving up the road toward the diamond, is a long line of headlights, zigzagging out across the landscape to a far horizon.[7]

Field of Dreams paints a magical world beyond space and time, a benevolent universe immune to the practical constrictions of adult life. "I've just done something totally illogical," says Ray after building his field. "That's just what I like about it," says his wife, who fits the supportive tomboyish image of the earlier films. Set in the idealized imagery of Middle America, *Field of Dreams* distills the mythos of baseball to its purest essence.

On the realist/idealist continuum, baseball films crowd the idealist pole with a disproportionate number of fantasies, musicals, and heroic legends. The idealism had always been inherent in baseball itself, a game unlimited by space or time. Unlike football, the game could theoretically go on forever; and since the fence was never a part of the rules, the field extends to infinity. It is a game of individualists facing events alone, performing serially rather than in unison. There is a changeless symmetry to baseball and a detached, insulated mood, like a nostalgic reverie, the competition contained and emasculated by a pervasive benevolence.

Set in a time when professional sport was still a game and not an industry, the films pander to the longing for a pastoral childhood where life's gritty conflicts are safely contained within the solicitous world of the father, projecting that longing onto images of America's agrarian youth. The pastoral imagery also abounds in baseball literature: the crack of the bat, a sound "clear, clean, woodsmanlike"; the "immense and tranquil field sparsely settled with poised men in white"; "the chatter of infielders, bright as bird chirps"; "the sweet attenuations of late summer afternoons." Baseball writing is deeply sensate: the ball, "that perfect object for a man's hand," is "so smooth that sensuousness awakens at the touch." And there is the sound of it smacking into the pocket of a well-worn glove; and the smell of leather, of varnish on a Louisville Slugger; and of grass upon your hands and knees. The game turns on minute detail, a step covertly taken to the left here, a batter choking up just an inch there, along with the small gestures, the tiny rituals that must be observed: the shortstop must kick the dirt and the umpire must brush the plate with his whisk broom.[8]

In *Baseball the Beautiful*, Marvin Cohen reprises James Earl Jones:

> Baseball goes on, essentially unaltered, though the
> nation itself goes through violent historical upheavals

and the times are always changing. . . . The world's cataclysms come about, and subside. But every summer is played the same eternal baseball game. We can time our lives to its peaceful eternity. We can trust to its repose and security. It's always going on.[9]

"It's our game, the American game," wrote Walt Whitman. "It will repair our losses and be a blessing to us."

One of the few exceptions to the genre's idealism is *Bull Durham*, a film closer to the realist end of the spectrum. In *Bull Durham*, baseball is a context for survival in a complex world of overwhelming limitations. If *Field of Dreams* imagines a transcendence of mortal limits, *Bull Durham* holds that such states of mind are flights of self-deception. "I believe in the church of baseball," says Annie Savoy, the minor-league club's resident nymphomaniac. She'd "tried all the major religions" but "it just didn't work out." Baseball, on the other hand, "is never boring, which makes it like sex." The story involves an aging catcher, appropriately named Crash Davis (Kevin Costner again), a fallen figure in a fallen world, the minor leagues. Amid bar fights, public fornication, and general amorality, augmented by the hollow electric sound of a stadium organ, the one positive image in the film is the big leagues, or "the show," as they call it. Crash was once there for 21 days, "the twenty-one greatest days of my life," he says, "the ball parks are like cathedrals." But like Annie's religions, they just didn't work out for Crash.

Crash is hired to shape up an ignorant, cocky pitcher with a wild arm—"a million dollar arm and a five cent head," says Crash, who calls him "Meat." But even though Meat eventually makes it to the majors, his real measure of success is his "Porsche 911 with a quadraphonic Blaupunkt." His move to the majors, moreover, results in Crash losing his job. Moving on to another team, Crash eventually breaks the minor-league home run record but feels it a dubious honor. Baseball's Bible, the *Sporting News*, never mentions it. He soon quits the game and drops by to see Annie, having no particular plan except to maybe do some coaching somewhere. "Full many a flower is born," quotes Annie in her closing monologue, "to blush unseen and waste its sweetness on the desert air."

The mood of *Bull Durham* is closer to that of films about football than baseball. The archetypal football film is *North Dallas Forty* (1979),

which opens with an aging player (Nick Nolte) lying in his Jockey shorts on a bloody pillow amid a plethora of pills and beer bottles, barely able to get out of bed with his accumulated injuries. He is on his way down, a modern Sisyphus who continues to play because "it's the only thing I know how to do." The film depicts a violent masculine world of drugs, sex, money, wild parties, and night games mired in mud, where women are mere objects, competition is everything, and the "only way to survive is the pills and the shots."

Unlike most football films (such as *Semi-Tough*, *The Longest Yard*, and *Number One*), which depict a profane, world-weary existence, baseball movies are almost always positive, if not transcendent, projecting an innocent world now lost. Among the early films are many light comedies, Disney-like fantasies, and musicals—*Angels in the Outfield* (1951), *It Happens Every Spring* (1949), *Rhubarb* (1951), *Take Me Out To the Ballgame* (1949), *Damn Yankees* (1958). Even those few baseball films that depict a jaded society usually include some compensating note of promise, if not idealism. The same contrast colors baseball and football fiction. As critic Kevin Kerrane notes, football fiction "directs our attention to the world of experience rather than innocence," often taking the form of an "apprenticeship novel dealing with the problem of learning how to live without romantic illusions. The resolute anti-idealism of football fiction is crystallized in its characteristic image of man as a fallen creature in a finite universe." The baseball novel "affirms the transcendent possibilities of illusion" while the football novel "confronts the obstinacy of reality." Baseball is an optimistic game while football is more pessimistic, tougher, more familiar with injustice. "Baseball is fathers and sons," wrote Donald Hall, "football is brothers beating each other up in the backyard."[10]

Like football films, *Bull Durham* appeals to the realist in its emphasis on experience over innocence, while *Field of Dreams* is food for the idealist. The fact that the critics who liked *Bull Durham* disliked *Field of Dreams* and vice-versa highlights the fundamental nature of the dichotomy. While the realists call *Field of Dreams* "manipulative," "batty," "daft," and "pointless," complaining that eternal children like Roy Hobbs and Ray Kinsella are not workable models for life, the idealists answer that they are less models than motifs—a healing kind of background music in a disenchanted world. Art, wrote Wallace Stevens, is "imagination pressing back against the pressure of reality," the attempt to restore meaning, to remythologize.[11]

The idealist pole carries the archetypes and myths, the sources of human meaning, the imagination of human ends. The realist pole is purely instrumental, critiquing, providing, at best, means to those ends. At the extreme, the idealist becomes the eternal child who never loses innocence, never accepts mortal limits, and who, like Roy Hobbs, must be "the best there ever was." The downside, for lack of boundaries defining a self, can be a failure to find some viable identity in a limited world of real human beings. The realist represents the loss of innocence—the acceptance of limits, mortality, and adult responsibilities in an imperfect world.

Once again, the polarity seems to parallel extraversion and introversion—those whose fulfillment comes from sensate outer experiences as such and those who look more into themselves for the meaning of that experience, or in terms of film, those who wish to be entertained and those who want to be moved. Of course there are no pure types. But to the degree that a film violates its real-world setting, the extravert may feel manipulated, while the introvert, coming to the same experience in search of inner meaning, can compartmentalize, bracketing the unreal as a kind of poetic license.

The same dichotomy applies to nostalgia itself. Realist psychologists—who declare that "we need to help our clients learn to live in the present and let go of nostalgic sentimentality for a past that never really existed"—need to understand that the past is who we are, and that nostalgia is a quest for an overarching essence, a thread of meaning and continuity in our journey across the panorama of that past. If images emerge purified, they are less illusion than abstraction. Seen from the air, the blanket of green forest lacks the dead trees and rotting wood, yet the larger meaning lies in such flight. In this sense, the essence of baseball transcends the errors and slumps, the money and scandals. Reviewing the movie *Moneyball* (2011), one critic wrote: "It's no *Field of Dreams* or *The Natural*, no thrill-of-the-grass, stand-up-and-cheer heartwarmer celebrating the impossible triumph of the underdog. It's too smart for that." We are often too "smart"—too sensible for metaphor, too literal for the larger context, too entangled in ephemera, too jaded to reflect on the timeless, let alone to indulge in nostalgia.[12]

	1	2	3	4	5	6	7	8	9	TOTAL
REALISTS	2	0	1	4	2	1	0	6	2	0
IDEALISTS	0	0	0	0	0	0	0	0	0	1

Mythic Nostalgia

Beyond personal memory and collective recollection is a third form of nostalgia that might be termed "mythic"—what George Steiner calls a "nostalgia for the absolute," whether a longing for some primordial Paradise or for a present purified through some final ideology or religion. Among the forms that proliferated during the American High—Marxist or Freudian orthodoxies, religious resurgence, psychedelics—the fantasy of rebirth in a new Eden in the wake of nuclear war produced enough literary and cinematic examples to qualify as a genre, or at least a subgenre. Chapter Eight begins with a national myth, the "Greatest Generation," and a man emblematic of that myth who also happened to collect "anything old." Chapter Nine analyzes the spate of nuclear films, then turns to romantic visions of the Dark Continent, evoking the Rosseauian myth of an original Edenic state in nature. Our accelerating retreat into technological bubbles and virtual realities intensifies this ultimate form of nostalgia.

"Let the word go forth from this time and place, to friend and foe alike, that the torch has been passed to a new generation of Americans, born in this century, tempered by war, disciplined by a hard and bitter peace."

—John F. Kennedy, Inaugural Address

"Uncommon valor was a common virtue."

—Shrine inscription, Mount Suribachi, Iwo Jima

8

The Greatest Generation

A Commemorative Speech on the Sixtieth Anniversary of D-Day

Charles McCandless' battalion was leaving the island of Ulithi, loading into LSTs for the advance toward Saipan, and he was to be the last man off the beach. "I'll never forget the next two hours," he later wrote, "waiting at the edge of the surf, standing alone in the rain, cold, wet, dog tired, and so hungry I'd lost my appetite. Up to this time in my life, I'd never been so lonesome or depressed. 'What a lousy birthday—twenty-seven years old and what have I got to show for it?' I thought, 'Maybe I should have gotten a deferment and stayed safely home and become rich by now.' In my heart, though, I knew that I belonged where I was."

While inspecting an American supply train captured during the allied push toward Germany, Wehrmacht Field Marshall Gerd von Runstedt was privately dismayed by the treasury of home-spun amenities filling the boxcars: woolen sweaters, mittens, stockings, and scarves; fruitcakes, cookie tins, chocolate brownies, candy bars, dried fruit, mail, and Christmas cards. At that moment, he later wrote, he realized that Germany was doomed to defeat, believing that any nation was

unbeatable whose people, in their unity of support for their armies, were able to deliver so much, so far, with each item individually addressed.

Such are the valedictions for what has been called the "Greatest Generation." This is the generation that gave so much and asked so little in return. Through cooperation, persistence, discipline, and endurance, they abided depression and war, defeating the darkest demon in history and leaving America a Colossus astride the Earth. Willing to accept risk and sacrifice, they had a vision of something larger than themselves. They succeeded on every front. They won the war; they saved the world; and they returned to re-create America—its communities, roads, businesses, government, arts, and sciences, and an economic strength unparalleled in the long curve of history. As their last great gesture, they put man on the Moon. Now they seem to tower out of the last century like monuments to communal values. Henry Luce called it "the American Century."

It was a Promethean generation. Raised in the depression and sent into war, they returned with a work ethic and willingness to invest that outperformed their communist rivals and won the Cold War. It was a generation willing, in Kennedy's words, to "bear any burden, pay any price" to achieve whatever goal it set. No other generation in history has been so adept in its aptitude for science and engineering. Their bridges, highways, tunnels, harbors, and housing projects were the biggest and best in the world. Theirs was the largest one-generation jump in educational achievement in American history. They won roughly two-thirds of all the Nobel Prizes ever awarded to Americans. Six in seven report having fared better than their parents, the highest proportion ever recorded.

Perhaps the final word belongs to Wernher von Braun, the man most responsible for the success of the Apollo moon landing. A young space enthusiast once asked him what it would take to send a man to the moon. His answer is the epitaph of his generation: *"The will to do it."*

When I interviewed members of the generation in connection with the sixtieth anniversary of D-Day, I asked what values they felt were most important. The common answers were honesty, integrity, loyalty, duty, service, courage, faith, fidelity, friendship, teamwork, responsibility, gratitude, and the Golden Rule. The list is no less revealing for its omissions; another generation might have put independence, self-fulfillment, self-expression, self-this, and self-that nearer the top.

Most were asked what they felt was the best thing that ever happened to them, what they were most thankful for, and what they considered their greatest achievement. The usual answer to all three questions was not a career or an achievement but "my wife," "my husband," or "my marriage," followed by "my children" or "my family." In *The Greatest Generation*, the book that coined the phrase, Tom Brokaw noted that "it's a legacy of this generation seldom mentioned with the same sense of awe as winning the war or building the mighty postwar economy, but the enduring qualities of love, marriage and commitment are equal to any of the other achievements."

If other generations seem to produce more creators, reformers, or individualists, the typical member of this generation has been the quintessential good citizen, good parent, and good human being. And isn't that all we really hope for in the end? Isn't all the rest just a footnote? In retrospect, a disproportionate number of them have belonged to that diminishing group of people who still care about a world beyond the self, who aren't likely to get up one morning and put on the gold chain and the cowboy boots and walk out on the family in the name of "self-actualization" or some such. And if most of the people interviewed seemed relatively ordinary, isn't that just the point?

Soon there will be no one who remembers Dunkirk, Tarawa, Iwo Jima, Anzio, or Omaha Beach. Most of the men who hit those beaches—terrified, longing for their loved ones, yet totally committed to their mission—now belong to the ages. Those who fell on the beaches so that others might succeed take their place in history with those who perished in frail galleons on uncharted seas or vanished with their Conestogas out on the vast prairie.

One by one, the Charles McCandlesses of that heroic time are falling. And we may need the help of God when they're all gone. One thinks of the dying lieutenant's last two words in the film to Private Ryan: *"Earn this!"* Too often, we fail to honor that debt. There is a failure of nerve, a loss of vigor, and a collective hypochondria that cripples our larger visions. We stand on the shoulders of giants. If we balk at the challenges before us, we will betray all those who lifted us into the present. If the generational cycle that has operated throughout modern history continues, then a new "greatest generation" is now coming of age.* Let us pray that it is so. Meanwhile, I'm sure their predecessors would close

*See the Appendix: Note on the Generational Theory of History.

on a different note. Because having talked to so many of that generation, I found over and over that they remain, in spite of everything, optimistic about the future of the human journey.

As they leave us one by one, wrote Brokaw, "many G.I.s probably wish they didn't have to go that way, but would prefer to go together in some heroic D-Day redux—one last civic ritual to remind everyone what they once did, as a team, for posterity."

Like those ragged men of the Revolution, marching to fife and drum, or the Statue of Liberty, or the Lincoln Memorial, the marines on Mount Suribachi, Iwo Jima, become the timeless symbol of human liberation, forever raising the flag of freedom over the future of all humanity.

Pieces of the Past

Take San Jose's Los Gatos-Almaden Road off Bascom Avenue, pass the Chevy dealer, some office buildings and condos, and you'll encounter a striking incongruity. Set back from the street under a great brooding redwood is an ancient, weathered-gray, two-story clapboard house with a large, round turret. Just behind the turret's conic roof, an old windmill towers against the sky. One feels the house has materialized through some rift in time out of the mists of long ago.

As if to confirm the feeling, a large antique clock stands at the entrance on a tall post near a pair of old street lamps. In the spacious front yard, among fountains, fruit trees, and a gazebo, are the scattered remnants of another time—a mining cart, an antiquated plow, wagon wheels, and an old-fashioned well. A tour of the property reveals a vast collection of such items—scythes, wagon jacks, buggies, churns, harnesses, hog troughs, a horse-drawn ground scooper. There are streetcar seats, rail-crossing lights, cast iron stoves, meat grinders, sausage makers, a wooden wine vat, a hand-operated washing machine. . . .

One imagines *Twilight Zone*'s Rod Serling emerging from the gazebo with his wry smile, offering the tale of a mysterious old house that is the past incarnate, harboring all things obsolete. Within dwells the Keeper of the Past, wending his way among a sea of old artifacts in a motorized wheelchair—old phonographs, telephones, clocks, coffee pots, railroad spikes, roll-top desks, straight razors, streetcar headlights,

and carousel horses. There's an upright player piano, a bread slicer, and slot machine from the twenties. The artifacts fill every room—boxes of old sheet music, washboards, an antique tricycle, a rocking horse, ship's wheel, chestnut roaster, copper still, and an old cash register. They crowd the long, high shelves: a foghorn and an old French phone, a grape press, gold separator, and cast iron coffee grinder; a brakeman's lantern, baby scale, and a sea bag full of old coins and streetcar tokens.

The Keeper is Mel Basuini, and Mel's own past is anything but fantasy. As for the house, it was built in 1880 on what was then 265 acres of prunes, peaches, apricots, and cherries. When Mel bought it in 1983 it was occupied by a woman with 57 cats. He bought a dump truck and took out 75 loads of papers, magazines, boxes, bottles, rugs, and overgrown yard waste. Completely remodeled with six bedrooms, the house now holds Mel's vast personal collection. There's a five-foot high music box with perforated records four feet in diameter, a life-size nutcracker-soldier, a huge Betty Boop, and the bilge pump off Laurel and Hardy's boat. Asked what exactly he's collecting, Mel says, "anything old." An imposing piece of furniture called an "Orchestrian" plays ten songs per roll and includes drums, cymbals, whistles, a tambourine, xylophone, and piano. A 1932 pearl-inlaid Eddie Peabody banjo lies near an organ-grinders organ, an old dynamite plunger, and his grandmother's rocking chair and wood stove. Model cars overflow shelves everywhere, while the 300 cookie jars and over a thousand dolls collected by Mel's wife Gloria fill cabinets throughout the house. Name anything old and someone collects it. If they don't, Mel does.

Outside, Mel transfers from his wheelchair to his Cushman cart, and we maneuver around countless old machinery parts strewn everywhere amid vintage bobcats, rototillers, forges, fork lifts, wine presses, and outboard motors. In one area, goats graze near an old tow truck, a 1914 Indian motorcycle, a hand-car for testing rails, and a horse-drawn spray rig with a wooden tank. Eating cherries plucked from one of Mel's hundred fruit trees, we pass the first electric gas pump from the twenties, a tool to cut the horns off a bull, and his grandfather's hand plow, once pulled by white horse named Nellie.

A long row of sheds house some of Mel's classic cars, which include a Page Daytona clocked at 102 m.p.h. in 1922 (one of four in the world), a 1917 Page roadster, a 1921 Model T Speedster, and Mae West's Duesenberg. Strewn among them are everything from old car emblems

and boxes of license plates (nearly every year and state) to oversize signs—"Packard Service," "Yellow Cab." "This is nothin'," Mel shouts over the rumbling Cushman, "I got a whole warehouse full of stuff. As a kid, I always collected old things. It was like a disease. I started collecting cars in the early fifties. But I never saw a new car until 1941." In his youth, in fact, Mel saw very few things new.

He was born in 1926 in an adobe house built in 1839 along the west bank of the Los Gatos Creek by a Mission Santa Clara Indian named Roberto. What is now Lincoln Avenue began as a dirt trail that led up to Roberto's house. Originally one-room with walls four feet thick, the house was remodeled extensively over the years. By the time Mel's grandfather became the fourth owner in 1906, it had become a ten-room house. Mel's father and eight siblings grew up there. (Now a California State Landmark, it houses law offices.) "At that time," Mel recalls, "the city was about two miles away. We used to hunt rabbit and dove around there. The whole area was farming."

"My father worked in the packing house for ten cents an hour ten hours a day—a dollar a day. My mother worked in the cannery cutting apricots and peaches. Without unions, they sometimes worked 12 hours with no overtime. The man who hired my father said, 'Don't bring your lunch.' Jobs were scarce in those Depression years, and people sat on the bench all day waiting for someone to quit. When there was no work in the packing house, my father found jobs picking fruit and cutting wood.

"We never knew anybody that had a new car. We all had old used cars. Nobody had any real money. My father was making $35 a month and the payments on the house were $25 a month. We used to work two or three years to buy a used car that cost fifty bucks. To cut food costs, we had chickens, rabbits, and ducks and sometimes we'd hunt deer. And we had an 'Italian lawn'—my father planted garlic and onions. Everybody else had nice cut lawns but we had something to eat. We only bought flour, sugar, and salt. I can still remember the scent of those big loaves of bread we baked in the old Dutch oven."

"For twenty cents a month I got little bottle of milk and graham crackers at school. One month I had the money tied in a handkerchief in my pocket and lost it. The whole family combed the school yard for hours looking for it. I felt so bad. My father asked my mother, 'What's he doin' carryin' that kinda money?' Twenty cents! I had no milk or crackers for a whole month." When they couldn't afford the clothes for

my seventh-grade graduation, they draped me in my uncle's clothes and stuffed paper inside the shoes."

But my favorite of Mel's recollections is that when he was five years old, he and his sister made a long list for Santa Claus and dreamt daily of his arrival. Unable to fill the list and at a loss for what to do, his father went outside, fired his shotgun into the air, and returned to announce that there could be no gifts because someone had shot Santa Claus.

Mel grew up playing baseball in the middle of Bascom Avenue with a taped-up ball. When he was ten, his father bought him a baseball glove that cost almost three days wages. "That made me so happy," he says, "I slept with that glove." His grammar-school team never lost a game. An all-round athlete in high school, Mel played every sport, set track records, and never lost a race. But there were many times when he had to go home to help his father and couldn't participate.

In the early 1940s Mel's father began farming—like his father before him who had come to Campbell from Genoa in 1890 and farmed with horses. "There wasn't much time for play," Mel recalls. "I used to cut lawns for ten cents. I pushed the lawn mower all the way from home. And I worked after school and all summer helping my father. We picked 90 tons of cherries in a year with 18-foot ladders and 32-foot snake ladders to get inside the tree, sometimes in winds so strong I had to tie myself to the ladder. We worked ten to twelve-hour days picking fruit and loading the trucks. Sometimes it would rain and crack all the cherries and we'd get nothing. Or we'd have to get out of bed in the dark with flashlights and stack all the trays of apricots that were drying in the field so they wouldn't rot, our hands full of slivers. We'd go home at night dead tired, our knees sore from picking prunes, our fingers sliced from cutting apricots. It took an hour to cut a box of apricots that sold for five cents a box. We all worked hard and we never had an allowance. We didn't know what an allowance was. Kids today don't know how to work. They have no respect for money; they want everything new and right now."

"There were no sprinklers then, just wells. So we got up early in the morning and made ridges for irrigating blocks of trees. But sometimes I'd get up just to watch the farmer next to us disc his orchard early in morning—to listen to that tractor and watch that guy make the turn with it. And I thought, boy someday I want to get me a tractor. And I loved watching the crop dusters. Sometimes the pilots would wave to me."

Mel never finished high school. Drafted in his junior year, he was sent to the South Pacific to serve on a destroyer through most of the major battles—Saipan, Iwo Jima, Luzon, Eniwetok, Okinawa—surviving kamikazes and, at one point, a 144 mph windstorm that took all the paint off the ship. Mel didn't see land for ten months and was underwater most of that time. His battle station was twenty feet down in the ammunition room where he and two other men put shells and powder on a conveyor belt. Crowded into that tiny room in the bow of the ship, they were sometimes down there six or seven hours with the hatch closed and without much air. For a long time after the war Mel had claustrophobic nightmares. Lying in bed at night, the room would close in on him and he would get up and go out into the yard. Sometimes it would be two hours before he could go back in.

After the war, Mel put in ten to twelve-hour days helping his father with seasonal work. He worked in the cannery, then for the city, taking care of a baseball park, then for Food Machinery Corporation, making parts for tanks. "I tried to get overtime but couldn't get it," he says. "I worked two shifts for awhile—tryin' t' get ahead, y'know." Eventually he went into landscaping for 15 years. During that time, he met Gloria Sanfilippo on a roller skating date. They were married in 1958 and bought a house in Los Gatos.

One July in the late sixties, Mel opened a stand to sell fireworks. To get the site, however, he had to rent an entire ten-acre apricot orchard. So the family (they now had two boys) picked the apricots and sold them at the stand. They began farming walnuts, corn, prunes, grapes, and cherries and were soon selling everything—chocolate-coated apricots, flowers for the holidays, even Christmas trees. Mel had a mongrel dog named Ace that walked all around the yard on his two hind legs dressed up as Santa Claus.

One of the first fruit stands on the south peninsula, it became a popular landmark. Mel had been told by the State Planning Commission that he could only have the site for two years because the freeway was coming through. But the freeway took 26 years to arrive. For the first 14 years, Mel and Gloria worked seven days a week. He missed all the graduations, birthdays, anniversaries, and Christmas parties (there were always last minute poinsettias and such). "I was always down there working," he says. "Gloria missed most of them too. We always wanted to go to Italy but never did. I'd never had a chance to make money like

that. When I had a chance to make money, I wouldn't quit. I'd be the last guy standing."

"No one sold pumpkins at that time so I bought a whole field of pumpkins for $100 from someone I knew in Watsonville and with the kids' help, hauled them all to my house in Los Gatos. But the city didn't want me to sell pumpkins and sent the police to stop me. With 10,000 pumpkins stacked on the lot, I got passed from department to department and finally got a petition signed by almost 300 adults and children and took it to the mayor. The Planning Commission passed a special ordinance for me to sell pumpkins." Mel's two sons worked after school and weekends helping him plant pumpkins by hand. His card reads: "The Last of the Family Farmers."

In the late sixties, Mel began buying land in Watsonville. "I took chances," he says. One deal led to another and twenty years later it was all sold for many times the initial investment. His model was his mother's uncle, Sal DiSalva, who came from Italy, couldn't read or write, and signed his name with an X. He bought land and cars and died in 1946 with seven million dollars. "Like Sal, I learned the hard way," says Mel. "I made some mistakes. But, you know, if you don't take a chance you don't go anywhere. I bet the pot when I was beat on the board and won. I had nothing to start with. What could I lose?"

How does he feel about his hard-working youth? "I wish I could do it over. Looking back, it was a good time. I had a lot of friends. I was playing ball at school and winning. I'd come home, feed the animals, and play with the dog. We played stick in the mud and went down to the creek to collect wood with a spear, pulling it in and loading it on a wagon. We went hunting and got a lot of our food that way. We made sausages and my mother canned tomatoes. My father made wine; he had all the presses and barrels. We were always busy doing something."

"Life was simpler then. We went to Santa Cruz once and planned it for weeks—just to go over the hill. Our aunts would come over on Saturday night and bring cake or some cookies and play cards all night while us kids watched and listened to the radio. Or we'd go to the neighbors and bring pie and cake or pizza. What I remember most is the warmth, the feeling of community. There were weddings in big barns with 50-gallon drums of wine. They'd make sandwiches and bring a little band in there and dance all night long. On New Years Eve everybody'd go down to First Street. You'd see all your friends—everyone shaking hands, hugging, asking 'how'r'y'doin'?"

"We used to go on the old Soquel road to Santa Cruz. If you got a flat tire, the next guy around the corner would stop to help and give you water. That's how a lot of guys met their wives. And everybody used to work together; if you finished picking prunes in your orchard, you'd go help somebody else because if it started raining you'd have a mess. But everybody worked, you know. If you didn't work, people wouldn't talk to you. And people kept their word without small print and law suits; a deal was a handshake."

Ask Mel why he likes old things and he'll tell you he likes the workmanship. But perhaps they also evoke that more personal, more innocent world. In Mel's youth, modernization had yet to reach critical mass. It was a seedtime, a vibrant time of creative energy and buoyant self-confidence. We tend to think of the sixties in that context, but the true innovators of that decade belong to the forties and fifties.

The man who never lost a race is now confined to his chair, the bones in his feet deteriorated from diabetes. Like the myriad conveniences of modern technology, the motorized chair can never compensate for what is lost. Looking back on a life of hard work, strong loyalties, and simple pleasures, Mel Basuini harbors the remnants of that world—washboards and music boxes, harnesses and hand plows, streetcars and carousel horses. His story—like so many of the generation that won the war and built postwar America—reminds us again that the true heroes are those with an ounce more courage, a hair more kindness, a mite more hope—those whose hard work and pedestrian virtues nurture the world.

9

The Romance of Extinction

Of all the contrived analyses that cling to science fiction films of the fifties—McCarthyist body snatchers, Russians from Mars, the Bomb in the guise of Godzilla—the most pervasive has been the anemic notion that viewers sublimated the Bomb as the stereotypical Victorians did sex. The survivors of Hiroshima themselves would be hard pressed to find much mythos in the destruction of Tokyo by a seventy-story snail. The six-acre moth and the one-chicken skyline were given radioactive rationales simply because radiation lay at the leading edge of science, where known and unknown interface. In the mutant monster cycle of the fifties (e.g., *Them!*), and in films about reconstructed or mutated societies of the distant future (e.g., *Planet of the Apes*), the Bomb served simply as a plot gimmick.

To argue otherwise is to attribute a two-dimensional, socio-political function to the profoundly personal nature of psychic images. At best, such interpretations misjudge the degree to which McCarthyism and the Bomb were perceived by the average moviegoer as immediate personal threats. Academics often live too much in the tiny clearing that is rational consciousness, swapping hack politicisms like adages from

Poor Richard, denying, as D. H. Lawrence said of Franklin, the primal immensity of the dark forest.

If the Bomb has had a psychological role in film at all, the fact should be most evident in such films as *Five, On the Beach*, and *Damnation Alley*, in which the holocaust itself is the point of departure. Yet the most obvious characteristic of this subgenre, focusing on the immediate aftermath of Armageddon, is not its peripheral concern with death but its suggestion that the holocaust may be a means to purification and rebirth in a New Eden. Beneath the post-holocaust films of the Cold War fifties lurked the ultimate nostalgia.

The cinematic pattern for the New Eden theme was set by the first postholocaust film, *Five* (1951), a melodramatic social allegory in which the last five survivors, four men and one woman, converge miraculously at a mountaintop retreat near the coast of Southern California (actually the home of writer-producer-director Arch Oboler, who shot the cast-of-five film for $78,000). By the end of the film, three of the four men are dead, leaving only the new Adam and Eve. First to succumb is an elderly bank clerk who rambles on about finance, believing he is on vacation from his job. Frail and spectacled, wearing his former identity like a spacesuit on a dead world, he is the "John Q. Public" in the editorial cartoons of the time; and his short role at the outset of the film is that of a brief afterimage, a collective ghost. Next to die is a saintly black elevator operator who has selflessly cared for the old man. He is the gentle folk figure of American legend, a young Uncle Remus whose buoyant faith gives hope to the others. He is tormented and finally killed by a Nazi-like mountain climber, a racist, male chauvinist named Eric. Arrogant, violent, and lazy, Eric lies in the sun while the others work the fields. His search for jewels in the empty city and his attempt to abduct the only woman ends in his timely demise by radiation. The woman, Rosanne, alone, pregnant, and dazed at the beginning of the film, is comforted by Michael, the agrarian idealist. Obsessed with finding her husband, Rosanne returns to the empty, skeleton-strewn city, encounters his remains, and later loses her baby. When she rejoins Michael in the mountains, he is repairing the vegetable garden destroyed by the evil Eric. "I want to help you," she says—the last line of the film. And together the new American Adam and Eve face the

sun as the music rises, and a verse, taken loosely from Revelations, is printed over the scene:

> And I saw a new heaven a new earth . . .
> And there shall be no more death
> No more sorrow . . . no more tears . . .
> Behold! I make all things new!

There is little coincidence in the fact that Arch Oboler was the first to create such a film. Having written almost 800 plays for radio in the early 1930s, most in the horror or fantasy genre, involving such gimmicks as giant earthworms that take over the world, or an expanding chicken heart that destroys civilization, he turned in the forties to propagandistic dramas about "smirky little Japs" and "the Jap-Nazi world." Among his melodramas of horror and romance was a radio script he had written for Bette Davis in 1938 called "The Word" (of God), about a couple alone on earth who start a new world. A decade later he dictated an updated version to his wife as they treked across Africa on mule back.[1]

The result, *Five*, is about beginnings rather than ends. More spectacularly, as the poster ads announced, it is about four men on a one-woman planet. It is about racism, chauvinism, and self-delusion versus the simple American virtues. It is about purification, renewal, and rebirth—about everything, in short, but violent, meaningless death. Buildings, plant life, and environment appear untouched; even the windows are unbroken, and the corpses have converted immediately to polished skeletons. All that has been lost is an imperfect society with its complexities and ambiguities. ("We're in a dead world," says Michael, "and I'm glad it's dead . . . cheap honkey-tonk of a world.") If Oboler had intended a realistic warning, the glimpses of aftermath would have been less antiseptic and the plot less contrived. Anyone intent on showing that "this could really happen" would at least do the few minutes of research necessary to discover that a holocaust sparing only five humans would not exempt someone "up in the Empire State building," or locked briefly in a bank vault. Not only do the survivors cross a continent to happen upon one another in an obscure mountain spot, but the one who had been climbing Everest chances to wash ashore in America right at the feet of the other four.

The real concern of *Five*, with its love triangle, its social preaching, and its arty pretense (predictably, it was a cult favorite in France), is

not the Bomb but the absurdity of modern society. Nuclear holocaust is a plot gimmick, which could just as easily have been a plague (*The Omega Man, Where Have All the People Gone*) or an astronomical disaster (*When Worlds Collide*). Oboler, in fact, had lived by the gimmick—the science fiction twist or the new technique (he made the first 3-D movie, *Bwana Devil*). *Five* is a fantasy of purification and personal transcendence, falling into the tradition that extends from universal tales of a Great Flood to the disaster film cycle of the 1970s. Its timely appearance during the floodtide of crisis in 1949-50—the fall of China, the Russian Bomb, atom spies, and the invasion of South Korea—reinforced the film's social metaphors: the aggressive, self-serving foreigner, the passivity and denial of the old man as Everyman, and Michael as the college-educated, middle class American Adam, beginning anew with his self-sacrificing helpmate in the garden of Suburbia. Even the token black man is part of the fifties vision: a poetic ideal who turns out in practice to be dispensable. The role of the Bomb in all this seems closer to what Robert Lifton has termed the religion of "nuclearism"; it is a cleansing, purifying agent, hosting the power of God to bring the Flood, the Second Coming, or the New Eden.[2]

Oboler's Edenic theme and microcosmic plot—love triangle, villain intruder, a handful who survive for flimsy reasons, sanitized or unseen destruction, and conventional social concerns—recurred in other fifties films such as *The World, the Flesh, and the Devil* (1959) and Roger Corman's change-in-his-pocket productions such as *The Day the World Ended* (1956), which included a rubber mutant to break the monotony. (A 1965 remake, *In the Year 2889*, may have been camp's finest hour, viewing like a high school play with the metal-shop teacher cast in the older lead, projecting every line for the benefit of lip-readers and the hard-of-hearing.) Corman struck again in 1960 with *The Last Woman on Earth*, shot with another film during a two-week Caribbean vacation write-off. The scriptwriter, who thought it up day to day as they filmed, filled in as juvenile lead, cutting travel costs and allowing him to think it up moment to moment as well.[3]

Not limited to immediate postholocaust scenarios, the Edenic theme was extended to natural catastrophe (*When Worlds Collide* [1953]) and to the regeneration of mutant, decadent, or regressed societies, where the holocaust had long passed and the new Adam was often a time traveler (e.g., *World Without End* [1956], *Teenage Caveman* [1958], *The Time Machine* [1960], and *Planet of the Apes* [1968]).[4] The visions of

renewal in postholocaust films were part of an increased longing for the innocent, pastoral settings of a simpler time, manifest not only in science fiction films but throughout postwar popular culture: MGM musicals, the spate of adult Westerns, historical and Biblical romance, the Davy Crockett mania, and the folk music revival, all against the backdrop of suburban migration and reemphasis on security, tradition, God, country, and family.

By the early sixties the Edenic fairy tale had lost favor with nuclear film makers, reappearing only in *Damnation Alley* (1977), a film well after its time, which recapped variations on the *Five* plot. While earlier films ended with "The Beginning" written across the screen, a Great Flood deposits *Damnation Alley*'s survivors on a pastoral shore where blue skies have returned; a female radio voice guides them to a rural town with lawns, trees, and white fences, and the small crowd of inhabitants—perhaps just out from a Little League game—runs toward them with outstretched arms. As one critic observed, not only is an unspeakable horror turned into "a household word, easily spoken because already confronted, already digested," but special effects make the atmospheric hell "thrillingly trippy," and the desolation becomes "a challenge for pioneers of the future who refuse to mourn, refuse to regret, but only carry on courageously."[5]

The first postholocaust film to break with the Edenic theme was Stanley Kramer's *On the Beach* (1959), based on Nevil Shute's 1957 bestseller. Nuclear war has annihilated the Northern Hemisphere and poisoned the atmosphere, dooming the rest of humanity to extinction within months. The southernmost and last surviving large city, Melbourne, carries on much as usual while awaiting the lethal cloud. An American nuclear submarine captain, Dwight Towers (Gregory Peck), falls in love with Moira Davidson (Ava Gardner), a middle-aged local wildflower. With no illusions about the reality, he nevertheless chooses to remain loyal to a sanity-saving vision of his wife and children awaiting him in Connecticut. Accepting this, the lonely Moira gives him love and companionship. In the end, hoping to die on home soil, Towers takes his ship to sea, submerging off the coast as Moira waves from the beach in the deadly breeze. Supporting characters include Peter (Tony Perkins) and Mary (Donna Anderson), a young married couple who care for their baby and plan for the future until the last moment, and a nuclear physicist (Fred Astaire) who fulfills his lifelong dream, buying a Ferrari and risking his now meaningless life in winning the Grand Prix.

Rejecting a new Genesis in favor of extinction, the film was touted by some as a courageous social message. Linus Pauling thought posterity might remember *On the Beach* as "the movie that saved the world."[6] To others, however, it was a "lucrative venture masquerading as social consciousness" —another fifties fairy tale of proper romance and domestic virtue, a *Woman's Day* approach to extinction, with the sun dancing on the water behind a kiss, sailors ogling Ava Gardner, and other devices on the level of Astaire's musicals.[7] Once again, we see no destruction, no corpses, no physical agony—only the poignancy of ill-fated love. Rather than show us what must have happened to New York and Moscow, complained one critic, the film "portrays sweetly sad images" of deserted San Francisco and San Diego, and "the elegiac last days of Australia," where business-as-usual is carried to the extreme of people in orderly lines being carefully checked off lists as they receive government-issued suicide pills in the final hours.[8] Others, however, noted that it is easier to identify with the concerns of healthy, attractive people in normal settings. Moira's rage at having wasted her youth only to lose her life to someone else's war, or the physicist's realization that his glamorous role was not only meaningless, but partly responsible for the end of all meaning, or the young couple feeding and changing their baby until the day when it must be given the dose of poison recommended for infants—these are closer to our personal perspectives than, for example, a man dragging himself through burning rubble in search of his leg.

The reason that *On the Beach* is not *about* the bomb any more than its Edenic predecessors is that it is about meaning rather than meaninglessness, life rather than death. More exactly it is about the meaning of life in the face of one's own death. At the very least it is implied that a simplified, albeit shortened, existence may achieve new levels of romantic intensity and personal discovery. In its celebration of the human spirit the film denies even the gesture of anarchy—unless one counts the wanton moment when the starched butler, perceiving he is the only one left in the stuffy men's club, elects for the first time in his career not to straighten the portrait that always lists when the door slams.

Contrary to critics who argued that the understated depiction of life-as-usual itensified the sense of doom, it was the understatement of doom that intensified life-as-usual. Mary continues to tend the garden and plan the baby's future, Moira's father improves his farm, and Captain

Towers and his crew, the last surviving Americans, never stray from even the most trivial navy regulation. The novel is even more insistent: Moira enrolls in a secretarial course, Dwight goes gift-shopping for his imaginary family in Connecticut, and Peter goes to great lengths in the last hours to obtain a decorative bench for his wife's garden. None of the characters accept the full implications of meaningless extinction. Perhaps this is because most human action is predicated on a perception of immortality, a faith that the individual, the family, the community, or the species will endure in some form.[9] Under the circumstances, however, anarchy would make no more sense than business-as-usual. To ask why Towers stays with his ship is no more reasonable than to ask "why not." Far from being unrealistic, the holocaust's intensification of life-as-usual forces the perception that meaning ultimately lies in process—in the mundane, inertial patterns themselves rather than their specific content or their idealized ends. The novel clarifies this point when Moira comments on the young couple's obsession with their garden:

> "They won't be *here* in six months time. I won't be here. You won't be here. They won't *want* any vegetables next year."
>
> Dwight stood in silence for a moment, looking out at the blue sea, the long curve of the shore. "So what?" he said at last. "Maybe they don't believe it. Maybe they think that they can take it all with them and have it where they're going to, someplace, I wouldn't know." He paused. "The thing is, they just kind of like to plan a garden."

Yet for all its effectiveness as a meditation on personal mortality, it remains true that the film sugar coats the holocaust. A lingering city that allows elegiac love affairs and long, sweet farewells seems at least an atypical postholocaust scenario. Once again there is a suggestion of Lifton's "nuclearism": All problems are solved by a single explosion, annihilating concern with decisions, responsibilities, complexities— even death itself. For, as Towers says in the novel,

> "We've all got to die one day, some sooner and some later. The trouble always has been that you're never

ready, because you don't know when it's coming. Well, now we do know, and there's nothing to be done about it. I kind of like that. I kind of like the thought that I'll be fit and well up till the end of August and then—home."

What we really fear, moreover, is not extinction but terror, pain, and suffering. Because it achieves the former without the latter, the film remains transitional, ostensibly pessimistic, but in fact idealistically celebrating rather than censuring the human spirit. Kramer boasted that, unlike the novel, his film ended on a note of hope—the Christian banner fluttering over empty streets in the last scene, reading "There's still time, Brother!" As a message film, *On the Beach* was far better than *Five*, but finally no more effective than the banner.

Just as the classic fifties Western, in which an innocent town was threatened by villains from outside, was replaced by the anti-establishment sixties Western, in which an evil town was cleaned up by a group of paid renegades, so the classic fifties science fiction film with innocent communities threatened by alien monsters, was superseded in the late sixties and early seventies by films in which dystopian societies battled underground rebels. Most of the dystopias and wastelands in these films were the product of some previous holocaust, and the "survivor"—whether the heroic rebel (e.g., *Logan's Run*) or the scavenger who caricatures all the decadent extremes of former civilization (e.g., *Road Warrior* or *The End of August at the Ozone Hotel*)—became an increasingly popular image. The appeal of these films had less to do with nuclear war than with a growing paranoia and survivor mentality. The leap in technological leverage has encouraged an illusion of individual autonomy within the larger reality of one's abject dependence on the depersonalized, demythologized, technological society. The increasing sense of individual isolation, vulnerability, and loss of control is reflected in the proliferation of disaster-films and action-hero vigilantes who repeatedly survive certain death to bring down archvillains and vast global conspiracies. The nostalgic need to simplify and purify in the face of impotence and ambiguity also underlies much of our obsession with sports, where the issues are clear-cut, confrontation is pure and direct, and the winner survives. In short, the paradox of apparent power and utter dependence produces an image of the superior man as a romanticized primitive—a survivor.

Among those films dealing with the immediate aftermath of the Bomb, *Panic in the Year Zero* (1962), based on Ward Moore's stories "Lot" and "Lot's Daughter," is the most explicit example of the survivor syndrome. Appearing during the bomb shelter mania, and depicting nuclear war as a temporary inconvenience, the worst effect of which is a breakdown of law and order, the film is probably an accurate representation of public illusions at the time. While on a fishing trip, a Los Angeles family discovers that the city has come under nuclear attack. Amid the ensuing anarchy, the heretofore civilized, middle class father (Ray Milland) and son (Frankie Avalon) seize weapons and attack anyone who stands in their way. "It's going to be survival of the fittest," says father, and "we can start with one basic fact—us." He knocks out a service station attendant to get gas, robs a hardware store when he cannot pay, and parts a stream of cars blocking the family's escape by pouring gasoline over the road and setting it on fire. Horrified at first by his commitment to violence, his wife is converted to his view when their seventeen-year-old daughter is raped by a gang of thugs. After hunting down the rapists and shooting them at close range, Milland leads his family back to what is left of civilization and the protective arm of the U.S. Army.

Panic in the Year Zero is a reactionary film, concerned with law, order, and the status quo, exemplifying, as one critic observed, "exactly the sort of attitude that is likely to cause World War Three."[12] "I looked for the worst in others and I found it in myself," is Milland's belated conclusion. Yet to the degree that his actions represent the willingness, indispensable to any healthy community, to accept a necessary evil in pursuit of a larger good, they exemplify what Robert Bly has called "making contact with the Wildman"—the dark, aggressive energy deep in the masculine side of the psyche.[13] The repression of this energy by a liberal tradition that has never granted evil its due has disturbed the psychocultural balance of masculine and feminine. The result is that the masculine face of this equilibrium—forceful action undertaken, not without compassion, but with resolve—is itself polarized: On one hand, the Wildman is paraded as the castrated, domesticated Dagwood, while on the other, he breaks loose to commit the macho excesses that characterize the survivor syndrome. The collective neuroses of the towns in fifties Westerns lay in the fact that they had to import their Wildman-stranger-saviors—their Alan Ladds and Gary Coopers—from the wilderness. But regardless of how one evaluates the issues raised,

Panic in the Year Zero remains another film that was never intended to be *about* the holocaust. To the degree, in fact, that the power of the Bomb is translated into the power of the Wildman, it is Lifton's "nuclearism" at its finest. And the final message, despite the film's underlying cynicism, is that even the Bomb need not sever the family that preys together.

To disqualify films that bathe the Bomb in auras of rebirth, elegiac death, or resurrected masculinity, raises the question of what a film truly about the Bomb would be like? For many critics, the immediate answer was Peter Watkins' *The War Game* (1966). Made for BBC television but never aired (allegedly because it was "too horrifying," though political motives seemed likely[14]), *The War Game* is a forty-seven minute, newsreel-style semi-documentary graphically depicting the nuclear devastation of Britain's Kent County. Released to theaters in 1966, it won an Oscar for best documentary of the year. Eschewing not only melodrama but any form of story line, the film exposes the absurdity of government civil defense policies and rejects the notion that survivors would remain orderly and civilized. One of the most controversial pictures in film history, *The War Game* included not only food riots, executions, gory wounds, and bleak, apathetic faces, but also the shooting of the hopelessly injured, bulldozers clearing bodies: and people being sucked into firestorms like dry leaves.

A similar film, Nicholas Meyer's *The Day After*, which cost $7 million and reached an estimated 100 million viewers on ABC-Television in 1983, included violence, suffering, and people being incinerated into skeletons. A problem for both films was the impossibility of living up to the orgy of controversy that preceded them. The BBC feared that *The War Game* might cause suicide and national panic, while previewers of *The Day After* called for the mobilization of crisis centers to handle the wave of grade-school suicides and mass catatonia anticipated in the wake of the program. Benina Berger-Gould, Berkeley "specialist" on the effect of the nuclear threat on children and the family, made it into *TV Guide* with her warning that "no one—child, adult or teen-ager—should watch it alone."[15] Just as ambulances were put on standby when *The War Game* premiered in Scotland, dozens of organizations like SANE, "The Day Before," and Physicians for Social Responsibility, feeling that *The Day After* should be watched "with others rather than alone and helpless in one's own home," made arrangements for group viewings and local post-broadcast gatherings.[16]

In truth, *The War Game*'s camera panned and jerked so rapidly over grainy, black and white scenes that often the subject itself, let alone the detail, was too unintelligible to be shocking. A public opinion poll reported that only 9.4 per cent thought the film too horrific to be televised, while another survey found that "*all* of those interviewed who had actually seen the film believed it should be aired."[17] As for *The Day After*, most came away with the feeling that it was just another disaster movie, flitting from miniplot to miniplot to suit the attention span of the TV generation, jerry-rigging cardboard characters in order to kill them off, and doing so with far more discretion than the mildest splatter movie, where heads blow apart like cherry-bombed tomatoes. Far from being controversial shockers, *The War Game* and *The Day After* failed partly because their low megaton scenarios did not go far enough. Ironically, they failed for their lack of realism.

On one side of this critical controversy is an extreme oversensitivity—the childlike innocence of the would-be counselors who previewed *The Day After*—something close to emotional hemophilia. At the opposite pole is an almost schizophrenic undersensitivity to anything outside the self—a feeling that no death could be worse than one's own, which is inevitable anyway, and that if we all go together, one avoids missing out on the future. The oversensitives tend to read their personal anxieties and insecurities onto humanity at large, projecting an attitude that can paralyze both the individual and society, while the undersensitives come close to losing touch with reality by carrying to an extreme the necessary ability to desensitize oneself to indirect, universal dangers. The oversensitives thus accuse us of "psychic numbing," while the undersensitives see us as paralyzed neurotics who lack the perception that evil is inherent in the human condition. The truth is that each extreme is speaking only to the other, while the great majority of us in the middle, who experience the same tendencies in a more complex balance, listen in bewilderment, if at all. To the degree that nuclear films were ever intended to be *about* the Bomb, they have failed to speak to this mass in the middle, for whom the norm tends toward undersensitivity.[18] Nor can an understanding of how the average man relates to the realities of the Bomb be accomplished with armchair catch phrases like "psychic numbing" which offer any and all possible conditions as evidence. If my honest optimism about my future is hiding an hysterical fear of the Bomb, how am I to be distinguished from

one who has achieved the conscious and healthy resignation so often required to live a productive life?

Perhaps what Watkins and Meyer have taught us is that it is not necessary to show the actual physical realities—the skin hanging down in sheets and the loose eyeballs popularized by Hiroshima accounts—for only the oversensitives are properly shocked. Such "realism" not only *increases* emotional anesthesia but appeals to the voyeur in us who seeks antidotes to everyday tedium in horrible human suffering—in fantasies of miraculous survival, renewed unity and purpose, and redeemer heroism. Instead, the prerequisites for an effective nuclear message film are that the probability of extinction be made inescapably clear,[19] that there be no emotional escape routes for the viewer, and most important, that the annihilation take place within a context that is personally meaningful to the audience.

In this respect, Lynne Littman's *Testament* (1983), based on "The Last Testament" by Carol Amen, is far more successful than *The Day After* because it stays with one family, develops characters in depth, and has an emotional unity and progression that draws the viewer in ever more deeply. A suburban family, apparently caught in the interstices of those circles of destruction that *Life* magazine used to superimpose on metropolitan maps, awaits its inevitable death by radiation. The father never returns from what was San Francisco, and the mother must bear up alone as she buries her children one by one, stitched in body-bags made from bed sheets. We are never present at the moment of death, we never witness intense physical pain, and we are never exposed to catastrophic special effects. World War III is a blank TV and a blinding flash through the windows. What we see instead is spiritual death, intense emotional pain, and catastrophic hopelessness. The contrast between *The Day After* and *Testament* is similar to that between contemporary films and those of the thirties and forties. The earlier films deal in symbol and suggestion rather than explicit special effects—a shadow on the wall rather than a chain saw in the groin. In the most memorable scene from *The Day After*, hospital workers stare in disbelief at the rising white vapor trails of Minuteman missiles, soaring from their silos, arcing away into the blue over the pastoral Kansas landscape. Likewise, the striking images from *The War Game* were not the nightmares of destruction but the man trying to protect his family from the knowledge that they would all soon die of leukemia, or the

child who had looked at the fireball and then stood sightless in a garden, weeping in pain and confusion.[20]

Testament is about an extraordinary event in the lives of ordinary people. Like *E.T.: The Extraterrestrial*, *Testament*'s long beginning establishes audience identification with the familiar uneventful routine of life in middle class, child-oriented suburbia. *Testament*, however, is actually *E.T.* in reverse: In *E.T.* a transcendent, Christlike power intervenes with a message of hope; in *Testament* a transcendent evil power intervenes with a message of doom. In both cases, the viewer is unable to pigeonhole the experience. Just as *E.T.* brought the extraterrestrial out of the remote deserts and cardboard communities of fifties science fiction films and into the real world of pizza and *Sesame Street*, *Testament* freed the holocaust from the Edenic fantasy, the romantic elegy, and the circus of special effects, planting it under the nine-to-five day with such stealth as to catch the thrill-seeking escapist completely off guard.

Habitual activities persist after *Testament*'s holocaust just as they did in *On the Beach*. The school play (*The Pied Piper of Hamelin* because they live in Hamelin, California) goes on, the last line spoken by the family's youngest boy: "Your children are not dead. They will come back when the world deserves them." And the preteen daughter continues her piano lessons with her intense teacher, whose demand for punctuality is less an obsession than a tenacious clinging to meaning. Like those in *On the Beach*, the characters discover that meaning derives from networks of connectedness and communion, no matter how pointless the patterns themselves become. Reflecting on the fact that a few have left town, the twelve-year-old explains to his mother that he is running errands for the old man who sits at the ham radio, that Mary Liz has her piano lessons, and that Dad might still come back. "And besides," adds his mother, "it's our home." But unlike *On the Beach*, *Testament*'s story is not diffused into global and institutional concerns, nor is it all stiff-upper-lip anticipation of a discreet off-screen nightmare. *Testament*'s deaths not only *take place*, but do so amid conditions that deteriorate so gradually, evenly, and inexorably that the viewer never regroups his perspective. One has almost adjusted—almost achieved the resignation of *On the Beach*—when one discovers that the next incremental step has already become a reality. Not only do we move from collapsed services to sickness to burials to a great bonfire of bodies, but the photography grows dark and monochromatic, sunshine gives way to rain, and people

seem to merge with the shadows. Yet all of this wilting, flickering, and dying never lapses into melodrama. The story, seen entirely from the mother's harrowed perspective, never loses the profaning sense that beyond even this last personal agony there remains that cosmic indifference which has always belittled our own crises.

This intense personal focus (along with a $750,000 budget which was unable, for example, to adequately populate the town) caused one critic to call the film "an overbearingly banal" and "genteel vision of the apocalypse," its "soap-opera sentimentality domesticating the unthinkable."[21] Ironically, however, it is not *Testament* but *The Day After* that domesticates the Bomb. The power of the "unthinkable" lies in its unseen mystery. Just as something essential is lost when God materializes as a bearded man in the sky, graphic special effects make the Bomb *thinkable*; there is a feeling that one has confronted it, digested it, and that it is nothing but those images. The critical dilemma concerning the nuclear message film is similar to the theological paradox concerning the image of God: to concretize it (idolatry) is to take away its numinosity; yet without concrete representation it cannot become immediate and personal. Unlike other films, *Testament* overcomes this dilemma by leaving the Bomb its numinosity and confining its "realism" to an emotional explicitness that is as raw as the physical images of *The Day After*. Much of this personal realism is achieved by ignoring the global perspective, including such meaningless abstractions as who started the war, or big-scale images of extinction.

The concern over extinction, whether of humans, whales, or sea otters, is an emotional luxury. The idea that extinction is greater than personal death is an abstraction that belongs with Copernican theory and relativity. For most humans, bound to subjective reality, the sun still rises and sets; and though relativity may be so real as to ultimately produce extinction, in most minds "matter" will retain color, odor, and texture to that last moment. In the common mind, "extinction" is the opposite of walking on the moon; "death" is the opposite of walking at all. The one is abstract and cerebral, like the explanation of "red" in an optics textbook; the other is personal and immediate, like seeing red itself. Abstractions provide necessary rationales for the narcissistic personality prerequisite to leadership, but the foot soldier never fights for an abstraction. He doesn't fight to preserve "liberty" or the peasant utopia or the perfect union; he fights to preserve his Wednesday night pinochle game, his wife's new curtains, or his Little

League champions. If the man in the street finally gets mad-as-hell about the Bomb it will not be in response to remote archival photos of charred Japanese children, or special-effect images of a bald, moonlike planet; more likely it will come from repeated visions such as those in *Testament*—a wife listening for the last time to her husband's voice on her answering machine, then transferring the last battery to the flashlight; or a mother's panicked search for the teddy bear before burying her little boy in the yard.

These things alone, however, cannot account for the film's effectiveness. An underlying counterpoint to *Testament*'s dominant pessimism affirms, even idealizes, the abiding spirit of the average individual. It is as though the human collective were some alien creature—an evil monster like the Bomb it has created—in the shadow of which each individual must somehow nurture hope. *Testament* simply depicts this predicament in its extreme form. In the final scene, the last three survivors—the mother, her twelve-year-old son Brad, and a retarded Japanese boy sit in the dark observing Brad's thirteenth birthday with three candles stuck to crackers.

> "What do we do now?" asks Brad without expression.
> "Make a wish," answers his mother.
> "What'll we wish for, Mom?"

After a pause she says: "That we remember it all. The good and the awful. The way we finally lived. That we never gave up. That we were *last* to be here—to deserve the children." The film then ends with another of the slow-motion, bright, flickering, home movies that have punctuated the story—this one a surprise birthday celebration for Dad in the backyard with cake and candles.

One recalls the last act of *Our Town*, in which the dead Emily returns to witness her twelfth birthday and says to the Stage Manager:

> It goes so fast. We don't have time to look at one another. . . . I didn't realize. So all that was going an and we never noticed. . . . Good-by to Grover's Corners . . . Mama and Papa. Good-by to clocks ticking . . . and Mama's sunflowers. And food and coffee. And new ironed dresses and hot baths . . . and sleeping and waking up. Oh, Earth, you're too wonderful for anybody

to realize you. Do any human beings ever realize life while they live it?—every, every minute?

At the deepest level, our reaction to the postholocaust film is less a feeling of fear and rage than a renewed appreciation of Mama's sunflowers, new ironed dresses, and hot baths, and of the fact that we all live under a lesser form of the same fate, that we are each finally alone, with our candles and our wishes, in the face of death.

Fragments of Eden

The images are indelible: eighty-five elephants bathing in the river in late afternoon light, a stone's throw from our launch; a pride of lions at the edge of a lake, devouring their kill in the sunset; a giraffe poised in a meadow on the end of a rainbow. The experience of Africa is essential to any sojourn on this planet, from the flight of a thousand flamingos to the earth-shaking thunder of Victoria Falls, plunging at three million gallons a second, as though some cosmic abyss had opened to swallow all the waters of the world. But the lure of the Dark Continent lies deeper than the images.

In the crisp chill of predawn, as our open vehicle crawled over rutted roads toward the first glow of day, a timeless aura lay over the land, stretching away to a horizon dotted with umbrella trees—bare limbed under brush-stroke foliage, leaning and reaching in the dawn light. I imagined the same fresh morning four million years before, when the Olduvai man stood in all his pristine vitality on the shore of his ancient lake, the hills rising up behind him, rolling dark and hulking, like a herd of great beasts. Africa! The word alone recalls some primal Source, some pulsating center deep in the racial memory, the mystery of origins, the Mother of man. Like the sea itself, this vast ocean of land with its dark jungles and majestic mountains is the primordial Home, the mythic Eden from which men spread over the planet like terrestrial astronauts, surviving ever more harsh and artificial environments.

We are drawn back. Europeans go back; Americans go back; people from Los Angeles go back, fleeing the quiet desperation of tire marts and daytime TV, drawn by some mythic remembrance of strength and sunlight, of fresh mornings when we walked with the beasts, woven gracefully into their world.

We return to Africa to reencounter the four million years of history that a mere four millennia could never efface. Like the hero in *Heart of Darkness*, we are drawn to the Dark Continent of our inner selves—the dark forest of the soul where the modern ego encamps in a tiny clearing. And we project our half-remembered wholeness onto that sun-drenched land of major chords and primary colors, of smiling primitives and beautifully painted creatures. We are the Shadow People, fallen from grace, cast from the inner Eden to a wilderness of externals.

We return to the Dark Continent and lie awake in our tents, projecting our monsters into the African night—startled from sleep by the sloshing of elephants along the lakeshore, or the hollow brays of hippos, afloat somewhere down the dark river. But these are the bogies of bad movies, the misplaced specters of a surreal civilization. The innocent creatures themselves, who once roamed the continent at will, now wander the Serengeti like artifacts of evolution, the last remnants of an unfragmented world.

One feels that this is the last refuge of innocence, that the last lions may soon lie in that sunset by the water's edge. Along the banks of the Chobe River, the elephants gather in the dusk; their great dark shapes endure as monuments to the vast ocean of life that once covered this continent. And the giraffe whose head soared above the rainbow into the gray mist, watching us with long-lashed liquid eyes, spoke the sad hope of all surviving species. Only the ringing of insects under the red sky seems eternal, like a residual trace of lost tribal rhythms—the melodious chants of Zulu and Maasai that once rose up like voices from the earth, echoing off the far hills in the heat of the day, to fade over the long grass, leaving the land in eerie silence.

Reflections in a Rear View Mirror

What happens as we try to come to terms with our past is that we see our lives as a process of continual disenchantment. We long for the security provided by the comforting illusions of our youth. We remember the breathless infatuation of first love; we regret the complications imposed by our mistakes, the compromises of our integrity, the roads not taken.
 —*Gordon Livingston,* Too Soon Old, Too Late Smart

Time is the fire in which we burn.
 —*Malcolm McDowell as Soran in* Star Trek: Generations

Lofty Days

When I met him in 1946, Tommy Alden was a chubby third-grader with merry eyes, curly black hair, and a jovial intensity. He lived in a white house with green shutters on a poplar-shaded street in old Palo Alto. We grew up together a few blocks apart, waiting at the same bus stops for the same buses to the same schools. I came to see his house as a second home and the Aldens as the model American family, descended from Mormon pioneers who had driven their wagons through frozen winters across the last west. There was an aura about the Alden house of immutable tradition and unspoken verities, like some fabled rift in the fabric of time, apt to melt at any moment back into the panorama of the great American past.

As Tom got older, they let him have the large room over the garage. We called it "the loft." Steep wooden steps led to a windowed door; and across the room, a small dormer looked down the driveway to the poplar-lined street. The roofline sloped from the low ceiling to within four feet of the floor, giving the loft a cozy feeling. Books, magazines, and model trains crowded the shelves. Clippings, drawings, and photos were tacked to the knotty pine walls. There was an old record changer plugged into a clock radio, an unmade bed, a musty chair, a lumpy sofa, and a desk cluttered with paints, model parts, and a sea of sundry items.

In our early teens we often spent evenings in the loft doing homework, drawing cartoons, leafing through magazines, and dreaming of rockets to the moon. It was the golden age of science-fiction films—*Destination*

Moon, The Day the Earth Stood Still, When Worlds Collide—and we sometimes biked to a late movie or went out into the cricket-pulsing night to turn a small telescope on the moon and planets.

In those lofty days we hovered in limbo between childhood and maturity, innocence and responsibility—like America itself, poised at midcentury between modern and postmodern. For two outsiders still innocent of life's limitations, the loft was a secluded haven in a world of somber parents, traffic-cop teachers, and simian peers. To climb the wooden steps and sprawl on the overstuffed chair, listening in the dark to Beethoven and laughing at the world's conceits, was to step into some timeless dimension. Looking back from the autumn of life, the loft looms like a brisk spring dawn, a bubble in spacetime where the dreams of adolescence could bloom in the dead of winter.

On a shelf over the window stood the centerpiece of our retreat—a six-foot-long locomotive, the Union Pacific "Big Boy" that Tom had crafted in great detail from a few blocks of wood. The old steam locomotives were his true love. Unfortunately, he spent much of his class time in school on meticulous drawings of Southern Pacific cab-forwards and Union Pacific mallet engines, many of which were strewn about the loft. Sometimes we biked to the depot to watch the earth-shaking monsters rumble out of the night, pounding and squealing to a halt. Tom would stand fixated, the glow of the firebox agleam in his eye.

The locomotive was Tom's mechanical counterpart, the one an explosive monster at boiler pressure, the other a fleshy hulk imploding with frustrations that would wear him down in the end. It seemed fitting that Beethoven's "Eroica" symphony, pulsing with the pent-up power of a locomotive, was Tom's favorite. In the Museum of Natural History in San Mateo, he once happened upon a fox whose cage was positioned under that of a great horned owl. Globs and runs of the owl's droppings were all over the fox's cage and all over the fox. The image possessed him. "How would you like it," he laughed through a mouthful of cookies, "if anytime anyone wanted to find you all they'd have to do is drive up to a cage full of birdshit in San Mateo? They wouldn't even have to call first to see if you were there."

"He can't get out," was my ritual response.

"That's just it!" he cried through tears of laughter, sliding off the sofa until he was propped against it like a sack of sand. "That's what's so goddam funny about it!" He threw his head back as though yelling at the ceiling: *"He can't get out!"*

Tom's cages were many—among them, the Mormon Church, made inviolable by the intimidating image of his exalted grandfather, the number three man in the Church. Tom's parents were the Church incarnate. His mother, Alice, was a refined and intelligent woman whose devotion to home and family was as solid as her certainties on everything from social class to keeping house. And though his father, a doctor of economics, was a multi-talented, many-faceted man, his quiet authority and leaden countenance cast a Jehovan aura over the Alden house. Tom's mother had painted the loft floor red with white dots; "each dot on this floor," she had written in white paint, "is a prayer and a wish for your happiness." His father laid carpet over it.

Like the Church itself, Kyle and Alice Alden embodied the paradox of those who are fundamentally right for the wrong reasons, whose solid communal values become inseparable from some outmoded doctrine, forming a tether of fear and guilt that stunts the free spirit. Tom's attempts to reclaim his freedom were limited to his fertile imagination and harmless eccentricities—his vision of leaping from a pew in the middle of the sermon to throw his body on the plunger of an ear-splitting air horn, or his Tourette-like compulsion to intone humorous nonsense phrases in a deep baritone, often in the middle of an unrelated sentence. Sometimes these twinkle-eyed bursts were in ominous monotone: "And the Mor-Man *Church*," or a lilting "*B-O-L-O-A-D-Y*," the incessant chant of an old lady he'd overheard while visiting a rest home. The mystery of its meaning possessed him all his life.

An animated boy with a taciturn father, an expansive mind with an overprotective mother, an overweight kid with an athletic big brother, Tommy Alden lived out in the loft, where rockets, trains, and Eroica promised power and motion, and the massive six-foot model called "Big Boy" would forever embody his being.

But in that time of innocence, when faith in the future displaced any thought of the past, we pored over the *Colliers* series on the coming of spaceflight and built a four-foot, three-stage rocket in the workshop. We packed the powder from skyrockets in aluminum tubes, encasing them in a sleek balsa ship that stood on three streamlined fins like the rocket in *Destination Moon*. Our plan was to ignite the red and white monster electrically, for which we engaged the services of fellow student Robert Baer, a Radio Club nerd whom bullies loved to drag out of the boys' room into the hallway, pants down, still defecating, kicking, and trying to bite his assailants.

On a hot summer day, the three misfits set out for the Baylands, hauling their telemetry in a Radio Flyer wagon. We were enraptured on arriving to find that the ground was parched and fissured like the imagined moonscape in *Destination Moon*. We set up our equipment, readied the camera, and signaled Baer to push his button. At first nothing happened, then we noticed a tame little fire creeping silently over the ship, leaving a charred, smoking shell.

It was a symbolic moment. The future, for Tom, would fizzle like the rocket, leaving him in limbo, his spirit immured in the charred shell of the past. He went on to Brigham Young, dropped out, spent two years on a Mormon mission, and returned to the white house with green shutters to work in the post office, care for his parents, and remain in the loft for most of his life.

Though I married, had children, and our lives took separate turns, the loft remained my occasional retreat for more than four decades. Sometimes, in the middle of a dark day or suffocating week, I would compulsively alter course for the poplar-lined street in old Palo Alto. I might find Tom sitting on the floor at the center of his train layout in his great baggy pants, dreaming aloud as he watched the S-gauge locomotives go round and round, in and out of the tunnels. If only he had a million dollars he'd buy a boat and a Chrysler Crown Imperial like those owned by his venerable grandfather. For a short time Tom did own a used Crown Imperial limousine complete with jump seats. Other than cheap cigars, which at age forty-five he still concealed from his parents, it was his only notable indulgence.

Between those who have shared adolescence there is a bond nurtured by a deep nostalgia for the innocence and irresponsibility of a timeless world where all things seemed possible. Childhood friends are the repositories of our roots, the shared memory traces of people and places long gone. Like many old friends, we evolved an extensive inspeak, capsulizing characters and events otherwise long forgotten. We shared a radical sense of humor to the degree that one would often perfect the thought of the other. If heads in the windows of a bus, all blankly facing the same direction, struck me as bizarre, he would add the definitive phrase: "*Being moved*"—with a twinkle in his eye and a knowing little nod. His pithy humor could seem slapstick on the surface, but like Laurel and Hardy, whose films we loved, the real message was multi-layered, lying less in what he said than in the way he said it.

Pushing 300 pounds in middle age, his unkempt figure even bore a resemblance to Oliver Hardy's. The image was unaided by his habit of spitting, his loud voice due to hearing loss, and an innocent if sometimes peevish lack of tact. Years of eroding self-esteem had left him often inapt, obsessively reminiscing, and profoundly alone. Yet he never lost his kind, unassuming, and deeply compassionate nature, nor that heightened awareness, that penetrating perception for which, however ingenuous, the outsider always pays the price. Like many free spirits trapped in the labyrinths of ordinary life, Tom was unappreciated and misunderstood by everyone, from dreary teachers to his well-meaning but complacent family. Yet within this failed, overweight, uneventful being, who had never ventured farther than the family's summer home in Utah, dwelt a unique soul, an insightful, imaginative, deep-feeling person whose promise had succumbed to the weight of the Mormon Church and middle-class propriety.

One great talent survived: the building of painstakingly accurate models from scratch. Using any materials at hand—ice cream sticks, toothpicks, empty spools, curtain rods, jar caps, tin cans—he duplicated in exquisite detail everything from cars, trains, and planes to entire landscapes. One thinks of John Merrick, Victorian England's grotesquely deformed "elephant man." A gentle soul retrieved from a freak show and imprisoned in a hospital where he was often treated as an animal, Merrick died at twenty-seven of a ruptured spinal cord due to the weight of his own horrifying head. In his room Merrick left a magnificently intricate model, built from scraps of cardboard trash, of the soaring spires of St. Philip's, the cathedral visible from his window. Tom's cathedral was his majestic "Big Boy" locomotive, embodying the energy, power, and intensive mission that might have been. But it was not his body that was deformed or imprisoned. One felt, in fact, that his corpulent size, like the boiler on "Big Boy," was the natural and necessary container for the repressed energy of his singular soul.

In his sixties, with frayed nerves and fading eyesight, he gradually gave up model making, devoting more and more time to tending his ailing parents. With passing years he became less apt to laugh and more prone to lament his life. We would get in the car and drive back through time—to the old schools, to a tree by the bus stop where we had carved the name, now barely visible, of an especially odious teacher—then to the old Creamery for lunch and back to the loft, drifting all the while in our world outside of time, detached from all ambition and obligation.

While those around us scurried into the future, we moved among them like specters from another dimension, spewing our inspeak nonsense, our laments, our faded memories from the fresh morning of our lives.

Tom's father died in front of the hospital while Tom was fetching the car to take him home, but his mother lasted another decade. When her death at 95 forced the sale of the house, the price of Bay Area housing forced him to move near a niece and nephew in Issaquah, Washington. But the uprooting was too radical. He began to have breakdowns and was diagnosed as bipolar. Perhaps parents and churches are no more than eddies in a neurochemical torrent.

Uprooting change and mobility destroy the sense of place, the lost landmarks of one's life—the old school, the theater where Roy Rogers rode on Saturday mornings, the magic ground where the circus set up, now a shopping center. In Issaquah, where place became mere space, Tom contracted terminal cancer.

His headstone reads:

<div style="text-align:center">

THOMAS K. ALDEN
1937-2011
B-O-L-O-*A*-D-Y

</div>

The eccentric outsider, Tom was misunderstood by the narrowly conventional, but charming and loveable to those who could see the humor and sense the core truth of this extraordinary soul. Such people are the lamps that line our journey—patches of light along the path, winding through the long night of life on this Earth. To the end he retained his jovial intensity and bighearted nature. Even as he lay dying, he was far more concerned with the fact that his brother was deathly ill than with his own fate—more concerned even about a friend down in Oregon who was broke and being evicted.

There is a need in every life for some constant that endures across the decades, some person or place to which we can return on days when the world seems alien—a shrine to halcyon times, or an old friend who is curator of our youth. I once had such a person, such a place—a loft over an old garage—where I could go on a gray day to relax, laugh a little, and forget my troubles. Like the fox, Tom was always there, an old friend who, no matter what his burdens, was always glad to see me. For many years I took it for granted, but such unconditional people are the greatest gifts we get.

The Best of Times

The day Tom left for Washington we watched the moving van pull away, towing his old station wagon on a trailer. As I too pulled away, heading home, I glimpsed Tom in the rear-view mirror, waving in the distance. And on a poplar-lined street in old Palo Alto, behind a white house with green shutters, a loft over an old garage descended into time.

Detritus

As the last of four generations of only-children, I inherited all my maternal grandmother's belongings when she died in 1965, along with those she had kept of my mother's, who died when I was five, and another vanload of things left by my great-grandmother. It all arrived one Tuesday morning, piled in the back yard of the small tract house where I lived with my pregnant wife. In addition to all the housewares, books, paintings, clothing, and decorative items, I found photos, letters, and diaries scattered in trunks, suitcases, and furniture drawers. I spent the day going through it, so fervently that I found myself working in darkness as raindrops began to fall. I tried to get most of the things inside and the remainder under the eaves. Sitting on the sofa amid an ocean of bags, boxes, papers, and pictures, with a mountain of trash beside me and various groupings strewn over the whole room, I noticed it was after three in the morning. I felt suddenly disoriented—in freefall. This was someone's *whole life*—three lives: mother, daughter, and granddaughter—things that had deep meaning for them; and I had no idea what to do with most of it.

There was a daguerreotype of my great-grandmother as a little girl, standing in her garden by a large basket of peaches, holding hands with her older brother, who died soon after. In a broken box in yellowed tissue was the wedding dress she wore at age 18, marrying a Sacramento hardware magnate who built her the gingerbread mansion that would later house California's governors. My grandmother, in her nightgown

at five years old, stared out of a photograph in some vast room of that dark house, lost in a forest of oversize urns, paintings, and statues. There were love letters, dated 1903, from her husband-to-be, a San Francisco doctor who died in the 1918 influenza pandemic; and wads of loose notes from evening lectures she attended while aging alone in her Washington Street flat. There was a flapper dress my mother must have worn to a party—some effervescent celebration of youth on a warm summer night, the future stretching away to infinity, everyone immortal. In a box in the drawer of a steamer trunk was the doll she took everywhere as a child, the arm now broken and the dress yellowed; and a menu from the SS *Luraline*, her honeymoon trip to Honolulu. And here was the white dress with large black polka-dots that I had long forgotten. She bought it one day while I was with her, choosing it over another at the entreaties of a five-year-old struck in that moment with how pretty his mother was.

I put down a handful of things, so suddenly aware of my charge as curator of three lives that it seemed an effort to breathe. Sitting back on the sofa, surveying it all, I broke down for a few moments and went to bed. The next day a more efficient self quickly dispensed everything to some expedient terminus. One of the realities of death is the utter inadequacy of the survivors to the responsibility—to the impossibility of even knowing what the nature of that responsibility might be. We are all destined finally to clutter someone's garage, attic, or basement, the antechambers to oblivion.

Goodbye to Gramma Watchie

Her name was Kathryn Wachhorst, but no one ever called her Kathryn. The nicknames revealed the age of her friendships: To her sister and four brothers she was Kate, to nieces, Aunt Kitty. As a young widow in San Francisco in the 1920s, she rode the stock boom with a crowd of wealthy cronies who called her Pump, after her craving for pumpernickel bread. To her closest friends, she was Kay. To me, she was Gramma Watchie.

After losing her husband in 1920 and most of her money in the crash of '29, she had gone to live with a widowed friend on a walnut farm by a small lake. When the war came, she joined my mother, helping to care for a four-year-old as we followed my father from camp to camp. When he was shipped overseas in 1944, Gramma Watchie remained with us in Pasadena, cooking meals on an old iron stove in the basement of our dingy hotel and carrying them up the creaky elevator to my ailing mother, who soon died of Lupus. I went back to San Francisco with Gramma Watchie to a one-bedroom apartment, where my father, released from the warfront, slept in the closet. She held us together while he built a dental practice, commuting to his office in Palo Alto until we bought a house there.

There was a free-spirited, open-heartedness about Gramma Watchie, befitting a woman who had lived the good life at middle age in the roaring twenties. But her years with us in Palo Alto were spent cooking, washing, cleaning, and carrying groceries home on the bus. Except for rare trips to

San Francisco, playing poker with her old cronies, her only escapes were cigarettes and evening TV. She refused household help, spent nothing on herself, fixed thousands of meals, tended sick beds, brightened holidays, gave us a near-normal life, and was taken totally for granted.

My father remarried the summer I left for Stanford, and Gramma Watchie was put to pasture in a small house in Menlo Park. It was only ten minutes from campus, but my collegiate reveling meant infrequent visits, leaving her a pile of laundry in return for lunch. My lifelong favorite, her squishy peanut butter and jelly sandwich now had an occasional hair in it. The house felt tattered and grimy, and the bathroom reeked.

After graduation, I was obliged to spend six-months on a Coast Guard cutter five hours north. I returned only once and made a brief stop at her house, staying for lunch when she insisted. Eating quickly, I announced that I should head back north. She handed me a brown bag with something even more squishy in it, which I tossed out at the first gas stop. She had always said goodbye at the door, but this time she followed me out to my car. I have an indelible image of her in the rear-view mirror, waving with her whole arm over her head from the middle of the empty street until I turned the corner. It was the last time I saw her.

I rarely live in the present. So it seems inevitable that a rear-view mirror frames my last image of this selfless woman. My regrets would seem to confirm Livingston's view of nostalgia—fleeting images of a past unlived in real time, a world where the rear-view mirror is the only real thing. Yet we are the sum of our past; the present is all process. Without the mirror of memory, we are chimera afloat in the moment, connected to nothing. There is a healing side to nostalgia, like a rush of cool air in the heat of a still summer night, a whole life held in a heartbeat. The dissonance of the minute-to-minute self dissolves to a harmonic sense of wholeness, of coming Home. Memory plays to music.

Gramma Watchie still waves from the empty street, forever receding, an image of lost origins, of love and sacrifice, inseparable from my larger self. More than sadness and regret, nostalgia brings a sense of belonging, of transcendence. Beyond loss, I am at one with the thing lost, completed by it, the ark of its essence, and so more than my transitory self. Nostalgia is redemptive, revitalizing, sustaining us through passing seasons as we make do with our mortality—the remembrance of roots, of truth, of who we really are.

Appendix

On the Generational Theory of History

How does one delineate a generation, let alone declare it the "Greatest?" Contrary to common belief, the length of a generation is not measured by the years from birth to parenthood, a time span that can vary from 20 to 40 years. A better measure is the length of a life phase, roughly 22 years. The four phases are youth (birth to 21), young adulthood (22 to early 40s), midlife (early 40s to 65), and elderhood (after 65). The turning points correspond to coming of age (legal majority, college graduation), seniority (higher responsibilities in return for experience), and retirement. Thus, at any given moment, four to six generations make up society. Each generation, however, is shaped by different historical circumstances. Those born during the first quarter of the 20^{th} century had a very different introduction to reality than those born in the second quarter (the so-called "Silent Generation") or from the late 1940s to the 60s (the Baby Boomers).

Roughly every two decades (the span of one phase of life), there has arisen a new constellation of generations—a new layering of generational personas up and down the age ladder. As this constellation has shifted, so has the national mood. History creates generations,

and generations create history. One generational constellation will underprotect children, for example, while another will overprotect them. The same is true with attitudes toward politics, war, religion, family, affluence, gender roles, pluralism, and a host of other trends.

The result in modern history has been a cycle of four generational types. The best exposition of the cycle is found in two books by William Strauss and Neil Howe, *Generations* (1991) and *The Fourth Turning* (1997). Briefly, they demonstrate that two types of key events—a material crisis and a spiritual awakening—have alternated approximately every half-century throughout American history. Every scholar who has looked closely at American generational rhythms has seen a similar pattern at work.

In America, freedom and relative isolation have provided ideal conditions for the natural operation of the cycle, from the Puritan awakening (1621-40), the "Glorious Revolution" (1675-92), the "Great Awakening" (1734-43), and the American Revolution (1773-89), to the transcendental awakening (1822-37), the Civil War (1857-65), the missionary awakening (1886-1903), the Great Depression and World War II (1932-45), and the Boomer or countercultural awakening (1967-80). The outcome, as Strauss and Howe document with overwhelming detail on each generation, has been a cycle of four generational types designated "civic," "adaptive," "idealist," and "reactive." The civic and idealist emerge, respectively, with the material and spiritual crises; the adaptive and reactive are transitional.[1]

In any era, the four generational types each occupy one of the four phases of individual life (e.g., when the civic is in childhood, the adaptive is in youth, the idealist in midlife, and the reactive in elderhood) and these configurations, along with child-rearing practices and other factors, help explain the progression of the cycle. Like the seasons, each crisis and awakening contains the seed of its opposite, and the cycle of four generational constellations (high, awakening, unraveling, crisis) constitute history's seasonal rhythm of growth, maturation, entropy, and destruction.

To oversimplify: (1) A self-sacrificing "civic" generation responds to a material *crisis* (e.g., depression and war) and in so doing creates a progressive, achievement-oriented Zeitgeist with a strong value consensus. (2) In the succeeding *high*, an "adaptive" generation thus grows up overprotected, cautious, and conformist; this is a period of strengthening institutions and weakening individualism (e.g., late 1940s

to 60s). (3) The consequent prosperity spawns an "idealist" generation able to afford an inner search for new values (*awakening*), reacting against a conformism now so removed from its original impetus that it is perceived as hollow (e.g., 60s and 70s). (4) The resulting *unraveling* is a period of weakening institutions and strengthening individualism (e.g., 80s to present); a streetwise "reactive" generation of self-serving realists both counters and exploits idealist excesses, fragmenting what is left of the old value consensus and setting society up for the new material crisis that will call forth a new "civic" generation.

Thus the role of hero in social evolution falls to the civic generation, which resolves, or at least brings society intact through its most threatening crises. The oldest member of the nascent civic generation, the one that will have to meet the crisis toward which we seem clearly headed, is now about 20 years old. It is the previous civic generation, born during the first quarter of the twentieth century, that has come to be called the "Greatest Generation."

Notes

1. A State of Mind

1. The reflective tone in the popular culture of the postwar forties was evident in the high proportion of nostalgic films and Broadway productions, such as *The Corn is Green, State Fair, A Tree Grows in Brooklyn, Centennial Summer, It's a Wonderful Life, Up in Central Park, Carousel, High Button Shoes, Miss Liberty, Easter Parade, I Remember Mama, So Dear to My Heart, Summer Holiday, Words and Music, Annie Get Your Gun, Three Little Words, Till the Clouds Roll By,* and *The Yearling.*
2. See Stephen Marche, "Is Facebook Making Us Lonely?" *Atlantic*, 309 (May 2012): 62, 64, 66-69. "As society's material conditions become ever more complex," wrote sociologist Richard Sennett, "its social relationships become ever more crude."
3. Paul Newman, quoted in *Newsweek*, October 6, 2008, p. 63.

2. The Nature of Nostalgia

1. Fred Davis, *Yearning for Yesterday: A Sociology of Nostalgia* (New York: The Free Press, 1979), pp. 14, 49, 57, 59; Janelle Wilson, *Nostalgia: Sanctuary of Meaning* (Lewisburg, Penn.: Bucknell University Press, 2005), p. 127; Frank White, *The Overview Effect: Space Exploration and Human Evolution* (Boston: Houghton Mifflin, 1987).

2. Studies confirming the positive effects of nostalgia have proliferated over the last two decades. See, for example, Constantine Sedikides, et al., "Nostalgia as Enabler of Self Continuity," in Fabio Sani (ed.), *Self Continuity: Individual and Collective Perspectives* (New York: Psychology Press, 2008), pp. 227-42; Anne Wilson and Michael Ross, "The Identity Function of Autobiographical Memory: Time Is on Our Side," *Memory* 11 (March 2003): 137-49; Angelina Sutin and Richard Robins, "Going Forward By Drawing from the Past: Personal Strivings, Personally Meaningful Memories, and Personality Traits," *Journal of Personality* 76 (June 2008): 631-64; and Clay Routledge, et al., "The Past Makes the Present Meaningful: Nostalgia as an Existential Resource," *Journal of Personality and Social Psychology* 101 (September 2011): 638-52.
3. James Phillips, "Distance, Absence, and Nostalgia," in Don Ihde and Hugh J. Silverman, eds., *Descriptions*, Albany: SUNY Press, 1985, p. 73; Ralph Harper, *Nostalgia: An Existential Exploration of Longing and Fulfilment in the Modern Age* (Cleveland, Ohio: The Press of Western Reserve University, 1966), pp. 29, 100, 120.
4. Milton L. Miller, *Nostalgia: A Psychoanalytic Study of Marcel Proust* (Boston: Houghton Mifflin, Associated Faculty Press, 1956), p. 106; T. S. Eliot, "Little Gidding," in *Four Quartets* (New York: Harcourt Brace Jovanovich, 1971), p. 59.
5. The far reaches of Jungian analysis, while intuitively compelling, can have a certain heuristic ring. At the other end of the spectrum, experimental psychology seems less than compelling, offering tautologies and common-sense observations camouflaged in heavy jargon. In most cases, people are too complex for simple questionnaires and single variables. Until we know vastly more about the brain, a black box will remain between subjective experience and any attempt to objectively explain it.
6. James Hollis, *The Eden Project: In Search of the Magical Other* (Toronto: Inner City Books, 1998), pp. 36-37, 50.
7. Mel D. Faber, *The Psychological Roots of Religious Belief: Searching for Angels and the Parent-God* (Amherst, N.Y.: Prometheus Books, 2004), p. 20.
8. This pattern, once universal across our species, is rooted in specialized mental processes evolved for survival over millions of years as hunter-gatherers. Our survival would be in jeopardy had our minds not evolved to understand the world in terms of patterns, purpose, causality, group loyalty, and respect for authority. Unlike other animals, our instincts are insufficient to guide us automatically in all situations. Young children are therefore predisposed by natural selection to believe whatever their parents tell them. We thus

learn many of our basic core beliefs before we have the rational capacity to evaluate them. We are programmed to process current information along neural pathways that harbor our previous experience; the more frequent the associations, the more solid they become, which makes beliefs, once learned, so difficult to change. The synaptic pathways become set and the stories are passed on in perpetuity. An expansion of these points can be found in Pascal Boyer, *Religion Explained: The Evolutionary Origins of Religious Thought* (New York: Basic Books, 2001); Bruce M. Hood, *SuperSense: Why We Believe in the Unbelievable* (New York: HarperCollins, 2009); Hank Davis, *Caveman Logic: The Persistence of Primitive Thinking in a Modern World* (Amherst, N.Y.: Prometheus Books, 2009); Michael A. Persinger, *Neuropsychological Bases of God Beliefs* (New York: Praeger, 1987); Michael Shermer, *How We Believe: Science, Skepticism, and the Search for God* (2nd ed.; New York: W. H. Freeman, 2003); Andrew Newberg and Mark Robert Waldman, *Why We Believe What We Believe: Uncovering Our Biological Need for Meaning, Spirituality, and Truth* (New York: Free Press, 2006), and *How God Changes Your Brain: Breakthrough Findings from a Leading Neuroscientist* (New York: Ballantine Books, 2009); Nicholas Humphrey, *Leaps of Faith: Science, Miracles, and the Search for Supernatural Consolation* (New York: Copernicus, 1999); Joseph Giovannoli, *The Biology of Belief: How Our Biology Biases Our Beliefs and Perceptions* (N.p.: Rosetta Press, 2000); and Daniel Dennet, *Breaking the Spell* (New York: Viking, 2006).

9. Roughly, the left side of the brain deciphers the *text* of experience (analytical) while the right side provides the larger meaning or *context* (gestalt). The one is literal and focused on means, the other metaphoric and concerned with ends. Both are vital to normal mental function. Damage to the left hemisphere, for example, can mean problems with speech and logic, while damage to the right causes problems with perception and attention. In a classic experiment, patients were asked to redraw from memory what they saw after studying a large H made up entirely of small A's. Patients with right hemisphere damage often simply drew scattered A's over the page, while those with left damage just drew a large H with no A's. Nostalgia's overview effect and the outsider/introvert's search for meaning would thus seem more at home in the right hemisphere. See Sally P. Springer and Georg Deutsch, *Left Brain, Right Brain* (4th ed.; New York: W. H. Freeman Co., 1993); D. Frank Benson and Eran Zaidel, eds., *The Dual Brain: Hemispheric Specialization in Humans* (New York: Guilford Press, 1985); Fredric Schiffer, *Of Two Minds: The Revolutionary Science of Dual-Brain Psychology* (New

York: The Free Press, 1998); and Richard J. Davidson and Kenneth Hugdahl, eds., *Brain Asymmetry* (Cambridge, Mass.: MIT Press, 1995).

On introversion and extraversion, see Kenneth J. Shapiro and Irving E. Alexander, *The Experience of Introversion* (Durham, N.C.: Duke University Press, 1975); Marti Olsen Laney, *The Introvert Advantage: How to Thrive in an Extrovert World* (New York: Workman Publishing, 2002); Larry Wayne Morris, *Extraversion and Introversion: An Interactional Perspective* (Washington, D.C.: Hemisphere Publishing, 1979); H.J. Eysenck, ed., *Readings in Extraversion-Introversion 3: Bearings on Basic Psychological Processes* (New York: Wiley-Interscience, 1971); and Susan Cain, *Quiet: The Power of Introverts in a World That Can't Stop Talking* (New York: Crown Publishers, 2012).

10. "Kant thought that space was the form of our outer experience, and time, the form of inner experience" (Svetlana Boym, *The Future of Nostalgia* [New York: Basic Books, 2001], p. 18). Given free time, the outsider/introvert may polish his novel, while the insider/extravert may travel the world. Perhaps we each need some form of balance between inner and outer and between order and chaos to stabilize our open search for meaning and identity. The outsider's inner quest may require a stable external order, from compulsive neatness and habit to monastic extremes, while the insider's outer quest may require the inner order found in a rigid social, political, or religious value structure.

11. There is an aspect to nostalgia itself that appeals to outsiderness. "There is the illusion, now that we are safely through a time, that the time was essentially safe. We forget that then, as now, we were turned toward an uncertain future. We did not know that we would survive our shoestring life. The fact that we did retroactively bathes everything in the glow of *vie bohème*" (Sven Birkerts, "American Nostalgia," *The Writer's Chronicle* [February 1999], p. 36).

12. Saul Bellow, *Mr. Sammler's Planet* (New York: Viking Press, 1970), p. 190.

13. Michael S. Malone, *The Valley of Heart's Delight: A Silicon Valley Notebook, 1963-2001* (New York: John Wiley & Sons, 2002), pp. 4-5; and "Silicon Insider: Tech Kills Tower . . .and Nostalgia?" (abcnews.com, December 14, 2006).

14. Quoted in Birkerts, "American Nostalgia," pp. 33-34.

3. Crossing the Wide Missouri

1. Alec Wilkinson, *The Protest Singer: An Intimate Portrait of Pete Seeger* (New York: Alfred A. Knopf, 2009), pp. 119–20.

2. All the songs cited are available on the internet: "Kentucky Moonshiner" (Rolf Cahn); "Alberta" (Bob Gibson); "The Bells of Rhymney" (Seeger); "Little Brown Dog" (Judy Collins); "Fi-li-mi-oo-re-ay" (Weavers); "It Takes a Worried Man"; "Pastures of Plenty"; "Colorado Trail"; "Shenandoah" (the man at the hungry i was Stan Wilson).

4. The Romance of Spaceflight

1. Willy Ley and Chesley Bonestell, *The Conquest of Space* (New York: Viking Press, 1949).
2. Although Robert Lippert had received story lines for *Rocketship X-M* prior to the contracting of *Destination Moon* and managed to release the film a month ahead of *DM*, his decision to proceed with it was nevertheless a direct result of *DM*'s extensive prerelease publicity. See Bill Warren, *Keep Watching the Skies: American Science Fiction Films of the Fifties, Vol. I, 1950-1957* (Jefferson, N.C.: McFarland, 1982), pp. 11, 13.
3. Michael Collins, *Carrying the Fire: An Astronaut's Journeys* (New York: Bantam Books, 1983), p. 253.
4. Leo J. Moser, *The Technology Trap: Survival in a Man-Made Environment* (Chicago: Nelson-Hall, 1979), pp. 48-50.
5. S. G. Schwartz, "Amour De Voyage," *Michigan Quarterly Review* 18 (Spring 1979): 266.
6. National Aeronautics and Space Administration, *Why Man Explores* (Washington, D.C.: U.S. Government Printing Office, 1976), pp. 18-20.
7. Loren Eiseley, *The Unexpected Universe* (San Diego: Harvest Books, 1969), pp. 67-73.

The Inner Reaches of Outer Space

1. Walter McDougall, . . . *The Heavens and the Earth: A Political History of the Space Age* (New York: Basic Books, 1985), p. 422.
2. Edwin Dubb, "Without Earth There Is No Heaven: The Cosmos Is Not a Physicist's Equation," *Harper's 289* (February 1995): 40.
3. Joseph Campbell, *Myths to Live By* (New York: Bantam, 1973), p. 246.
4. Charles L. Sanford, "An American Pilgrim's Progress," *American Quarterly* 4 (Winter 1955): 302.

5. Come Back, Shane!

1. David Brion Davis, "Ten-Gallon Hero," *American Quarterly* 6 (Summer 1954): 117.
2. Jane Tomkins, *West of Everything: The Inner Life of Westerns* (New York: Oxford University Press, 1992), pp.198-99. In *The Lives and Legends of Buffalo Bill* (Norman, Okla.: University of Oklahoma Press, 1960), Donald Russell explains that because Buffalo Bill employed only the Sioux and a few other Plains tribes, the Indians in Westerns ride horses and wear feathered headdresses, though many Indians did neither. Also, "cowboys wear ten-gallon Stetsons, not because such a hat was worn in early range days, but because it was part of the costume adopted by Buffalo Bill for his show" (p. 470).
3. See John Lawrence and Robert Jewett, *The Myth of the American Superhero* (Grand Rapids, Mich.: William B. Eerdmans Publishing Co., 2002), which finds examples in history and every conceivable area of popular culture.
4. Tomkins, *West of Everything*, pp. 37, 44-45.
5. Tomkins, *West of Everything*, pp. 14-15.
6. David Thomson, "Better Best Westerns." *Film Comment* 26 (March/April 1990): 6.
7. Tomkins, *West of Everything*, p. 198.
8. Jenni Calder, *There Must Be a Lone Ranger: The American West in Film and in Reality* (New York: McGraw-Hill, 1974), p. 13.
9. John K. Stockton, "The Trail of the Covered Wagon," http://iagenweb.org/taylor/history/tci131.htm.
10. Michelle Ferrari, "Kit Carson," *American Experience* (Boston: WGBH TV, 2008).

6. The Last Locomotive

1. Alan Lomax, *The Folk Songs of North America in the English Language* (Garden City, N.Y.: Doubleday, 1960), p. 406.
2. Illinois Central Gulf Railroad: "The City of New Orleans," words and music by Steve Goodman. His original line was "This train's got the disappearin' railroad blues."

7. Our Game

1. A. Bartlett Giamatti, "The Green Fields of the Mind," in Peter H. Gordon, *Diamonds Are Forever: Artists and Writers on Baseball* (San Francisco: Chronicle Books, 1987), p. 142.
2. Doris Kearns Goodwin, "From Father with Love," in Gordon, ed., *Diamonds Are Forever*, p. 144.
3. Benjamin G. Rader, "Compensatory Sport Heroes: Ruth, Grange, and Dempsey," *Journal of Popular Culture* 16 (Spring 1983): 12-14. See also Leverett T. Smith, Jr., *The American Dream and the National Game* (Bowling Green, Ohio: Bowling Green University Popular Press, 1975), pp. 123-24, 127-28, 190-207; and David Quentin Voigt, *American Baseball, Vol. II: From the Commissioners to Continental Expansion* (Norman, Oklahoma: University of Oklahoma Press, 1970), pp. 13-16. The new phenomenon was partly the result of skillful promotion as sports became increasingly commercial, along with a new ball-manufacturing technique that enabled the batter to hit it farther.
4. What was often retained in subsequent films was the notion of baseball as a lesson in life. Earlier, this meant sport as a builder of character in boys—a kind of Teddy Roosevelt, Boy Scout, inspirational, muscular Christianity, which included sport as a teacher of hard work, self-sacrifice, competitive drive, and respect for authority. Although there is some of this in *The Bad News Bears* (1976) and *Aunt Mary* (1979), the larger message of these and other films is a rejection of myopic competition in favor of a broader human perspective. *The Bad News Bears* lose the championship because the coach, shamed by the cutthroat parental spectacle, lets the perennial benchwarmers play the last inning. In *Aunt Mary*, Jean Stapleton plays a wheelchair-bound Baltimore Orioles fan, lovable and feisty, who coaches neighborhood kids in the fundamentals of baseball and life. In *Million Dollar Infield* (1982), a group of men facing individual midlife crises escape the outside world and fulfill their fantasies on a softball team. After suffering domestic problems, job sacrifices, and escape from social and financial ruin, the four main characters emerge as lesser softball players but better human beings. *Bang the Drum Slowly* (1973) depicts a squabbling team drawn together by the catcher's impending death from Hodgkins Disease. In *Bull Durham* (1988) a wild, egotistical minor league pitching prospect gains some human perspective from a has-been catcher. And in *Eight Men Out* (1988) White Sox players who threw the 1919 World Series learn the meaning of man's tragic flaw.
5. Michael Oriard, *Dreaming of Heroes: American Sports Fiction, 1868-1980* (Chicago: Nelson-Hall, 1982), pp. 211-12.

6. Oriard, *Dreaming of Heroes*, pp. 211-20; Wiley Lee Umphlett, *The Sporting Myth and the American Experience* (Lewisburg, Penn.: Bucknell University Press, 1975), pp. 156-68.
7. An irony is that the farmhouse and ball field in the quaint little town of Dyersville in northeastern Iowa where the film was made became a lucrative tourist attraction, with souvenir shops, ghost players who emerged from the cornfield, and hundreds of visitors a day who could rent equipment and play on the diamond.
8. W. P. Kinsella, *Shoeless Joe*, and Gail Mazur, "Spring Training in the Grapefruit League" quoted in Gordon, *Diamonds Are Forever*; Kevin Kerrane and Richard Grossinger, eds., *Baseball Diamonds: Tales, Traces, Visions, and Voodoo from a Native American Rite* (Garden City, NY: Anchor Books, 1980), pp. 241-42; Michael Novak, *The Joy of Sports: End Zones, Bases, Baskets, Balls, and the Consecration of the American Spirit* (New York: Basic Books, 1976), p. 56.
9. Marvin Cohen, *Baseball the Beautiful: Decoding the Diamond* (New York: Links Books, 1970), p. 120.
10. Kevin Kerrane, "Reality 35, Illusion 3: Notes on the Football Imagination in Contemporary Fiction," *Journal of Popular Culture* 8 (Fall 1974): 438, 441; Donald Hall, "Fathers Playing Catch with Sons," quoted in Gordon, *Diamonds Are Forever*, p. 143.
11. Wallace Stevens, *The Necessary Angel: Essays on Reality and the Imagination* (New York: Vintage Books, 1951), p. 36.
12. Irene Rosenberg-Javors, "Nostalgia for a Perfect World," *Annals of the American Psychotherapy Association* 7 (September 22, 2004): 51; Carol Cling, "'Moneyball' About More Than Money, Baseball," *Las Vegas Review-Journal*, September 23, 2011.

The cartoon is by Dana Fradon, *New Yorker*, June 28, 1976.

9. The Romance of Extinction

1. J. Fred MacDonald, *Don't Touch That Dial: Radio Programming in American Life, 1920-1960* (Chicago: Nelson-Hall, 1979), pp. 56-57, 67, 68, 106; *Columbia Pressbook* for *Five* (Hollywood: Columbia Pictures, 1951).
2. Robert Jay Lifton, *The Broken Connection: On Death and the Continuity of Life* (New York: Simon & Schuster, 1980), pp. 369-87.
3. Joe Bonham, "The Return of Roger Corman," *Starlog* 4 (February 1979): 46-49.

4. The Edenic theme in film was not initiated by the bomb; in *The End of the World* (1916), the new Adam and Eve survive a comet catastrophe.
5. Judith Bloch, "Damnation Alley," *Film Quarterly* 35 (Fall 1981): 51. The film differs radically from Zelazny's novel, which is superior in intent, focus, and resolution.
6. Joseph Keyerleber, "On the Beach," in *Nuclear War Films*, ed. Jack G. Shaheen (Carbondale, Ill.: Southern Illinois Press, 1978), p. 31.
7. Keyerleber, p. 34; Robert Hatch, "Films," *Nation*, January 2, 1960, p. 20.
8. Midge Decter, "Stanley Kramer's 'On the Beach,'" *Commentary* 29 (June 1960): 524.
9. Robert Lifton elaborates on this idea in *The Broken Connection* and other writings.
10. Nevil Shute, *On the Beach* (New York: Signet Books, 1957), pp. 88-89.
11. *Ibid.*, p. 103.
12. John Brosnan, *Future Tense: The Cinema of Science Fiction* (New York: St. Martin's Press, 1978), p. 156.
13. Keith Thompson, "What Men Really Want: A *New Age* Interview with Robert Bly," *New Age Journal* [n.v.] (May 1982): 30-37, 50-51.
14. *The War Game* was the first film ever banned by the BBC. Asked if she agreed with the decision, Mrs. Winifred Crum Ewing, producer of documentaries for the BBC, answered that "having lived in the Southeast of England throughout the war, having seen how people behave in circumstances of war and bombing, it was an absolute slander on humanity. His [Watkins'] observations are profoundly wrong. . . . We don't need these emotional, left-wing intellectuals to tell that we can destroy the world" (quoted in Jack G. Shaheen, "The War Game," in *Nuclear War Films*, ed. Jack G. Shaheen, p. 313. See also James M. Welsh, "The Modern Apocalypse: 'The War Game,'" *Journal of Popular Film and Television* 11 (Spring 1983): 25-41; Joseph A. Gomez, *Peter Watkins* (Boston: Twayne, 1979), pp. 45-66.
15. Howard Polskin, "Educators Worry About Effect of 'The Day After.'" *TV Guide*, November 9, 1983, p. A-1. See also *Forum* 2 (Fall 1983) [newsletter of the Educators for Social Responsibility], special issue on *The Day After*; and Judith Michaelson, "The End of Denial: A Psychiatrist Looks at 'The Day After,'" *San Francisco Sunday Examiner and Chronicle*, November 30, 1983, Datebook, p. 59.
16. Welsh, "The Modern Apocalypse: 'The War Game,'" p. 30; Gerzon, "Watching the World End: How Hollywood Faced Up to Nuclear War," *New Age Journal* [n.v.] (November 1983): 87.
17. Welsh, "The Modern Apocalypse: 'The War Game,'" p. 38.

18. Public opinion polls at the time continued to show that the majority of Americans did not consider themselves seriously affected by thoughts of the bomb. Surveys of children's reactions suggested more fear, probably because opposite results tend to be ignored. And what can a child say in reaction to a questionnaire other than to repeat what he has heard and give descriptions that could hardly be positive? See Hazel Erskine, "The Polls: Atomic Weapons and Nuclear Energy," *Public Opinion Quarterly* 27 (1963): 155-90; Eugene Rosi, Mass and Attentive Opinion on Nuclear Weapons Tests and Fallout, 1954-1963," *Public Opinion Quarterly* 29 (1965): 280-97; Vincent Jeffries, "Political Generations and the Acceptance or Rejection of Nuclear Warfare," *Journal of Social Issues* 39 (1974): 119-36; Howard Means, "Freedom from Fear," *Washingtonian* 116 (August 1981): 77-86; Lawrence D. Maloney, "Nuclear Threat through the Eyes of College Students," *U.S. News and World Report*, April 16, 1984, pp. 34-37; Harry F. Waters, et al., "TV's Nuclear Nightmare," *Newsweek*, November 21, 1983, pp. 66-72; Michael Kernan, "Children in Fear of Nuclear War," *Washington Post*, October 14, 1983, pp. C1, C4; Marcia Yudkin, "When Kids Think the Unthinkable," *Psychology Today* 18 (April 1984): 18-25; Sylvia Eberhart, "How the American People Feel about the Atomic Bomb," *Bulletin of the Atomic Scientists* 3 (June 1947): 146-49, 168; "How U.S. Citizens React to the Bomb," *U.N. World* 1 (October 1947): 9; and Alice Cheavens, "Facing the Fear of Bombs," *Parents Magazine* 25 (November 1950): 42, 136.

19. The most popular case for extinction is Jonathan Schell's *The Fate of the Earth* (New York: Alfred A. Knopf, 1982), which reflects the scientific consensus. See also Paul R. Ehrlich and Carl Sagan, *The Cold and the Dark: The World after Nuclear War* (New York: Norton, 1984).

20. *The Day After* originally contained a powerful scene showing a child screaming but was cut when a child psychologist retained by ABC said it would upset children (Gerzon, "Watching the World End," p. 34). *The War Game* examples are noted by Richard Schickel in *Second Sight: Notes on Some Movies, 1965-1970* (New York: Simon & Schuster, 1972), p. 104.

21. David Ansen, "A Quiet Apocalypse," *Newsweek*, November 14, 1983, pp. 98, 101.

22. Thornton Wilder, *Three Plays by Thornton Wilder* (New York: Bantam Books, 1961), p. 62.

Appendix

1. The self-perpetuating nature of cycles, in which a thing taken to its extreme becomes its opposite, is seen most simply in predator-prey cycles. When the wolves have eaten most of the rabbits, they begin to starve, which results in fewer wolves, which in turn allows the rabbit population to expand and regenerate the wolves, ad infinitum. The wolves and rabbits are a two-stroke cycle; the four generational types propel a four-stroke cycle, which is really a two-stroke cycle with two transitional stages.

About the Author

Growing up in America in the forties and fifties, Wyn Wachhorst lived the topics of these essays. He performed in the urban folk music revival, was part of the duck-and-cover generation, and came of age in a time before television eclipsed radio, football superseded baseball, and crime shows replaced Westerns, a time before the reality of spaceflight displaced the wonders of science fiction and the romance of the railroad receded into history.

His book, *The Dream of Spaceflight: Essays on the Near Edge of Infinity* (Basic Books), was on the science bestseller lists of Amazon and Barnes & Noble. *Thomas Alva Edison: An American Myth* (MIT Press) was a history book club selection, picked by *Choice* as an outstanding book of the year, and reviewed favorably in *Newsweek, Discover, Smithsonian, Science*, the *New York Times*, London *Sunday Times*, and some three dozen other publications. His fifty-five articles and essays have appeared in the *Yale Review, Virginia Quarterly Review, Massachusetts Review, Southwest Review, San Francisco magazine, Narrative* magazine, *Endless Vacation, Mechanical Engineering, Isis, Extrapolation, Explorers' Journal, Planetary Report*, the *Journal of American History, Wall Street Journal, USA Today, San Francisco Chronicle* and in anthologies. Three of his essays were noted in *Best American Essays*, and one recently won the McGinnis-Ritchie Prize for best essay of the year. He writes speeches and articles for Apollo astronaut Buzz Aldrin and was asked by NASA's Decade Planning Team to write the new NASA myth, an inspirational long-term mission statement. Wachhorst received his Ph.D. in American history from Stanford and taught history and American studies at Stanford, the University of California Santa Cruz, and San Jose State. He resides with his wife in Atherton, California.

www.ingramcontent.com/pod-product-compliance
Lightning Source LLC
Chambersburg PA
CBHW030949180526
45163CB00002B/720